BENDING THE FRAME

BENDING THE FRAME

Photojournalism, Documentary, and the Citizen

by **Fred Ritchin**

aperture

To all those who are doing the work.

CONTENTS

Preface

What do we want from this media revolution? Not just where is it bringing us — where do we want to go? When the pixels start to settle, where do we think we should be in relationship to media — as producers, subjects, viewers? Since all media inevitably change us, how do we *want* to be changed?

Do we want to know more about the world, or less? Which worlds — our internal one, the consumer-oriented one, the one concerning other people and the planet and our relationship to both of them? Do we want to know about issues and events in a timely manner, and if so, do we want others to have similar information so that we can discuss it together — and maybe do something about what we find? Or should we all be able to pursue our own idiosyncratic trajectories, making use of whatever we want whenever we want it? Do we want all of these things? (And are we willing to pay for any of it?)

What should be expected of professional photographers of the journalistic and documentary ilk? Should they be more neutral, more independent, more knowledgeable, more transparently credible than before? And should there be any similar obligations for nonprofessional photographers, now that we increasingly depend upon them to tell us about the world? Do we now need — even more than we need photographers — *metaphotographers* capable of sorting through some of the billions of images now available, adding their own, and contextualizing all of them so that they become more useful, more complex, and more visible?

The era of the photograph as automatically credible is over, for better and for worse. Photographs lied, but they were also capable of telling truths, however partial. They still have that capacity, perhaps more than ever, but now, like other media, photographs have to be employed rhetorically to build a case and to persuade. Rather than routinely indicate what *is* (as records of the visible), they increasingly point to what *might be* — with the potential for much deeper understanding, as well as for a particularly subversive simulation designed to mislead.

Many photographs (or images that look like photographs), invoking the previous paradigm of photography—as lens-based recording—are designed to elevate the status of a subject or of their authors, or to immediately confine those they depict to convenient categories by invoking an already existing visual trope. The increasingly malleable photograph—whether manipulated before or after the shutter's release—is employed to fashion the world according to the intentions of the person making it, or of the institution for which it is being made. The world and we become one (there is no *there* there, as Gertrude Stein put it), refracted together in a self-portrait, basking in the glow of Image while disingenuously unaware of how frayed the connections have become between the photograph and the world it was once meant to signify. We are insulated (as I titled a previous book) "in our own image."

But then what can a photographer—not wanting to contribute to the pursuit of branding (of things, people, institutions) or to the image wars that hover around every significant event—do to be of more service to society? What are the possible approaches, including those emerging and those marginalized, that may establish stronger, more thoughtful, more straightforward connections with the actual and the essential? Which kinds of image-based strategies might best engage readers, and which might manage to respect the rights, and the agency, of those depicted? How does today's image-maker create meaningful media?

Vincent van Gogh saw the world differently from his predecessors (and from most everyone else): he was liberated to paint as he did partly by photography, which was far more efficient than painting as a sheer representational medium. We too can be liberated by the achievements of recent decades to make other kinds of imagery. What we produce should rely much less on photography's celebrated decade of the 1930s, when faster cameras and films emerged along with mass picture magazines; we do not need to make more *Migrant Mothers* and *Falling Soldiers*. There is an enormity of complex issues today that cannot be similarly encapsulated—how, for example, is it possible, through photography, to proactively address global issues like climate change, or to participate in the healing process for the many still living with the traumas of war?

Bending the Frame explores some of the many efforts to create different kinds of imagery, and the values that they express. Some of the models described are decades old, others are contemporary, and some have not yet been achieved. All, in one way or another, may be useful. What then happens, of course, is up to all of us.

CHAPTER 1
The Useful Photographer

It was once thought, at least in democracies, that a photographer of the documentary or journalistic persuasion who witnessed a horrific event or situation, or a painful one, would record what it looked like in order to alert society, so that society might respond. The intrepid photographer was thought to fill an essential role in providing such visual descriptions and, quite often, in provoking readers (and at times governments) to confront issues that might not otherwise have been of concern. Despite being inevitably interpreted and framed according to the photographer's own point of view, a photograph, no matter how unfamiliar or even grotesque its depiction, was considered difficult to refute given its status as a reliable trace of the visible and the "real."

The obverse was also true—*without* a photograph (or a video), it has been difficult to get people to respond; the urgency and relevance of an event, its importance, and sometimes even the fact of its occurrence might be called into question. The photographic image of a young girl being napalmed in Vietnam, of a black man being menaced by a police dog in Birmingham, and of a hooded man with wires attached to his extremities being forced to stand on a box in Iraq's Abu Ghraib prison, all led to outcries over American policies. Photographs could be effective, viscerally so, when words alone were not enough.

The photographer's sanctioned role as a societal scribe meant that the imagery was received as more than voyeurism, or what is sometimes now crudely labeled as "violence tourism." Photographs indicating various kinds of injustice were allowed and even solicited to inform both members of society and their elected representatives—even those made by soldiers, from Abu Ghraib prison, surfaced with enormous clout. Professional photographers were expected to serve as active witnesses, and for many of them their encounters with various manifestations of the human condition, some excruciating, were thought of as both necessary and central to their responsibilities.

To borrow a term from the late John Szarkowski, longtime director of photography at the Museum of Modern Art, photographs could act as "windows" onto the world—in the case of photojournalism, windows that were able to nearly demand that one look through them, both as a prerequisite of citizenship and as a moral obligation. Although never as transparent as a window, the photograph was able to evoke a response that approximated that of actual seeing; when the photograph was published in a newspaper or magazine, the seeing became collective.

These sets of relationships, however, have become the stuff of the rearview mirror. As a cascade of screens submerges viewers with enormous numbers of images, including billions of their own photographs and videos, imagery of a larger societal significance has a much harder time surfacing, let alone demanding attention. One's Facebook page, Instagram account, and Twitter feed typically connect with various snippets and streams from other like-minded individuals, not with a menu of overriding issues (formerly a "front page") that far-flung eyewitnesses and their editors would have considered crucial to a contemporary understanding of the world.

But mainstream media has itself added to the confusion, often choosing the low road when it comes to image, in order, paradoxically, to enhance their own. By repetitively relying on imagery of celebrities (and noncelebrities treated as minor ones), on innuendos of sex, displays of explicit violence, and other forms of the spectacular, many publications have abandoned a large part of their commitment to looking as a means of engaging with events. Rather than working over a period of time as attentive observers, photographers are now frequently placed in the position of setting up imagery (as in "photo-ops" or "photo-illustrations") to get a desired result, or can be expected to act like paparazzi, on the trail of the incendiary.

While the embrace of the facile has always been a powerful tendency, and editorial imagery has nearly always been treated as illustrative, as secondary to words (although some frustrated writers may not agree), diminishing readerships and drops in advertising have exacerbated the predicament. Partially as a result, more photographers have chosen to work independently on long-term projects, applying for grants to sustain themselves in the field, or attempting to collaborate with nongovernmental organizations. Liberated from the constraints of mainstream media and able to "author" their own work without editorial interference, they now have the challenge of finding somewhere, other than their own websites, to publish—and yet another challenge: to be paid for their work.

Today nonprofessionals have found that they can post photographs and videos that are not so very different from those of mainstream media, if at times considerably quirkier and more immediate. A politician's gaffe at a private fundraiser, a somersaulting cat, or an actress working out at a gym can become the subject matter for anyone

with a camera, provided at no cost to the viewer. Work by mainstream professionals (likewise distributed mostly for free) is often more static, showing what must be seen according to an accompanying article. But these images can also be appropriated, quickly becoming part of a recontextualized mix. Information, as the saying goes, wants to be free, and the notion that professionals provide essential information that should be reimbursed has met with only modest success.

The photographic print, an object, now commands record prices, but the photograph as information has comparatively little value. In the 1970s, when I began my career, it was the opposite: one looked at documentary photographs for the vision of the world they articulated and for the details of existence that they recorded, but never thought of *buying* the prints. (If one did, each might have cost five or ten dollars.) The validation of the photographs was in their publication and distribution to a larger audience, a more extensive viewership than a photographic print could ever attract.

The photograph's documentary status has been altered, in part, by its transformation from a physical object derived from chemical processes to an expression of digital code. Rather than being viewed as the result of a recording process in which anyone present would have seen something similar, the ephemeral and easily malleable online photograph (digital-imaging software is pervasive and highly efficient) can be increasingly considered an expression of a particular point of view, a commentary on events that is more akin to writing than it is a definitive rendering.

Certainly nearly everyone working with photographs, including those in mainstream media, has always known that all images interpret rather than laying automatic claims to the truth. But photographs were also thought to contain useful information captured via the lens, including some that had escaped the photographer's control—recalling Garry Winogrand's famous phrase: "I photograph to see what things look like when they are photographed."

The rawer, first- and second-person images on social-media sites referring to "me" (the photographer) and "us" (the photographer's friends, family, and community) are viewable as at least as authentic as the aesthetically harmonious, more indirect third-person photographs made by journalistic professionals. Not only must professionals frequently produce images that fit the needs of publications—which have their own particular styles and worldviews—they also have to try to conceal, for the most part, their own personal reactions to the situations they experience. And they must attempt, despite often having little time on site, to create documents that are somehow emblematic of the unfolding situation, or at least depict several of its major components. As a result, the images they produce can seem impersonal, or borrowed from iconographies used by others in very different situations (the war in Iraq being photographed to look like World War II, for example).

The more fluid, participatory images coming from the owners of cellphones, rather than staking a claim to being definitive, can often be easily supported or contradicted by contrasting them with the many others made of the same scene. Most important, they tap into the local knowledge and experience of the phones' owners. During the 2011 uprisings in Cairo, for example, while professionals representing international publications photographed the major conflagrations, locals made images of smaller-scale activities, such as demonstrators wearing eye patches in honor of the sacrifice of fellow protester Ahmed Harara. As *Al Akhbar* reported in November 2011: "Harara, who lost his right eye on January 28 during protests leading up to the ousting of former President Hosni Mubarak, lost his left eye on November 19, according to social media activists. 'I would rather be blind, but live with dignity and with my head held up high,' Harara was quoted as saying on Egyptian activists' Facebook pages."[1] Many protestors were similarly disabled during the demonstrations, when certain police were said to have specifically targeted their eyes.[2]

Rather than claiming a doctrine of journalistic objectivity or neutrality, the very subjectivity of nonprofessionals, their transparent self-involvement and lack of financial incentive, can be reassuring—many viewers may empathize with the motivations of these ordinary citizens, which are possibly similar to their own. These images constitute, to a certain extent, a common, diaristic dialect based on showing and sharing with cellphones—a language that is more detail-oriented and everyday, with fewer elaborately constructed attempts at the larger, synthesizing statement.

The collapsing boundaries between author and reader—a collaborative coauthoring that literary deconstructionists have been theorizing for decades—opens up the expectation that the greater media world now may function in more of a conversational rather than simply a hierarchical, mostly top-down system. With digital image-capturing devices on some one billion portable telephones (a new iPhone advertisement refers to "one billion roaming photojournalists"), and the Internet increasingly available, access to the means of production and to channels of distribution is hardly exclusive. No longer are there rigorous requirements to master the "craft" of photography. Yet the medium is easily personalized, with minimal additional costs to produce enormous numbers of new images, and software that enables the photographer to efficiently, and often undetectably, modify the initial record. In the digital environment, lens-based image making has become a form of communication nearly as banal, instinctive, and pervasive (or profligate) as talking.

For the small minority of image makers who strive to work professionally as visual witnesses, the migration from paper to screen has created new challenges, most of them still unmet. As newspapers and newsmagazines have become less indispensable and are perceived as less credible, the photograph as societal arbiter has lost its most persuasive

platforms. There is little question, for example, that a photograph printed as a cover or double-page in a print publication once constituted a focal point in ways that the more transient, cluttered online environment does not often allow. (Photographs are rapidly replaced, and content-management systems are usually too formulaic to allow designs that highlight images or amplify synergies among them; short videos are more self-contained.) For example, the photograph printed on the front page of the *New York Post* on December 4, 2012, with the headline "DOOMED: Pushed on the Subway Track, This Man Is About to Die," was widely discussed (and condemned); prominently displayed on paper, it existed in the physical world for an entire day.

Adjusting to the digital environment has been challenging for all those professionally involved in the journalistic enterprise. A 2009 survey, "Photojournalists: An Endangered Species in Europe?," found that the three major crises for photojournalists were low pay scale, competition from nonprofessionals, and the protection of authors' rights—issues that trouble photographers in many regions.[3] The paradigm shift in thinking required to take advantage of the newer possibilities of digital media is difficult to accomplish. Even for major publications such as the *New York Times,* the *New Yorker,* and *Time,* much of the most interesting photographic work and commentary are published on blogs—"Lens," "Photo Booth," and "LightBox," respectively—rather than integrated into the main body of the publication, reflecting an unwillingness or inability to experiment with some of the ideas expressed in these offshoots.

The planning required to innovate in a digital environment can be considerable: among the challenges are allowing for meaningful interactivity and a mixing of media that is synergistic—amounting to more than the sum of its parts—creating narratives that can be sustained among all the hyperlinks, and providing sufficient context for the curious. Some innovations can be much easier to implement, such as a roll-over that allows the reader to place the cursor on a photograph to see another one underneath, augmenting or contradicting the first (the subject in her office and at home, say, or the photo opportunity as it was intended and what it looked like from the side)—for simpler strategies like this one, the hurdle is conceptual.

Potentials such as these are, for the most part, ignored. Photography, like other media, is made to continue fulfilling a role not unlike the ones it was assigned prior to the current media revolution, with single captioned pictures and a de facto adoption of the old-fashioned slide show as the preeminent presentation strategies for images online. These images and the ways in which they are presented can seem stodgy compared to the less tradition-bound work seen on social-media sites (invigorated by biting comments and "likes" by a coterie of collegial, often supportive observers). Uploaded by a wide gamut of people, including "citizen journalists" (the catchall term used for anyone ranging from Arab Spring revolutionaries to neighbors concerned about

something happening next door), whose approaches may stray a good distance from journalistic norms, the photographs and videos presented can be overwhelming in their emotional tenor, or silly, or enlightening, or distracting and addictive (it is hardly coincidental that viewers of the Web are called "users"). The vastness of the ever-expanding social-media archives feeds the perception that there is always something, somewhere, of potential interest if only one is willing to spend the time looking for it.

The word *magazine* comes from *magasin*, or store, which itself evolved from *mahsan*, an Arabic and Hebrew word meaning warehouse. It is as if we want to circumvent the filtered publications to forage more serendipitously in the warehouse of the Web—we prefer, in short, the experience of wholesale to that of retail. Certainly the Web still features brand names, but they hardly constrict one's choices—there are so many other opportunities just a click away. It is now likely that a search engine, having analyzed one's predilections, including previous searches, will lead one astray.

The very enormity of the Web, with its promise of revelation, recalls the Argentine writer Jorge Luis Borges's 1945 short story "The Aleph." Borges describes the protagonist's encounter with the Aleph, in the home of the cousin of a woman, now deceased, whom he had loved:

> The Aleph's diameter was probably little more than an inch, but all space was there, actual and undiminished. Each thing (a mirror's face, let us say) was infinite things, since I distinctly saw it from every angle of the universe. I saw the teeming sea; I saw daybreak and nightfall; I saw the multitudes of America; I saw a silvery cobweb in the center of a black pyramid; I saw a splintered labyrinth (it was London); I saw, close up, unending eyes watching themselves in me as in a mirror; I saw all the mirrors on earth and none of them reflected me.[4]

The Web, at this point, still has a considerable distance to go to resemble Borges's confrontation with wondrous knowledge. While instantaneously providing an impressive array of examples and answers, a cacophony of possibilities, it lacks a similar reverence for (or indeed any sense of) mystery's unveiling. A reason may be found in a rabbinical commentary on why the "aleph" itself, a letter that has no sound when pronounced, was chosen to begin an entire alphabet—because, the commentary goes, before the sound there must be the silence. Silence—visual or any other kind—is not something at which the Web excels.

What then is the difference between a professional and a nonprofessional photographer? The question was asked to major figures in the photojournalism industry several years ago at a New York University forum. The answer that slowly emerged to start the discussion, from an editor at the *New York Times*, was that one could trust a professional's work not

to be fabricated. (We also later talked about certain professionals' abilities to build more complex narratives with their images.) But given the vast number of staged events into which only professionals with press passes are allowed, for example, such trust may be misplaced (think of George W. Bush's infamous 2003 "Mission Accomplished" appearance on an aircraft carrier). It is difficult to record a photo-op without being at least somewhat complicit in a fabrication, even if that fabrication is of someone else's devising.

Today, if a photograph does emerge from the media haze with something essential to say about contemporary events, there is a growing probability that it was authored and distributed by one of the legions of amateurs with digital devices. For the moment at least, the work of these nonprofessionals—making awkward, raw, and frequently intimate imagery—is often perceived as more "authentic." (And, without even the slight hindrance of an assertive authorship that might include a claim of copyright, it may be more likely to go viral.)

Rather than advocating for a publication's worldview, the amateur may be explicitly advocating for his or her own. In 2011 computer programmer and blogger Azyz Amami, from Tunisia, spoke at the Rencontres d'Arles photography festival, pointing out several ways in which his practice and that of his colleagues during the Arab Spring differed from that of the media professional. To begin with, Amami and his cohorts were clearly motivated by their personal stake in the future of Tunisia as a democratic society. His interest, as he explained it, was not in framing a scene—taking the time to frame might mean being spotted by the security forces, and subsequent arrest. Nor was it in photographing the dead and injured—a citizen journalist would likely try to help fellow protestors who are hurt, whereas the professional is often dependent on making more shocking photographs of casualties in order to come away with saleable imagery for the international press. On the other hand, a citizen journalist might have less compunction about inflating the number of people at antigovernment demonstrations in a caption, if it might help to attract new recruits to the revolution (although, it could be added, professionals quoting official counts from ill-informed or biased authorities often get the numbers wrong as well).

That same year I curated an exhibition of photographs of the Libyan revolution by Bryan Denton, who had been working there as a freelancer for the *New York Times* over a six-month period. Denton is nearly fluent in Arabic, has lived in Beirut for several years, and had devoted himself to making imagery that explored, as best he could, the complexities of the general uprising, quite a few of which appeared in the *Times*. (He is also a former student of mine.) After a slide show of his recent work that Denton presented in a public forum at New York University, where the exhibition was held, I turned to a young Libyan woman on the panel—a student pursuing a career in health sciences—and asked her to comment. She began by thanking all who had made

photographs of her country's revolution, and then referred to a specific photograph of her grandfather in Libya that she had received only the day before as being the one that was most important to her. She described it as a cellphone image of her grandfather, posing with the corpse of former dictator Muammar el-Qaddafi in a meat locker. In the photograph, she said, her grandfather was smiling for the first time in forty years.

Aside from this photograph, there were no other specific images to which she referred. The young professional photographer next to her, who had just braved wartime violence to serve as a witness, was made to realize that a family's cellphone image, for a young Libyan woman living in New York, was apparently the most consequential. But it is also not surprising: like everything else (to borrow the title of photographer Eugene Richards's recent book), war is personal.

Of course, while there was never any assurance in photography's short history that the photographs made by social documentarians would arrive at their intended result, at times they did, and effectively. "I'm sure I am right in my choice of work," documentary photographer Lewis Hine wrote more than a century ago, in 1910. "My child-labor photos have already set the authorities to work to see 'if such things can be possible.'" Interestingly, he added: "They try to get around them by crying 'Fake' but therein lies the value of the data and a witness. My 'sociological horizon' broadens hourly."[5] Therein also lies, of course, the value of the photographs themselves—Hine's exposé stimulated legislatures to pass laws against child labor. Similarly persuaded, readers of W. Eugene Smith's 1951 photo-essay in *Life* magazine on Maude Callen, a dedicated African-American nurse-midwife serving, with few resources, a large, impoverished rural South Carolina community, spontaneously donated so much money that a new clinic was built that she said "looks like the Empire State Building to me."[6]

With the collaboration of his wife, Aileen, Smith also made a series of photographs in the early 1970s on the impact of mercury poisoning in Minamata, Japan, due to industrial pollution. The work, showing the grotesquely mangled limbs of victims, the polluted water being discharged, and government and company officials, was published first in *Life* magazine and then in a 1975 book, *Minamata*. The photographs served both as excruciating evidence of the effects of industrial waste on the local population (Smith was himself severely beaten by employees of the polluting factory) and also to spur on the larger environmental movement. Living in Minamata for three years, he and his wife had become, in a sense, hybrid citizen-journalists, both witnesses and advocates: "This is not an objective book," Smith writes in the prologue of *Minamata*. "The first word I would remove from the folklore of journalism is the word 'objective.'" He continues: "My belief is that my responsibilities within journalism are two. My first responsibility is to my subjects. My second responsibility is to my readers."[7]

Environmental concerns had been sparked a few years earlier by a man we might now call a "citizen journalist," astronaut Bill Anders. On Christmas Eve, 1968, at the end of an enormously turbulent year rife with political upheaval, Anders photographed the Earth from his perch on an Apollo spacecraft, for the first time depicting our planet as fragile and alone in the cosmos. *Earthrise*, as the photograph was called, was placed on a U.S. postage stamp and inspired Earth Day, celebrated for the first time by millions on April 22, 1970, sixteen months after Anders made the image.

Both for their impact on morale and for the damning evidence that they may gather, one of the most contested and restricted purviews of professional photographers has been the coverage of war. It is also, of course, at least in hindsight, one of the most celebrated of photography's domains. The modern turning point in war's portrayal, transitioning from the heroic to the excoriating, was that of the Vietnam War. Allowed a large amount of freedom to cover almost anything they wanted by officials who initially thought the photographs would serve a public-relations effort, the photographers in the field—by making images, such as one of a grimy, exhausted G.I.; a Vietnamese father cradling his young, injured child; a Vietcong prisoner executed at point-blank range; terrified Vietnamese children running down a road away from a napalm attack—effectively contested the U.S. government's claims about the nature and progress of the conflict.

In response, during the first Persian Gulf War photographers were largely marginalized by governments. In an effort to avoid what President George H. W. Bush called "another Vietnam,"[8] U.S. policy was to keep photographers as far away as possible; perhaps the most memorable images from that conflict show the roof of a building in the cross-hairs of a camera linked to a bomb about to strike it. Photographs that spoke directly to the consequences of the violence were negated in the "image war" that enveloped the on-field battles. For example, the pictures of a bunker destroyed in central Baghdad by an American Tomahawk missile were quickly obscured by a cloud of questions meant to nullify their impact: Were the Iraqi dead civilians or soldiers? Who was at fault? Was the claim that the victims were civilians a propaganda ploy by Saddam Hussein? As a 1991 front-page headline in the *Los Angeles Times* put it: "Images of Death Could Produce Tilt to Baghdad." The actual death of individuals was not the focus, apparently, but the fact of the image and the ways in which it might be used.[9]

The restrictive policies for photographers were modified for the second Gulf War, but still with an eye to controlling any potential fallout: photographers were now required to be "embedded" with troops, and had contracts stipulating under what circumstances photographs could be published. The limitations of embedding, along with a facile tendency to initially see the war as a battle between good and evil,

contributed to the circumstance that the most revelatory photographs to emerge from that conflict were those made by soldiers at the Abu Ghraib prison.

But even before the current crises in journalism and the diminished opportunities for editorial support, the approaches of many documentary photographers and photojournalists had already evolved significantly. Declining to rely so heavily on the camera's recording function, and borrowing from techniques usually attributed to art photographers, they came up with hybridized strategies to report on contemporary issues. In some ways these methods resemble the "New Journalism" first identified by Tom Wolfe in 1972, combining methods of the journalist with those of the novelist.[10] Writers such as Norman Mailer, Truman Capote, Gay Talese, and Wolfe himself speculated on the inner thinking of their subjects, or placed themselves in the situations on which they were reporting, using conventions from fiction in their own cross-disciplinary narratives. Similarly, many documentary and journalistic photographers departed from the mythic status of the photographic document as "fact" to explore reality as a much more contested and nuanced phenomenon—an implicit critique of traditional documentary function.

These photographers have enhanced the role of conjecture and intuition, some of them using a visual vernacular to achieve imagery that could be at times deceptively bland (Robert Adams, Bill Owens, Sophie Ristelhueber, Celia Shapiro, Stephen Shore, and Alec Soth, to name but a few), while others deployed evident formal flair, more explicit in their points of view (included among these are Bill Burke, Raymond Depardon, Jim Goldberg, Jeff Jacobson, Gilles Peress, Sylvia Plachy, and Eugene Richards). Some, of course, belong on both lists. Others, like Martha Rosler and Allan Sekula, have been quite explicit in their critiques of documentary activity and the ways it purports to frame and describe reality. Despite a "just the facts" appearance of much documentary work, there have always been numerous formal approaches in operation, some better concealed than others; indeed, the blandest imagery may be the most deceptive.

Photographic histories tend to conceptualize a significant divide between the documentarian and the artist without exploring overlapping strategies, whereas, when visiting contemporary galleries, one can only be struck by the variety of documentary work being shown—although one's reading of the imagery can be colored by its commercial appeal. An obvious exception to the lack of historical attention was Szarkowski's 1978 survey *Mirrors and Windows: American Photography Since 1960* at the Museum of Modern Art, in which the most interesting photographs were those that the curator could not place either in the category of art (inward-looking mirrors) or documentary (the outward-looking windows, mentioned previously), but that belonged to a third, hybridized approach—acknowledging the ongoing dialogue between inner and outer states that has always made photography, like writing, much more than a mere recording.

That overlap is evident in the work of many of the most important photographers exploring social issues, and helps to bridge some of the perceived gaps in contemporary imagery—between, for example, photojournalist and "citizen" journalist. Henri Cartier-Bresson, for one, believed that photojournalism was "keeping a journal with a camera": a diarylike, personal activity, and a way to combine his leanings as an artist (he initially aspired to be a painter) with those of a journalist. While Cartier-Bresson was not known for photographing his breakfast or other minutiae of his day, his stance straddles those of today's professional and amateur: "As far as I am concerned," he once stated, "taking photographs is a means of understanding, which cannot be separated from other means of visual expression. It is a way of shooting, of freeing oneself, not of proving or asserting one's own originality. It is a way of life."[11]

Similarly, Walker Evans argued that while his straightforward photographs of Depression-era tenant farmers in Alabama may have been taken as evidence to define a period, they were also an expression of an inner lyricism—leading him to characterize his own work as "documentary style." (Szarkowski commented in 1971: "It is difficult to know now with certainty whether Evans recorded the America of his youth, or invented it.")[12] His tenant-farmer photographs and James Agee's text, initially assigned by *Fortune* but ultimately judged too unwieldy for publication in the magazine, were instead released several years later as a book, *Let Us Now Praise Famous Men* (1941), today a classic. It was a work in two distinct voices, with a section of Evans's images grouped together so that they precede rather than illustrate Agee's text (on certain points, in fact, the text and photographs strongly disagree).

Endeavoring more pragmatically for solutions to the problems they observe and depict, in recent years some photographers have chosen to work in concert with humanitarian organizations to advance the goals of these groups. (Although, as some have pointed out, certain imagery may serve more for "branding" purposes than for an exploration of what is actually occurring—a broader question concerning the operations of NGOs, as shall be discussed further.) As editorial publications suffer from reduced funding and limit their coverage of news, humanitarian organizations have taken on a larger role in documenting the world's hotspots, combined with advocacy.

Doubt as to the eventual impact of one's images has long been central for many of the most talented and committed observers. Even during that most visually explored of conflicts, the Vietnam War, the title of Don McCullin's book of excruciating war imagery—*Is Anyone Taking Any Notice?* (1973), or *The Destruction Business* in the British edition (1971)—reflected the photographer's enormous misgivings as to the efficacy of witnessing in media: misgivings, along with guilt, that still remain with him forty years later. A small 1968 book by David Douglas Duncan, called *I Protest!*, was a condemnation of U.S. military policy in Vietnam from a photographer (and former

Marine) known for his glorifying imagery of soldiers' valor in World War II and the Korean War, as well as in Vietnam. (Philip Caputo's 1983 novel *DelCorso's Gallery*, pits a Duncan-like character named P. X. Dunlop, seeking heroes, against a McCullin-like character named Nicholas DelCorso, haunted by the horrors of war, each despising the other's approach.)

Philip Jones Griffiths's 1971 volume *Vietnam Inc.* was accomplished after two and a half years of photographing in the field with only several days of actual assignments. Griffiths, who originally trained to be a pharmacist in Wales, presents some of the expected images of heroism in war, but they are powerfully undermined with critical juxtapositions of photographs, as well as with highly sardonic captions ("U.S. combat troops arrive, outnumbering the enemy 3 to 1 and possessing the most sophisticated military hardware; the job seemed easy. Earlier, spirits were high among the troops, intoxicated as much by the spectacle of their own strength as by the cold beer delivered to them daily"). The 1966 discussion by a pilot of napalm that he cites is horrific: "We sure are pleased with those backroom boys at Dow. The original product wasn't so hot—if the gooks were quick they could scrape it off. So the boys started adding polystyrene—now it sticks like shit to a blanket. But if the gooks jumped under water it stopped burning, so they started adding Willie Peter (WP—white phosphorus) so's to make it burn better. And just one drop is enough, it'll keep on burning right down to the bone so they die anyway from phosphorus poisoning."[13]

Griffiths also included in the book what might be the first domestically published photographs of American soldiers in the act of consorting with prostitutes while fighting a war, as well as a section on young girls joining the sex trade. *Vietnam Inc.*, remaindered shortly after its publication, was acknowledged as a classic decades later—one of the earliest books of photojournalism in which the photographer effectively contextualized and recontextualized his imagery through his own editing, page design, and text.

As these and other photographic works gradually emerged, providing reference points for individuals' developing moral landscapes, photography became an increasingly compelling medium for those interested in social issues. Young people in growing numbers embraced photography as a career over the following decades, hoping to provide eyewitness testimony that might play a role in raising consciousness about social issues, if not in actually solving them. But especially among the more articulate photographers, sharing the complexity and nuance of what one had witnessed by publishing only a few selected images in magazines and newspapers was often frustrating; hence the numerous gallery and museums shows, along with the shelves of books published in recent years, by a generation of serious photojournalists and documentarians intent on providing a more comprehensive sense of what they had witnessed in their own voice (a migration that preceded the current one into the online world).

Paradoxically, however, as their images have gradually begun to play a less pivotal role in societies experiencing a surfeit of images, in a less influential journalistic media environment, some of these photographers have been plucked from behind their bylines and celebrated as heroes—the author at times overshadowing his or her subjects, the messenger supplanting the message. Society seems to find some reassurance that there are those running considerable risks to bring back strong images, even if the response may be more awestruck than effective. One European photographer, for example, having long been frustrated at not finding sufficient magazine venues for his in-depth work on serious issues, recently pointed out in a conversation the irony that, due to his growing fame, magazines are now eager to display his work—not because of the importance of the subject matter, but because he is its author.

In the current shift, publications, trying to become more consumer-friendly, have been reconceived at least in part to respond not to what editors think readers should know, but to what they think readers might *want* to know. It is a transition that diminishes the journalistic focus on policy matters, for example, and elevates that on diets, celebrity divorces, personal health, and political scandals. The potential political clout of readers/viewers is diluted in order to concentrate on arousing and satisfying their self-interest as consumers, rather than as citizens. (Undoubtedly this is what advertisers, if not readers, prefer—although many advertisers have since abandoned such publications, leaving them behind for the more selective reach of search engines plugged in to even more individualized interests.)

Images that might provoke new thinking, or that might aid in the search for even a partial solution to societal problems, tend to be displaced by those that are more vividly exotic and render problems as somewhat remote, concerning "others." Compare, for example, the intense interest in covering demonstrations by the Tea Party and Occupy Wall Street—especially those involving police brutality—but the very few visual explorations of the underlying economic and political issues that gave rise to those demonstrations. What, in this country, do we really know about the diverging strata of rich and poor beyond a few easy stereotypes? Compare also the history of war photography, with an enormous number of exhibitions and books devoted to it, to that of the unrecognized genre of *peace photography*, which might be conceived of as an attempt to proactively diminish potential conflicts, to concentrate on rehabilitating individuals and rebuilding societies, and to avoid the voyeuristic spectacle of war. (We will explore these ideas further in chapter 5.)

Segments of the world, or "causes," may momentarily surface in the media. A few, like the shooting of elementary schoolchildren in Newtown, Connecticut, are just too close to home and too horrific to ignore. More distant events or issues may temporarily attract attention due to the commitments of particular celebrities (consider

George Clooney in Darfur, or Angelina Jolie as ambassador for the United Nations High Commissioner for Refugees). Or they may momentarily emerge due to a targeted, narrowly focused video like *Kony 2012*, a controversial thirty-minute indictment of Joseph Kony, head of the Lord's Resistance Army guerrilla group operating in several African countries.[14] But without an ongoing and assured interest in the outside world, it can be difficult for social documentarians to find access to an audience. ("Your work is too depressing," or "People are not interested in that now" are standard refusals—although it is likely that, if it were solely up to the picture editors themselves, much more important and hard-hitting work would be regularly published.)

Even when there is interest from a publication, the character of the venue itself might seem to trivialize the imagery: photographer Bob Adelman once described, for example, how he had a gun pointed at him while covering the U.S. civil-rights movement for *Life* magazine, noting that he would not have considered putting himself in that kind of danger on assignment for a more celebrity-oriented magazine such as *People*. Lacking appropriate platforms, many photographers feel in a similar bind today, not wanting their work to end up only on blogs that are seen by few, and—if it is the photographer's own blog—may be viewed as both self-promotional and solipsistic.

The fault, of course, does not lie just with the publications. Stephen Mayes, formerly a longtime recording secretary of the Amsterdam-based World Press Photo Awards (to which now more than a hundred thousand images are submitted annually for consideration), was more broadly critical in a talk he gave upon resigning his post in 2009. As Paul Lowe reported online at *Foto8*, Mayes reiterated one juror's point that 90 percent of the pictures submitted were about 10 percent of the world. According to Lowe, Mayes then went on to question

> why most photojournalism investigates a very limited series of tropes in a very limited series of visual approaches, becoming a self-replicating machine that churns of[f] copies of itself in perpetual motion, which [Mayes] described as a "feeling that photojournalism, rather than trying to reinvent itself, is trying to copy itself," and that the industry is in essence reactionary and unrealistic in its understanding of the changes in global media and society. Too many photographers are "reflecting the media not as it is but as we wish it was" and assuming that it is the world that must come to them, not they that must go to the world.[15]

There is also a wider sense from outside the photographic community that a diminished visual vocabulary is not helping. For example, in his 2010 book, *Africa: Altered States, Ordinary Miracles*, Richard Dowden condemns the repetitive kinds of imagery disseminated by journalists and aid workers alike. "Persistent images of starving children and men with guns have accumulated into our narrative of the [African] continent,"

he argues. "However well intentioned their motives may once have been, aid agencies have helped create the single, distressing image of Africa. They and journalists feed off each other." It is a criticism that has often been applied to the depiction of Africans in particular, linked to consequent distortions not only of outsiders' perceptions of the continent but of the policy making that results.

A sizeable number of photographers no longer believe that anyone can make a substantive difference; indeed, those who still strive to impact society in meaningful ways seem Old School. "I'm not going out doing campaigning photojournalism, because nobody wants that anymore," Martin Parr told David Walker of *Photo District News* in 2008. "There is the old approach, whereby you try to change the world. Nobody is going to obliterate war, famine, AIDS, and all the other things that are the usual subject matter that more campaigning photojournalists would be attracted to." What did one of the world's most sought-after photographers, a global expert on the history of photographic books, and a member of the Magnum Photos agency, suggest? "I shoot interesting subject matter but disguise it as entertainment. That's what people want in magazines."[16]

Do photographs still actually help anyone? Or is this an unfair expectation in the world of images?

The expectation that the subject should benefit remains at the forefront for many, although photography's impact is difficult to measure. Nor is it always predictable. For example, South African photographer Kevin Carter won the Pulitzer Prize in 1994 for his photograph of a small, emaciated girl being stalked by a vulture as she tried to make her way to a feeding station in the Sudan. After winning the prize, the photographer was roundly criticized with hundreds of letters for not having picked up the child to make sure that she made it. The messenger was lambasted for choosing, as one of the more polite notes put it later, "to be an observer rather than a participant." As photographers are increasingly viewed as being part of the story, it is a criticism one hears more often. Paul Velasco, another South African photographer, saw it otherwise at the time: "If that picture hadn't played, today we still wouldn't know how to spell Sudan. It became the catalyst for incredible awareness for change."[17] Evidently both the *New York Times,* which published the photograph, and the Pulitzer committee similarly believed in its power to evoke a horrific situation.

Previously, Carter had been covering, on a daily basis, the South African struggle to overthrow apartheid. Just after he received the Pulitzer, he lost one of his closest colleagues, Ken Oosterbroek, killed by crossfire in a town outside Johannesburg. Dealing with his own issues, including drug addiction and guilt, Carter was distraught. He felt that with numerous children starving all around him it would have been impossible

to save them all—and as a journalist he was there to observe and report so that other, more powerful forces could be of help. Carter committed suicide in July of 1994, leaving a note explaining that he was "depressed . . . without phone . . . money for rent . . . money for child support . . . money for debts . . . money!!! . . . I am haunted by the vivid memories of killings & corpses & anger & pain . . . of starving or wounded children, of trigger-happy madmen, often police, of killer executioners." And then he added: "I have gone to join Ken if I am that lucky."[18]

Carter's stance was a reference point for several critics of the 2012 *New York Post* cover photograph of a man seconds before his death on a New York City subway track. Many people asked why the photographer, R. Umar Abbasi, had not physically intervened and attempted to pull the man up. (Abbasi's response was that he flashed his camera multiple times at the train conductor to warn him, and the man on the track was too far away to reach in time, although other bystanders might have helped—some then stood photographing the aftermath.) Earlier in 2012, the *Guardian*—reacting to the case of two journalists videotaping rather than intervening in a sex attack on a busy street in India in which no one interceded as a laughing mob of men attacked a teenage girl over the course of approximately forty-five minutes—published several responses from photographers who had been in situations where it was difficult to decide whether to photograph or to intervene.[19] "What's it like to witness a mob attack, a starving child or the aftermath of a bomb, and take a photograph instead of stopping to help?," the article begins. The collected responses express the anguish of the photographers' personal dilemmas. One in particular is striking in its resemblance to Carter's situation—while also revealing the influence of such pictures on the behavior of the subjects themselves, who now may pose for the camera. Photographer Radhika Chalasani, a New York native, wrote:

> Some photographers and journalists have a very absolute point of view that you never interfere, because your job is as an observer and you can do the most good by remaining one. I decided a long time ago that I had to do what I could live with in terms of my own conscience, so when it felt appropriate to try to do something, I would. There are certain situations you struggle with. We're interfering with a situation by our very presence, and that automatically changes the dynamic. At one point, I was photographing a woman carrying her son into a feeding centre. He was extremely malnourished, and I was photographing her as she walked along. All of a sudden, these Sudanese people started directing her for the photos. They had her sit down and were indicating how she should hold her child. I ran to get a translator, and said, "Tell her to take her child to the feeding centre. She should not be stopping because I'm taking a photograph." . . .
> I've been in situations where it's been a hard call, though. On one occasion, a group of photographers went into an abandoned refugee camp and found a

massacre site. There were some children who had survived. There were two baby twins in a hut: I tried to get one child to take my hand and realised it had been chopped off. We didn't know how long they had been there. And it's in the middle of a civil war, so you're not sure how safe things are.

Myself and another photographer wanted to take the kids out of there in the car. Several of the other people didn't think it was safe, in case we got stopped at a checkpoint, and they wanted to get back for their deadlines. In the end, we didn't take the children. We found the Red Cross and reported the situation to them, but I found that another photographer went there the next day and found another child who was a survivor. To this day I think that I didn't necessarily do the right thing.

I do believe that our main contribution is trying to get the story understood. And sometimes, when you think you're helping, you're actually making a situation worse. But, for me, you try to do what you can live with.[20]

A fictional version of this nightmare—one might call it the revenge of the subject—occurs in the setup of the novel *The Painter of Battles* by former journalist Arturo Pérez-Reverte. A Croatian man, who has been depicted in a prizewinning photograph seen worldwide on the cover of newsmagazines, later tracks down and confronts the novelist's protagonist, a photographer-turned-painter. The Croatian blames the image, which had been made during a desperate retreat by new recruits in Vukovar, for the unimaginably sadistic deaths of his wife and son and his own lengthy torture by Serbs, who he says were motivated by the image's fame to greater cruelty: "You took a photograph of a soldier you crossed paths with for a couple of seconds. A soldier you knew nothing about, not even his name. And that photograph traveled around the world. Then you forgot that anonymous soldier and took other photos. Of other people whose names you also didn't know, I imagine. Maybe you made them famous the way you did me. It's a strange profession, yours."

"'Why have you come looking for me?'" the former photographer asks a few moments later. "The visitor had put down his glass and was wiping his mouth with the back of his hand. 'Because I'm going to kill you.'"[21]

Too often the well-meaning motivation of those involved in the enterprise of making and publishing photographs about issues of importance is considered sufficient—whether or not the imagery has the desired effect is frequently not the focus. And, as nearly anyone in the field will admit, it can be difficult to foresee with any precision the eventual effect of particular imagery—although this is certainly not a reason to avoid such reflections. *Life* magazine readers responded surprisingly generously to the difficulties of nurse-midwife Maude Callen, and *New York Times* readers and others shocked many journalists with their vitriol for Kevin Carter.

Part of the problem is that, while advertisers spend large sums of money testing the impact of visuals on potential consumers—as politicians do with voters, and as movie producers do with films before the final cut—there is much less thought given in journalistic and documentary circles to the kinds of images that might be most helpful in particular situations. Nor, with the global reach of the Internet, do we sufficiently factor in the cultural, political, and economic differences of various potential audiences. A larger discussion of these issues is now emerging within the field, spurred on in part by the many independent photographers wanting to be of greater use to society, and by the increased adoption of such imagery by humanitarian organizations with specific goals in mind.

Yet another difficulty is that even when photographs do prompt a strong response from readers, their effect on those depicted may not always be helpful. Mary Ellen Mark's photographs of the homeless Damm family, for example, published in *Life* magazine in 1987, elicited an outpouring of monetary donations from readers totaling some nine thousand dollars, as well as two used cars, toys, and job offers. But as *Life* later reported: "It looked like the hard times were over. Four months later, the Damms were on the street again. The money was gone; the cars and furniture were gone, trashed or sold for drugs." In 1995, Mark published a follow-up photo-essay that showed how far the Damms' situation had spiraled downward in eight years. Daniel Okrent, the magazine's managing editor, addressed well-meaning readers in an accompanying editorial:

> Eight years ago, *Life* published a series of wrenching photographs by Mary Ellen Mark of Linda and Dean Damm and their two children—a homeless family in Los Angeles. Our readers rose to the occasion: You sent money, household goods, offers of help. You opened your hearts, and your wallets, to a family in need. As journalists, we try not to insert ourselves into our stories, but in this instance our human instincts took over. We sent your contributions on to Dean and Linda Damm.
>
> In this issue we publish some new photos of the Damms Things have changed for the family over the past eight years—almost all for the worse. It's now clear to us, as it will be to you, that at least some of the money sent to them was spent for drugs.
>
> An editor has a responsibility to play it straight with readers. We were wrong in 1987 to think that the Damms could handle receiving a large amount of money at one time. But you were right. Getting involved is always right. I will be sending a personal check not to the Damm family but to the National Committee to Prevent Child Abuse . . . one of many organizations that spend their money well, on children who can and must be helped.[22]

The questions that arise are diverse and increasingly urgent, with repercussions for individuals and the larger communities in which they live, as well as for the image

makers and their readers trying to help. Can photographs assist societies to transition to more just, democratic systems, as has been attempted during the Arab Spring and other recent upheavals? Can they help communities recover from, or even avoid, certain kinds of disasters? What are the rights of subjects, and how can they be protected? Is a new code of ethics required for photographers and their colleagues? Should a new form of "front page" be devised as a way to filter the enormous amounts of information now constantly available? How does one better engage the reader as a collaborating author, and the citizen journalist as a collaborating producer? Should photographs be labeled, like writing, as either *nonfiction* or *fiction*, or are they always a hybrid of the two?

More broadly, how can the digital environment be utilized for new forms of more effective witnessing and storytelling? What are the landmarks emerging for those in the field? How can an image maker feel useful?

N.B. All websites cited in this volume's notes were accessed December 2012–January 2013.

NOTES

1. "Protestor Loses Second Eye Defending Egypt's Revolution," *Al Akhbar* English, November 21, 2011.

2. See, for example, Jessica Satherley, "Blinded by the Eye Hunter: Egyptian Police Expert Marksman 'Takes Out Eyes of Five Protesters with Rubber Bullets,'" *Mail Online*, November 26, 2011. http://www.dailymail. co.uk/news/article-2066537/Egyptian-protesters-blasted-policeman-targets-eyes.html.

3. See the International Federation of Journalists 2009 report: http://www.ifj.org/assets/docs/ 023/247/2cdcf17-bac4cf7.pdf.

4. Jorge Luis Borges, "The Aleph," in *The Aleph and Other Stories*, Eng. trans. by Norman Thomas di Giovanni, in collaboration with the author (New York: Dutton, 1970). Interestingly, Borges's story was originally published in Spanish ("El aleph") in 1945, the same year in which the prophetic postwar essay by Vannevar Bush, "As We May Think," appeared in the *Atlantic*. Bush's text introduced technical innovations that, as the editorial note preceding his essay put it, "if properly developed, will give man access to and command over the inherited knowledge of the ages."

5. Lewis Hine, letter to Frank Manny, 1910, in "Notes on Early Influence" (1938), Elizabeth McCausland papers, cited in Alan Trachtenberg, "Lewis Hine: The World of His Art" (1977), in Vicki Goldberg, ed., *Photography in Print: Writings from 1816 to the Present* (Albuquerque: University of New Mexico Press, 1988).

6. "Maude Callen Gets Her Clinic," *Life*, April 6, 1953; cited in Vicki Goldberg, *The Power of Photography* (New York: Abbeville, 1993).

7. From *Minamata: Words and Photographs by W. Eugene Smith and Aileen M. Smith*, an Alskog-Sensorium Book (New York: Holt, Rinehart and Winston, 1975).

8. See, for example, Robin Toner, "Political Memo, A Year in Sound Bites: 10 Seconds to Remember," *New York Times*, December 31, 1990. "'This will not be another Vietnam,' the President [George H. W. Bush] said. 'This will not be a protracted, drawn-out war.'"

9. See Fred Ritchin, "The March of Images," *New York Times*, June 10, 1991.

10. Tom Wolfe, "The Birth of 'The New Journalism': Eyewitness Report by Tom Wolfe," *New York*, February 14, 1972.

11. Henri Cartier-Bresson, from "L'Imaginaire d'après nature," in *Henri Cartier-Bresson* (Paris: Delpire, Nouvel Observateur, 1976); Eng. trans. in idem., *The Mind's Eye* (New York: Aperture, 1999).

12. John Szarkowski, introduction to *Walker Evans* (New York: Museum of Modern Art, 1971).

13. Philip Jones Griffiths, *Vietnam Inc.* (New York and London: Collier/Collier-Macmillan, 1971).

14. *Time* magazine ranked *Kony 2012* "the most viral video of all time, tallying more than 100 million views in its first six days online." "Top 10 Everything of 2012," Time.com, December 4, 2012. http://entertainment.time.com/2012/12/04/top-10-arts-lists/slide/kony-2012/.

15. Paul Lowe, "World Press Photo 09," *Foto8*, n.d. http://www.foto8.com/new/online/blog/858-world-press-photo-09-by-paul-lowe.

16. Martin Parr, "Why Photojournalism Has to 'Get Modern,'" *Photo District News*, July 2008.

17. Paul Velasco, in Dan Krauss's excellent short documentary film *The Death of Kevin Carter: Casualty of the Bang Bang Club* (2005).

18. Kevin Carter, quoted in ibid.

19. "NewsLive channel, whose journalists filmed the attack, defended its staff for not intervening. 'Some [media] questioned me as to why my reporter and camera person shot the incident and didn't prevent the mob from molesting the girl,' tweeted its editor-in-chief, Atanu Bhuyan. 'But I'm backing my team since the mob would have attacked them, prevented them from shooting, that would have only destroyed all evidence.'" Helen Pidd, "Indian Anger over Media Footage of Girl Being Sexually Assaulted," *Guardian*, July 15, 2012. http://www.guardian.co.uk/world/2012/jul/15/india-media-sexual-assault-girl.

20. Radhika Chalasani, quoted in "'I Was Gutted that I'd Been Such a Coward': Photographers Who Didn't Step In to Help," *Guardian,* July 28, 2012. http://www.guardian.co.uk/media/2012/jul/28/gutted-photographers-who-didnt-help.

21. Arturo Pérez-Reverte, *The Painter of Battles*, trans. by Margaret Sayers Peden (New York: Random House, 2008).

22. See Mary Ellen Mark, "The Sins of the Fathers," *Life*, May 1995. http://www.maryellenmark.com/text/magazines/life/905W-000-052.html.

CHAPTER 2
A Dialectical Journalism

While their enterprise is undergoing a paradigm shift, journalists have found it difficult to evaluate the trajectories of their own profession, let alone guide them. Although they are trained as observers, a perspective may be lacking. The fish, as Marshall McLuhan put it, are the last to know about the water; they don't know it's wet, because they don't know what dry is.

Some ideas that were previously marginalized by mainstream media can be reclaimed. Photojournalism and documentary photography's last few decades offer examples, some from the fringes, that suggest other ways to report, explore, and interpret events and issues, and may be helpful to those who find conventional strategies constricting, given the wider potentials of a digital environment.

With the advent of social media (Web 2.0) and "citizen journalism," of masses of easily available data and multiple points of view (it was recently reported that there are as many photographs produced every two minutes today as were made in the entire nineteenth century),[1] the journalist's role as both chronicler and filter is resisted as a remnant of an archaic elitism (Web 1.0). Web browsing has a tendency to become, instead, an entitled form of consumerism (a low-level form of interactivity) wherein reports on contemporary events become another easily overlooked item on the menu of choices.

Journalistic expertise is disparaged by many as a manifestation more of corporate branding than of knowledge. In photography and video, likely the majority of recent news-related scoops (Abu Ghraib, the 2011 earthquake and tsunami in Japan, the execution of Saddam Hussein, the Arab Spring, and so on) have become principally the province of amateurs equipped with sophisticated portable technologies. With reduced budgets, journalism's role becomes increasingly reactive, waiting for the next eruption; its responsibility as governmental watchdog and societal glue is diminished, deemed either unnecessary or ineffective by people who no longer view an active press

as essential to their own well-being. Given the sensationalism, self-interest, and explicit bias exhibited by the so-called "fourth estate," a weakened confidence may seem, all too often, merited—circumvented, to some extent, by an emergent "fifth estate," a blogosphere disappointed in the other four.

Meanwhile, billions of images are available for viewing (some 3,500 are uploaded every second to Facebook alone),[2] and unfiltered sites such as YouTube have become a major source of news worldwide (over four billion hours of video are watched there every month).[3] In contrast to the experience of traditional media, now viewers are able to see whatever they want whenever they want it, without a hierarchy of importance imposed by the eyewitnesses who created the imagery or by their editors. The most popular news videos tend to depict natural disasters or political upheaval, "usually featuring intense visuals," according to a 2012 Pew Foundation study.[4] YouTube's internal data reports that in 2011, for four months out of twelve, news events (of varying levels of importance) were the most searched terms on YouTube: the earthquake in Japan, the killing of Osama bin Laden, a fatal motorcycle accident, and a story of a homeless man who spoke with what those producing the video called a "god-given gift of voice."

It would be naïve, however, to separate the state of journalism from that of the larger political process. The assumption of a knowledgeable, participatory citizenry interested in understanding issues and events in order to vote according to their own best interests, as well as the presumption that meaningful political choices exist, can hardly be taken for granted. In 2012, three and a half years into Barack Obama's first term of office, another Pew Foundation poll reported that 48 percent of registered voters either thought that the president is Muslim or were not sure of his religious beliefs, while 30 percent of Republicans asserted that Obama *is* Muslim (approximately double those who said that during the earlier 2008 campaign).[5] Even after a series of horrific mass murders, including one in a Colorado cinema in which twelve people died while watching a *Batman* movie and another in which a congresswoman was shot in the head during a public meeting in an Arizona parking lot, the chances of banning automatic weapons were considered remote. It took the murder of twenty schoolchildren in Connecticut, along with six members of the school's staff, for a concerted public outcry to begin to move government officials at the end of 2012. The 2003 invasion of Iraq—although protested in February of that year in at least a hundred American cities and in dozens of countries worldwide by millions of people—was nonetheless implemented the following month. Even with the enormous numbers of people troubled by climate change, the subject was never broached in the 2012 presidential debates. Why bother to be informed, many must think, if one's own potential impact on society can seem so negligible?

Many working in what is now called visual journalism have long had as their mandate the rousing to consciousness of a distracted people and a sometimes oblivious

government. But in an ever-more-preoccupied society, with increased defenses against an unrelenting barrage of vivid, often heart-wrenching imagery, there is little consensus with regard to how to amplify the strategies of visual journalism, and far too little experimentation, particularly given the array of new digital tools available.

Multimedia is often interpreted simply as *more* media, so that greater numbers of photographs are added, some parceled into online slide shows that tend to be haphazardly sequenced and captioned—and with jumbled responses by viewers unsure of what they have just seen. Short videos may be added to complement the still images, but often end up competing with them until, in the never-ceasing news cycle, both are quickly displaced. And, given the templates used by the content-management systems that dominate online news and apps, the placement and scale of the imagery is often predetermined, disallowing a hierarchy of importance or a specific visual design to emphasize underlying meanings of the imagery. (One site that uses photographs vividly, The Big Picture, simply runs many captioned pictures on the same subject in a vertical scroll, all at the same generous size).[6] Such strategies add quantity, but can make the world seem even more incomprehensible, while destabilizing any sense of authorship by the visual journalist.

Photo-reporters working with the mainstream press, cognizant of what remains of tradition in their field, are uncertain of which emerging media strategies to employ (even initial forays using their own cellphone apps to photograph have ignited much indignation by colleagues). Furthermore, they do not know whether, from their position in a fraught journalistic atmosphere struggling to survive, they even have the *right* to assert other media strategies, without straying too far from their assigned roles still entwined with the illustration of others' ideas. A strong point of view with complexity and depth is rarely what is asked of them. (Tod Papageorge has coined a twist on Robert Capa's famous maxim "If your pictures aren't good enough, you aren't close enough." In a wonderful counterbalance, Papageorge advises: "If your pictures aren't good enough, you don't read enough.")[7]

For many photographers, whether on staff with publications or freelance, surviving in the crumbling economy of the press may be a fully consuming battle with little choice but to produce what is expected, if given the opportunity. Furthermore, the major standard-setting industry awards, such as the Pulitzer Prize and World Press Photo, have been slow to reward experimentation using visual media, highlighting too many clichés—photographs that look much like other, previously praised photographs.

Photojournalists and documentary photographers working independently, on the other hand, have long had to take more risks in conceiving and implementing new strategies, especially when the parameters of their self-defined projects are set by their own ambitions. Sometimes, too, there are particularly fertile moments when photographers

who have established themselves with an idiosyncratic body of work have been challenged to create imagery that transcends the conventional—although few publications are known for their investment in experimentation, preferring to wait until such work is at least nearly completed, often at the photographer's expense, before committing to its support and eventual publication. (This is not a generalized critique of picture editors, many of whom have generously supported independent photographers with advice while pushing for their acceptance.)

In the process of producing their projects, independent photographers have had to transcend some of the traditional strategies of visual media and its limited vocabulary in order to introduce other ideas, and also to get noticed. Now, with crowd-sourced funding from entities such as Kickstarter and Emphas.is, some are trying to go directly to their future audiences for financial help. And, as conventional media have become less pivotal in setting societal agendas, there are those photographers who choose to engage as witnesses but then collaborate with humanitarian organizations that may be able to use their work to more directly help resolve the situations depicted. Some also go to museums and galleries with their pictures, or seek to publish books, create installations, or identify other strategies to provoke a larger conversation. In terms of finding the means to produce and new ways to distribute, the field is in enormous ferment.

New narratives are also possible. Just as some writers and reporters in the 1960s and '70s engaged in what Tom Wolfe and others called the "New Journalism"—traditional nonfictional strategies combined with modes that are more subjective, interior, and borrowed from fiction—so too a small number of photographers have over the last several decades experimented with what might be called a "New Photojournalism." It is a term (and a notion) that has not caught on widely, in part because there is an expectation, even more than with writers, that journalistic images will create a certain amount of excitement in the mainstream press while remaining somehow "objective"—making anyone carrying the moniker of "New Photojournalist" more difficult to employ. (It is reminiscent of Capa, the pragmatist, advising his colleague Henri Cartier-Bresson at the birth of Magnum Photos, in the late 1940s, "Don't keep the label of a surrealist photographer. Be a photojournalist.")[8]

Raymond Depardon's 1981 "Correspondance new-yorkaise," for the French newspaper *Libération*, exemplifies the potentials of the "New Photojournalism": every day over the course of a month, he transmitted a photograph and a short, diarylike text, which were published on the paper's foreign-affairs page; this chronicle, told in both the first and the third person, succeeded in humanizing New York, transcending the normal news filters, and presenting the photographer as both subjective and discerning.

Next to a gray-toned photograph of three men, shown from the back, holding umbrellas in the rain and wind on the Staten Island Ferry, Depardon's text read (in French): "July 4, 1981. New York. It rains, it rains. It is Independence Day, a holiday, the city is empty. A visit to the Statue of Liberty. Discussion all night with a girlfriend. I want to go back to France, to let everything go. I force myself to make a photo. I ask myself what am I doing here. All is sad. A bad day. I begin to read *G* by John Berger."[9] Depardon's work allows the "camera reality" (the men on the ferry in the rain) to be contravened by a text that calls the viewing into question—would the image have been rendered as sadly were its author in a different frame of mind?

Another image in the series, of seven young girls skipping rope, wearing matching T-shirts, was accompanied by this text:

> This morning I leave with a photographer, Dith Pran, Cambodian, of the *New York Times*. In the subway that goes to 116th Street in Harlem he speaks to me of Cambodia, of the rice fields, of his four years with the Khmer Rouge. "I was not a prisoner, it was worse." He speaks to me in French with a soft voice . . . with modesty. His wife and four children live in Brooklyn, the rest of his family was killed. He has worked at the *New York Times* for one year. We speak of the photographers Sylvain Julienne, Son Vichitt, Gilles Caron. It's the first time that I go to Harlem. I am 39 years old today. We leave the subway, people look at us, the police organize games for children in the streets. Several minutes later we run to a fire 100 meters away . . . no victims. . . . We go to the Bronx for a police rally, then to Brooklyn for a Republican leader, at the end of the day to a press conference about an accident in the subway several days earlier.[10]

The happy girls shown in midair belie the conventional press coverage of Harlem at that time as a place rife with murders and drug dealers—worthy of attention only for its violence. This was a very different kind of foreign reporting, "a photographic journal of the summer," as *Libération* described it, along the lines of Cartier-Bresson's description of photojournalism as "keeping a journal with a camera." It was also a pioneering effort foreshadowing today's blog culture in which the personal and anecdotal are given prominence. (Another European magazine at about the same time published a long series of double-page color photographs of the New York subway system, each one, as I remember it still, a vivid, glistening depiction of a murder. As someone who had been riding the subway many times weekly for a number of years, and who had never once encountered a murder or any violent crime, I was astonished. New York was rendered as a violent place I would never want to visit, let alone live in. The journalist had employed a strategy similar to the one that is so often used to depict the inhabitants of conflict areas as inhuman and irrational, making them into the "other.")

A selection of Gilles Peress's photographs from Iran were published in the *New York Times Magazine* in 1980 as "A Vision of Iran"; I was the *Magazine's* picture editor at the time. Peress's kaleidoscopic images of the country's postrevolutionary chaos became the first glimpse for most Americans of the unknown and perhaps unknowable. The word *vision* in the title seemed an acknowledgment (remarkable for the *Times*) that no one knew what was happening in Iran at that moment, including the State Department and journalists; in this case, photographs were not being utilized to confirm a certain version of reality—instead, Peress's intuitive grasp of the situation, his vision, would have to be relied upon. Peress's work from Iran was later honored with the Overseas Press Club Award. As I was on my way, alone, to the ceremony at the Waldorf-Astoria Hotel to accept Peress's award, the *Magazine's* editor in chief confided in me that neither he nor the top editor of the *New York Times* liked or understood Peress's photographs. It seemed to me an odd response to winning one of journalism's major awards, and an apparent sign of the distress that the unconventional images had caused.

A larger selection of these photographs were later published in book form as *Telex: Iran*, with a caution from the photographer himself: "These photographs, made during a five-week period from December 1979 to January 1980, do not represent a complete picture of Iran or a final record of that time." (Cartier-Bresson gave a similar warning in his 1952 book *The Decisive Moment*.) The reader is forced to see the photographs as inquiries into Iranian reality by a photographer who described his own position as that of a kind of foreign-media mercenary, taking the unusual step of explicitly detailing in the accompanying telexes (messages typed on a special machine that are then transmitted to another machine that prints them out) many of the business arrangements involved in being a freelance photojournalist.

The book's first photograph, a nearly double-page image of Farsi writing, is unreadable by most foreigners; the second, of a hand-drawn sign, is in English: "As an Iranian I want you corresponders + journalists + film-takers [to] tell the truth to the world." The following photograph, made partly through Peress's magnifying loupe, depicts a table covered with a contact sheet, telexes, an identity card, and front pages from the New York tabloid press: "Khomeini's Cowards Humiliate Hostage," "100,000 Shriek Hatred," "Mideast Madness." The subsequent spread presents, more calmly, two consecutive images on a contact sheet, with the film numbers and dark frames still surrounding them, helping the reader understand that the photograph is part of a mediation, and is not to be read as asserting a definitive reality. (See page 82.)

Peress describes his own role in a series of telexes with his agency, Magnum, that are scattered throughout the book beside photographs (all *sic*): "Gilles has a small minimum ex Paris Match and keen interested from Now . . . "; "Jon Kifner of New York Times will bring cash. He lives at Intercontinental. Do you need film. Please specify

what kind and how many rolls. Bises. Natasha"; "Attention say to the lab to watch out particularly for a roll that might be in part ruined since the Revolutionary Guards opened my camera and tried to expose film after I shot heroin smokers. I hope they can save them. Thanks, Gilles."[11]

Similarly, Richard Avedon's sixty-nine portraits for *Rolling Stone* magazine of the U.S. power elite at the time of the 1976 Bicentennial went far beyond the conventional portraiture found in the press, much of which (both then and now) attempts to be either neutral or flattering, and rarely probes the subject's psyche (page 81). Created on assignment for *Rolling Stone*'s publisher, Jann Wenner, the forty-eight pages of imagery featured portraits of three future presidents (Jimmy Carter, Ronald Reagan, and George Bush Sr.; secretary Rose Mary Woods was a substitute for her boss, Richard Nixon, who had recently resigned the presidency), Defense Department head Donald Rumsfeld, consumer advocate Ralph Nader, civil rights leader Julian Bond, and media titans Abe Rosenthal of the *New York Times* and Katharine Graham of the *Washington Post*. The series was called "The Family," disturbingly suggestive of imprisoned killer Charles Manson's "Family" of followers. Posed and abstracted to be studied against a seamless background, the subjects are both enlarged and diminished as if under a microscope, hands occasionally cut off, the dark edges of the negative visible.

"At the outset, Avedon decided to approach the project from the perspective of an objective observer," writes curator Paul Roth (for a time director of the Avedon Foundation) in Avedon's 2008 book *Portraits of Power*. He continues:

> While he told his subjects where to stand, positioning them within the camera frame, he generally gave only subtle direction. For example, he sometimes mirrored their posture, standing and moving as they did: he found that this subsequently induced them to mimic his gestures. He was thus able to subtly direct their pose. Typically he encouraged his subjects to appear as they were when they arrived, their hair and clothes unadjusted. If they brought items to the session, these often became "props" of a sort in the finished image. "I try to allow the people really — if that's possible — to photograph themselves." Avedon later stated that the process "was an attempt at real reporting . . . it [was] the first time I have functioned as a journalist."[12]

"I just popped in and did it and left," Rumsfeld said of his session for the "Family" series, according to Blake Gopnik in the *Washington Post*. And Julian Bond, chairman of the NAACP, recalled: "All of the photos were rather matter-of-fact — minimal instructions and minimal posing by him. Just look in the camera and click."

But there was more to it than that. Avedon too was quite affected by the sessions, Roth observes, describing "how such interactions, or 'exchange of feelings,' left him

uneasy," with "almost a kind of embarrassment" when it was over. Roth writes: "The subjects pose as though submitting to a visual interview. A performance is recorded: 'They present the image that they choose,' Avedon told a reporter. 'I do the editing.' The portraits are not entirely—or even principally—objective. They are the result of strategic inquiry; they engender permanent interrogation." But finally, for Avedon, the reality is in the photographs: "The photographs 'have a reality for me that the people don't. It's through the photographs that I know them.'"[13]

Like the work of Depardon and Peress, Avedon's endeavor combines first- and third-person narratives, the explicitly political, and an emphasis on the intuitive that is only partially camouflaged by the use of the machine. The resulting work—a performance—reframes the conversation among photographer, subject, and reader. It includes a questioning (and even an amplifying) of the authority of the professional as a unique image-maker, and also rethinks the creation of the photograph as a hybrid of artistic and documentary strategies. While many postmodern artists and critics have focused on deconstructing and making visible the limits of the documentary mode, these "New Photojournalists" were embracing, if at times ironically, the photograph's credibility while asserting its eternal subjectivity, as well as their own presence.

The work of the New Journalists, appearing in *Esquire, New York, Harper's, Rolling Stone,* and other publications, as well as in a number of books, such as Truman Capote's *In Cold Blood* (1966) and Norman Mailer's *Armies of the Night* (1968), used "the imaginative resources of fiction," as one reviewer put it, to amplify the reporter's palette, inviting readers into the process of authorship while displacing a more conventionally distanced, authoritative reporting. The work was controversial; it was attacked as unreliable. Some, like Gay Talese, felt it was, and had to be, as credible as conventional journalism. Introducing a collection of his own writings, much of it from the pages of *Esquire,* Talese stated: "The new journalism, though often reading like fiction, is not fiction. It is, or should be, as reliable as the most reliable reportage although it seeks a larger truth than is possible through the mere compilation of verifiable facts, the use of direct quotations, and adherence to the rigid organizational style of the older form."[14]

Cartier-Bresson, in an interview with Byron Dobell of *Popular Photography* magazine in 1957, said something very similar:

> We often photograph events that are called "news," but some tell the news step by step in detail as if making an accountant's statement. Such news and magazine photographers, unfortunately, approach an event in a most pedestrian way. It's like reading the details of the Battle of Waterloo by some historian: so many guns were there, so many men were wounded—you read the account as if it were an itemization. But on the other hand, if you read Stendhal's *Charterhouse*

of Parma, you're inside the battle and you live the small, significant details. . . .
Life isn't made of stories that you cut into slices like an apple pie. There's no
standard way of approaching a story. We have to evoke a situation, a truth. This
is the poetry of life's reality.[15]

As with the work of the photojournalists cited above, the vantage point of the personal was critical for the New Journalists: "The important and interesting and hopeful trend to me in the new journalism is its personal nature—not in the sense of personal attacks, but in the presence of the reporter himself and the significance of his own involvement," author Dan Wakefield wrote in 1966. "This is sometimes felt to be egotistical, and the frank identification of the author, especially as the 'I' instead of merely the impersonal 'eye' is often frowned upon and taken as proof of 'subjectivity,' which is the opposite of the usual journalistic pretense."[16]

For some photojournalists, the explicit introduction of the "I" over the "eye" was an ultimately productive leap. It involved presenting the photograph as dialectical, as a representation first constructed by the subjective photographer, with input from those both within and outside the frame, re-presented by a publication, and then reconstructed by a reader made wary of its actuality by the photographer's contextualizing thoughts and unconventional style of image making. The photograph stood less chance of being, on its own, perceived as an objective, automatically credible witness, nor could photographers escape their role as "authors"—opening a more extensive reconsideration of photography's nonfictional pedigree, while making it evident that such reporting, as was the case for writers like Mailer and Talese, involves considerably more sophistication than just being at the right place at the right time. The "imaginative resources" of fictional photography or of the photo-based artist also had been considered off-limits for serious photojournalists. Now, given the enormous shifts as to what is acceptable and where, one may see the work of photographers of the ilk of Depardon, Peress, and Avedon as easily in a museum as in the press.

The New Journalism's most relevant legacy to today's challenges may be its enthusiastic experimentation in the face of what was seen then as a constricting paradigm. As Tom Wolfe wrote: "What interested me [about New Journalism] was not simply the discovery that it was possible to write accurate non-fiction with techniques usually associated with novels and short stories. . . . It was the discovery that it was possible in non-fiction, in journalism, to use any literary device, from the traditional dialogisms of the essay to stream-of-consciousness, and to use many different kinds simultaneously, or within a relatively short space . . . to excite the reader both intellectually and emotionally."[17]

To experience the application of fictional techniques to the nonfictional, one might consider the opening paragraph of a 1966 Gay Talese *Esquire* piece, named by the magazine as the greatest story ever published on its pages, titled "Frank Sinatra Has a Cold":

> Frank Sinatra, holding a glass of bourbon in one hand and a cigarette in the other, stood in a dark corner of the bar between two attractive but fading blondes who sat waiting for him to say something. But he said nothing; he had been silent during much of the evening, except now in this private club in Beverly Hills he seemed even more distant, staring out through the smoke and semidarkness into a large room beyond the bar where dozens of young couples sat huddled around small tables or twisted in the center of the floor to the clamorous clang of folk-rock music blaring from the stereo. The two blondes knew, as did Sinatra's four male friends who stood nearby, that it was a bad idea to force conversation upon him when he was in this mood of sullen silence, a mood that had hardly been uncommon during this first week of November, a month before his fiftieth birthday.

And the article's conclusion:

> Frank Sinatra stopped his car. The light was red. Pedestrians passed quickly across his windshield but, as usual, one did not. It was a girl in her twenties. She remained at the curb staring at him. Through the corner of his left eye he could see her, and he knew, because it happens almost every day, that she was thinking, It looks like him, but is it?
>
> Just before the light turned green, Sinatra turned toward her, looked directly into her eyes waiting for the reaction he knew would come. It came and he smiled. She smiled and he was gone.[18]

Anyone can write—amateurs and professionals alike—but very few can take us to visit worlds external and internal, tie them together, melding facts and suppositions while creating a narrative flow that functions like a great piece of fiction, and base it all on an out-of-sorts famous singer who refused to be interviewed.

Similarly, nearly anyone can point a camera at people or events of importance. But few could emulate the sustained, confrontational gaze of Avedon's portraits, taking in, as if with an oversized microscope, those firmly ensconced within the shielding aura of power, or Peress's restless frames in search of details intimating the forces at work within a dizzying revolution. Today's journalists, looking toward their own past, would find a moment of the "new" in journalism that combines some of what is being searched for now: the anarchy and spontaneous first-person approach of contemporary citizen journalism with the third-person élan of the seasoned observer, and a sense that subject matter both intimate and public should be in their purview.

However, there have also been, and continue to be, productive approaches that are radically different from those described above. Peress, for example, later embraced a more matter-of-fact style in his 1990s work in Rwanda and the former Yugoslavia. "I work much more like a forensic photographer in a certain way, collecting evidence," he told *U.S. News and World Report* in 1997. "I've started to take more still lives, like a police photographer, collecting evidence as a witness. I've started to borrow a different strategy than that of the classic photojournalist. The work is much more factual and much less about good photography. I'm gathering evidence for history, so that we remember."[19] Depardon, for his part, has concentrated on film, making dozens of important documentaries in a cinéma vérité style on subjects such as a psychiatric hospital in Italy, the Paris police, photo-reporters, the judiciary, and French peasants. His first fictional film, *Empty Quarter*, about a filmmaker's relationship with a young woman while traveling through Africa, was released in 1985. Avedon continued in the documentary vein with *In the American West*, a rare five-year commission from the Amon Carter Museum in Fort Worth, Texas, which depicted working-class people in ways that were monumentalizing (the seamless background gave no sense of place), sometimes empathetic, and also somewhat perverse, seeming to magnify their foibles. Responding to the controversy surrounding this work, first exhibited in 1985, Avedon said: "All photographs are accurate. None of them is the truth."[20]

To find other truths, given the increased quantity of imagery recently available while sensitive to the contested role of the photographer, there are others who have moved into a role not unlike that of an archivist, or a "metaphotographer," gathering work from people who, from direct experience, may know the most about a situation. Consider, for example, Geert van Kesteren's 2008 *Baghdad Calling*, a collection of cellphone images and testimonies from Iraqi refugees that testify to the profoundly unsettling and long-lasting impact of the war on their personal lives, or Susan Meiselas's akaKurdistan website, for which Kurds were asked to participate in creating their own collective history by contributing their photographs and helping to identify each other's imagery.

The largest archive now to be found, of course, is in the ever-expanding social media, a potential source of enormously rich imagery. The diverse experimentation to be encountered in the billions of images now available, from the strident activism of citizen journalism to the playful, diaristic YouTube videos and exchanges of family albums to the commentaries by a generation of homegrown experts (media literacy is hardly taught in schools) to the banal imagery detailing the everyday, should eventually prove an essential reservoir of social documentary alongside the work of a much smaller group of professionals.

But while there are overlapping goals shared by professionals and amateurs, there are also significant differences in the media environments they now inhabit. With the

advent of "user-generated" sites, the public's role as producer and disseminator of media resembles a conversation in which people share, in words and pictures, the details of their own lives with every expectation that others will do the same. It is as if imagery is presented, as in an older oral tradition, to incite discussion and attract attention — success, if it is to be, is in the confirmation by the group. The photo-reporters working for conventional media, with some exceptions, have been allowed, or have taken, few such liberties; they are outsiders, and as such their imagery must somehow penetrate the purview of the larger, social-networked public, rather than surfacing from within it. (This helps to explain a recent interest by professionals in using cellphones, rather than more sophisticated cameras, to cover major events.)

Along with efforts by individual practitioners, a number of emerging movements attempt to address, or at least to recognize, contemporary concerns; there is as well a surge in photography collectives that have been founded in various countries. There are practitioners of Slow Journalism (the philosophy of which is similar to that of the Slow Food movement) whose work is a response to the twenty-four-hour news cycle and the need to constantly churn out imagery without much reflection. In a similar vein, some photographers are sticking to analog practices, more comfortable with their less frenetic pace. Carles Guerra and Thomas Keenan's 2010 exhibition *Antiphotojournalism* interrogated what they see as the clichés of classical photojournalism, arguing for "an image unleashed from the demands of this tradition and freed to ask other questions, make other claims, tell other stories," while concluding: "And sometimes the question is simply whether we even need images at all." They cite Allan Sekula's commentary from his 1999 project "Waiting for Tear Gas" as an inspiration: "The rule of thumb for this sort of anti-photojournalism: no flash, no telephoto zoom lens, no gas mask, no auto-focus, no press pass and no pressure to grab at all costs the one defining image of dramatic violence."[21]

Recalling, if sometimes only vaguely, the worker-photography movements of the earlier part of the twentieth century (such as those in the Soviet Union and Germany, and the Photo League in the United States), or the Farm Security Administration, in which the group had primacy over the individual, there are more photographer- and artist-driven collectives forming today.[22] The group called Facing Change: Documenting America, for example, describes itself as "a non-profit collective of dedicated photojournalists and writers coming together to explore America and to build a forum to chart its future."[23] A recent opening screen on the Facing Change website had photographic reports on an attempt to organize a union for those who wash cars, another on the various impacts of Hurricane Sandy on New York City communities, and one on the housing crisis in the U.S. West. Other collectives, some with only a handful of people in them, are created for a variety of reasons: a desire to collaborate and to

have a community within which to work; a shared political ideology; the advantages of sharing business tasks, studio spaces, and financial risks; and a sense that working in a group is a better way to get messages out, along with "the feeling of being part of something greater than myself," as one former member put it. In Amsterdam, a September 2012 conference sponsored by the Dutch Doc Photo Foundation on the growth of collectives was called, somewhat optimistically, "End of Ego."

Many are also acknowledging that conventional media may no longer be the best publishing venues—print magazines, for example, do not constitute the photographers' paradise they once sometimes did. (Five hundred thousand copies of Avedon's issue of *Rolling Stone* were printed; some 1.6 million copies of the *New York Times Magazine* featured Peress's "A Vision of Iran.") Photojournalist Ed Kashi noted that his adolescent children remained unmoved when he had the cover story of *National Geographic*, but were much more impressed and engaged when he published a project on the same subject in multimedia form (his "Iraq Kurdistan," online at MediaStorm since 2006, is an enormous crowd pleaser).

In both old and new arenas, photographers are redefining their roles, experimenting with new narratives and strategies of dissemination while attempting to broaden the photographic enterprise even further. Less focused on the priorities of the mainstream press, they employ strategies that may be more arcane and are often more complex, offering to engage the reader differently.

There are many such projects that have taken place in recent years or are ongoing, although they are not always widely known, even in the photographic community. A few examples (some of which will be revisited in later chapters):

- In James Balog's "Extreme Ice Survey," begun in 2006, cameras are positioned in remote arctic and alpine areas, automatically photographing the melting of the ice to help calculate precisely the impact of global warming, and to create a visual record of a planet in crisis (page 83). According to the Extreme Ice website: "Currently, 34 cameras are deployed at 16 glaciers in Greenland, Iceland, the Nepalese Himalaya, Alaska and the Rocky Mountains of the U.S. These cameras record changes in the glaciers every half hour, year-round during daylight, yielding approximately 8,000 frames per camera per year."[24]

- French artist JR, in his "Inside Out" project, has created photo-booths that print oversized portraits of subjects. In one of many such installations worldwide, at the 2011 Arles photography festival the prints floated down from a processor high overhead, after the visitors signed a pledge to use the photographs to impact society in a positive way. The self-representation is meant to increase the impact of individuals and their stories on their own societies, with the stipulation that

the images are not to be used for publicity for any organization, including NGOs. For JR's 2008–9 project in Africa, "28 Millimeters, Women Are Heroes," photographs were used to document the faces of individual women living in modest dwellings in Kenya, Sierra Leone, Liberia, and Sudan—the large prints were used as roof coverings for their houses as well (page 84). As JR's website notes: "Most of the women have their own photos on their own rooftop and for the first time the material used is water resistant so that the photo itself will protect the fragile houses in the heavy rain season."[25]

- Sebastião Salgado's "Genesis" project, which began in 2004, focuses on the planet's primal past and is intended to encourage environmental efforts. Images from the series are featured on Brazilian bank cards from Banco do Brasil, with a small portion of the proceeds from client transactions regularly going to Instituto Terra, founded by the photographer and his wife, Lélia Wanick Salgado, for the reforestation of the Mata Atlantica forest. (Since reforestation began, in 1999, some 162 bird species and 25 species of mammal are said to have returned to the area, and more than a million trees have been planted.)[26]

- Laurie Jo Reynolds is working in "supermax" prisons (segregated, maximum high-security units) in Illinois, Maine, and Virginia, asking people held in long-term solitary confinement what it is that they would most like to see—real or imagined—and then, along with others, providing photographs, such as of the view outside the prison, or of volunteers advocating for prison reform. Among the requests posted online in late 2012: "the Masonic temple in DC"; "what's left where the Robert Taylor Homes used to be"; "a heartsick clown with a feather pen"; "my mom in front of a mansion with money and a Hummer"; "Michelle Obama planting vegetables in White House garden"; "any Muslim Mosque or Moorish Science Temple in Chicago or Mecca or Africa"; and "fallen autumn leaves (which we do not have access to in the 'concrete box' which is deemed a yard here)."[27] Working with the activist groups Tamms Year Ten and the National Religious Campaign Against Torture, Reynolds has used the photographs as part of a larger campaign for more humane prison conditions. (And with some success—in January 2013 the Tamms Supermaximum Security Prison in Illinois was closed.)[28]

- Swedish photographer Kent Klich has created a series of images over several decades of Beth R., a former prostitute and drug addict living in Copenhagen (he first chronicled her life in *The Book of Beth*, published in 1989). More recent photographs of Beth were presented in his 2007 book *Picture Imperfect*, with case histories and photographs from her family album as a child (page 85). The photographs are paired with a DVD of Beth's daily life for which Beth herself was the primary filmmaker; the DVD is enclosed within the book. That short film, *Beth's Diary*, won the Best Short Documentary award from the Copenhagen International Documentary Festival, while Klich's book about Beth was named Best Photography Book by the Association of Swedish Professional

Photographers. A smaller, third book, *Where I Am Now*, was published in 2012. Klich and Beth R. have now known each other for more than thirty years.[29]

- Over the course of several years, Jennifer Karady has collaborated with soldiers and veterans from the wars in Afghanistan and Iraq, restaging aspects of traumatic war events within their civilian lives (the day a soldier almost died; finding a prone teenage girl with a badly stitched Caesarean; a Native American female soldier calmed by the spirits of her tradition; being fired at by a sniper, etc.). The work is intended to be helpful and even therapeutic for the soldiers, and as a documentation of a performance that may help others, including those nearby, to understand what they experienced overseas (page 86).

- Several artists, including Celia A. Shapiro and James Reynolds, have undertaken projects re-creating the last meals of inmates on death row, as a way of drawing attention to the prisoners' social backgrounds, personalities, and their executions (page 87). Reynolds's series "Last Suppers," from 2009, contains a photograph of an unpitted olive on a plastic tray, with the explanation: "Victor Feguer asked for an unpitted olive because he thought it might grow into an olive tree from inside him. It was supposed to be [a] symbol of peace." The text for Shapiro's photo-essay, published in *Mother Jones* in 2004, begins: "When Arkansas executed Rickey Ray Rector back when Bill Clinton was governor, the mentally impaired inmate famously set aside half of his last meal—a pecan pie—for after the execution."[30]

- Susan Meiselas, in a project she called "Reframing History," returned to Nicaragua in 2004 with nineteen murals created from her own photographs made during that country's Sandinista Revolution twenty-five years earlier (page 88). She placed the murals at the sites where the imagery was originally made as a way of collaborating with local communities in visualizing their own collective memory, and to help better acquaint Nicaraguan youth with their own past.[31]

- For Jim Goldberg's "Rich and Poor," an older but still influential project published in book form in 1985, wealthy and poor people in San Francisco were photographed and then asked to comment on the images portraying them, in their own handwriting. Their notes are often telling: next to one portrait of an older couple, the wife, Regina Goldstine, writes: "Edgar looks splendid here. His power and strength of character come through. He is a very private person who is not demonstrative of his affection; that has never made me unhappy. I accept him as he is. We are very devoted to each other"; she ends by addressing the photographer with her wish: "May you be as lucky in marriage!" Her husband, on the other hand, is rather more phlegmatic: "My wife is acceptable. Our relationship is satisfactory."[32]

- Photographer Azadeh Akhlaghi's extensively researched restagings of pivotal, often violent moments in Iranian history point to a diverse and tumultuous past. For example, in Akhlaghi's 2012 *Mirzadeh Eshghi, 3 July 1924, Tehran*, the events leading up to the killing of the dissident writer and poet Mirzadeh Eshghi are

recounted thus: "On June 30th, Mirzadeh's servant encounters two strangers in the street. They want to see Mr. Eshghi, and they insist that it is an important issue. The servant tells them that the poet is out. The strangers leave but they stand at the corner of the street. The servant spends two whole days to get rid of them, but anyway, they are sure that the poet is in his home."

- Ariella Azoulay's recent tracings in pencil of photographs from 1947–50 were created both as documentation of the early years of the Israel-Palestine conflict and as a protest against the International Committee of the Red Cross, which did not allow her to exhibit the original photographs due to the points of view expressed in her accompanying texts. Introducing the project, called "Unshowable Photographs/Different Ways Not to Say Deportation," Azoulay argues: "Because I insisted on my right to describe the photograph in a civil way that suspends the national paradigm of 'two sides'—namely, Israeli and Palestinian—I was not authorized to show them publicly."[33]

- "Question Bridge: Black Males," a 2012 project led by photographers Chris Johnson and Hank Willis Thomas, in collaboration with Bayeté Ross Smith and Kamal Sinclair, is a five-screen video installation in which African-American men ask questions that others—filmed separately over the course of several years—answer; thus conventional subjects are empowered as both interviewer and interviewee (page 89). Among the provocative questions: "My whole thing is, first and foremost—and I should have said this from the beginning, but I'm going to sum it up with this: Why didn't y'all leave us the blueprint?," and "This may seem like a silly question, but I want to know. Am I the only one who has problems eating chicken, watermelon, and bananas in front of white people?"

- Trevor Paglen's *sousveillance* (surveillance from below) imagery of spy satellites, CIA aircraft, and military installations—pictures that are often blurry and remote—make the nearly invisible liminal, mapping an approach to that which is frequently ignored and hidden (page 90). Paglen's books include *Blank Spots on the Map: The Dark Geography of the Pentagon's Secret World* (2009) and *Invisible: Covert Operations and Classified Landscapes* (2010). His most recent project and publication, *The Last Pictures* (2012), concerns the communications satellites orbiting the Earth that Paglen, a geographer by training, contends will become the major ruins left behind from our era, potentially for billions of years, outlasting the pyramids of Giza and the cave paintings of Lascaux.[34]

A few of these individuals (Karady and Klich, for example) work directly with their subjects in relationships that can be supportive and at times possibly even healing, enabling their collaborators to revisit difficulties from their past. For her project "Riley and His Story" (page 91), published at the end of 2009, Monica Haller had the therapeutic in mind, but she also emphasized the project's potentially disruptive impact on the reader—"I want you to see what this war did to Riley."

The all-type cover of the book—which the author argues is *not* a book—disputes any conventional reading while calling for a "tactical reader":

> This is not a book. This is an invitation, a container for unstable images, a model for further action. Here is a formula: Riley and his story. Me and my outrage. You and us.
>
> Riley was a friend in college and later served as a nurse at Abu Ghraib prison. This is a container for Riley's digital pictures and fleeting traumatic memories. Images he could not fully secure or expel and entrusted to me. . . .
>
> Pay attention. This experience happens right in your lap. To make it happen you must read compassionately, then actively. Then the experience happens wherever you take this container and whenever you respond to my invitation.
>
> You and us, yes. Then you and another. This invitation is a model for veterans, families and friends to speak and share openly with each other. The artwork and artist are adaptable; you, the tactical reader, can use this object for your own devices, or you can attend to another archive in need of careful attention. This is not a book. It is an object of deployment.[35]

Haller's project, the first of several similar interventions that she has attempted (including one with Riley Sharbonno's parents), is intended to help him resurrect buried memories and deal with some of what he went through in a war that, despite his efforts to resist it, destabilized his life. Like soldiers, it also "deploys," attempting to show to others the effects of war's environment of violence. There are pictures that Riley does not remember taking of events that he does not remember witnessing. Photographs, once rediscovered, sometimes assuage his guilt because they give a reason for what happened, even if he might have forgotten it. The volume's mass of particulars, over the course of its 480 pages, including small texts by Riley, distill the enormous archive of imagery about the Iraq War to the life of one individual during a single tour of duty. Some of the grand half-truths that guide our understanding of that war, or any war, are diminished.

Conceptual artist Alfredo Jaar, who often deals with both photography and violence, cites a line from the poet William Carlos Williams when one first visits Jaar's website: "It is difficult to get the news from poems yet men die miserably every day for lack of what is found there." Given the enormity of what they have personally witnessed, as well as their desire to engage, it's not surprising that so many have enlarged their documentary practices, sensitive to "what is found there."

NOTES

1. See Paul Caridad, "Smile for the Cellphone," *Visual News*, June 11, 2012. http://www.visualnews.com/2012/06/11/smile-for-the-cell-phone-new-photography-trends/?view=infographic.

2. Ibid.

3. See YouTube statistics at: http://www.youtube.com/t/press_statistics.

4. "YouTube and News," Journalism.org (The Pew Research Center's Project for Excellence in Journalism), July 16, 2012. http://www.journalism.org/analysis_report/youtube_news.

5. "Pew: Many Americans Don't Know the Religion of Either Candidate," "Belief" (blog), CNN.com, July 26, 2012.http://religion.blogs.cnn.com/2012/07/26/pew-many-americans-dont-know-religion-of-either-presidential-candidate/.

6. The Big Picture, Boston.com, ongoing. http://www.boston.com/bigpicture/.

7. Tod Papageorge, quoted in David Campbell's blog "Visual Storytelling: Creative Practice and Criticism," which also features Campbell's own trenchant commentaries. http://www.david-campbell.org/.

8. See Henri Cartier-Bresson, cited in Fred Ritchin, "What Is Magnum?," in *In Our Time: The World as Seen by Magnum Photographers* (New York: Norton, 1989).

9. Raymond Depardon, "Correspondance new-yorkaise" *Libération* (Paris), July 2–August 8, 1981.

10. Ibid.

11. From Gilles Peress, *Telex Iran: In the Name of the Revolution* (New York: Aperture, 1983).

12. Paul Roth, introduction to *Richard Avedon: Portraits of Power* (London and Washington, D.C.: Steidl/Corcoran Gallery of Art, 2008).

13. Ibid.

14. Gay Talese, *Fame and Obscurity: A Book About New York, a Bridge, and Celebrities on the Edge* (New York: Doubleday, 1970).

15. Cartier-Bresson, cited in Ritchin, "What Is Magnum?"

16. Dan Wakefield, "The Personal Voice and the Impersonal Eye," *Atlantic*, June 1966. I am indebted to an especially thoughtful and well-researched Wikipedia article on "New Journalism." http://en.wikipedia.org/wiki/New_journalism.

17. Tom Wolfe, "The Birth of 'The New Journalism'; Eyewitness Report by Tom Wolfe," *New York*, February 14, 1972.

18. Gay Talese, "Frank Sinatra Has a Cold," *Esquire*, April 1966. http://www.esquire.com/features/ESQ1003-OCT_SINATRA_rev_.

19. Gilles Peress, "I Don't Care that Much Anymore about 'Good Photography,'" *U.S. News and World Report*, October 6, 1997.

20. Richard Avedon, in *In The American West* (New York: Abrams, 1985).

21. Allan Sekula, cited at http://antiphotojournalism.blogspot.com/.

22. For examples, see Pete Brook, "7 Budding Photo Collectives You Need to Know," Wired.com, May 14, 2012. http://www.wired.com/rawfile/2012/05/photo-collectives/.

23. See http://facingchange.org/.

24. See James Balog's "Extreme Ice Survey" at http://extremeicesurvey.org/.

25. See JR's projects at http://www.jr-art.net/projects.

26. See the Instituto Terra website, http://www.institutoterra.us/.

27. "Photo Requests from Solitary," Tamms Year Ten website: www.yearten.org/2012/10/photo-requests-from-solitary-display-and-discussion-nov-17/.

28. In January 2013, Tamms Supermaximum Security Prison in Illinois was shut down after years of campaigning by Reynolds and others. See the extraordinary responses of family members and others at "Tamms Supermaximum Security Prison Now Closed," Amnesty International, January 10, 2013. http://www.amnestyusa.org/our-work/latest-victories/tamms-supermaximum-security-prison-now-closed; see also http://www.yearten.org/.

29. See Kent Klich, *The Book of Beth* (New York: Aperture, 1989); *Picture Imperfect* (Stockholm: Journal, 2007); and *Where I Am Now* (Munich: Bellyband, 2012).

30. Clara Jeffery and Emilie Raguso, photo-essay by Celia A. Shapiro, "Last Suppers," *Mother Jones*, January 2004. http://www.motherjones.com/photoessays/2004/01/last-suppers/.

31. See "Reframing History" at http://www.susanmeiselas.com/nicaragua/index.html. See also the film *Pictures from a Revolution* (1991), made by Meiselas with Richard Rogers and Alfred Guzzetti, documenting her attempt, a decade after the publication of her book on the Sandinista Revolution, *Nicaragua: June 1978–July 1979* (New York: Pantheon, 1981), to track down the people in the book's images.

32. Jim Goldberg, *Rich and Poor* (New York: Random House, 1985).

33. See Ariella Azoulay, *Different Ways Not to Say Deportation* (Vancouver: Fillip Editions, forthcoming 2013).

34. See Trevor Paglen's website: www.paglen.com.

35. Monica Haller, *Riley and His Story* (Paris and Värnamo, Sweden: Onestar Press/Fälth and Hässler, 2009/2011).

CHAPTER 3
Making Pictures Matter

I

What then are the potentials for a reinvented visual journalism?

When photography was introduced in the nineteenth century, many feared that painting, as a result, would die. Instead a renaissance occurred, with an expansion of both technical and conceptual strategies. Many of the most talented artists, now considering themselves freed from the task of direct representation, chose newer, more explicitly subjective ways of seeing the world—Impressionism, Cubism, Pointillism, Expressionism, and on into the future of new painterly movements, installations, video art, and so on. One stimulus was financial—photography was a more efficient recording medium and consequently representational painters lost clients—but the more important desire to rethink their medium opened up inquiries that fomented an artistic revolution.

Photographers today are also losing clients—to nonprofessionals making their own wedding albums, doing their own portraits, covering their own revolutions, as well as taking on all the other functions that are lumped under the rubric of "citizen journalism." And some photographers, partially as a result, are also looking for their own renaissance so as to transform and amplify their reach.

But the urge to pronounce photography dead today also might be contested by another idea: the introduction of expanding digital media challenges photography— now the elder medium—to transform itself. While digital media are considerably more efficient and cheaper, easier to master and to distribute, in their near omnipresence they may lack a sufficient singularity (what Walter Benjamin referred to as "aura") as well as enough subtlety to engage viewers deeply, or even to provoke their sustained attention. Current criticisms of the Internet, with its billions of images online, are in fact reminiscent of earlier critiques of photography, such as Charles Baudelaire's famous

1859 remark: "If photography is allowed to supplement art in some of its functions, it will soon have supplanted or corrupted it altogether, thanks to the stupidity of the multitude which is its natural ally."[1]

Baudelaire and others ultimately underestimated photography's ability to evolve. Grumbling about the enormous numbers of images online now makes little sense without acknowledging that they constitute a new, expanding visual literature that, riddled with its share of inanities, will in the end transform our understanding of ourselves and our universe. To a greater extent than we may currently anticipate or desire, this constellation of imagery will eventually displace and even replace much of the environment we once inhabited—a map (of sorts) abandoning the territory it once represented.

The existence of all of these images should similarly stimulate practitioners of various photographic traditions to push harder against long-held constraints in order to reinvent their medium in other ways. If a billion persons with cellphone cameras have greater proximity to breaking news events as well as to quirkier manifestations of the human condition, then the photojournalist and documentary photographer, having lost their privileged societal perch, must rethink their approaches, both destabilized and liberated by this wrenching moment of shifting paradigms.

While celebrating the democratization of the social-media revolution, all the multitudes of images online captured via lenses need not be thought of as successful photographs. Many are more of a rapid-fire scribbling, less sophisticated in their construction, lacking photography's larger relationship among forms, its considered use of depth of field, and a modulated responsiveness to light—just as text messages and Twitter feeds, while vastly popular and at times revelatory, do not have anywhere near the same range and shading as writing, nor do they reference, for the most part, the same vocabulary.

To be clear, many if not most of the photographs made by professionals are less than successful, inarticulate in their descriptions, with little subtlety and complexity in their points of view. Many of these indicate the required content but lack the formal strategies to interrogate its various meanings—a pervasive problem in photojournalism where "being there" should be only the starting point, especially given the number of others with cameras. A photograph that strives to provide a single answer intimates its own manipulation; one that provokes questions, whether intentionally or not, better allows the viewer to engage with the subject and become, in a sense, the photographer's collaborator in his or her inquiry.

An enlarged understanding that photographs are not incontrovertible recordings of visible reality, but interpretations and transformations of it, leads to a moment at which, like writers, the authors of the imagery must work harder to convince—an image on its own is not automatically proof of anything. This shift then leads to a greater rhetorical

conception of the picture, a consideration of how to persuade with one's imagery. What new approaches are conceivable in an era many now call "postphotographic"—when the image output from a camera is no longer thought of as being, or needing to be, above all a recording?[2]

Postproduction transformation of the image is considerably stronger in the digital realm, where retouching and compositing are so easily accomplished. Few go through the lengthy process of processing film and printing on paper, only then to add or subtract elements within the photograph. But in the digital realm there is a growing expectation today, for example, that photographs of people who are deemed important will certainly be retouched, at least as a courtesy, or that many will modify their own self-portraits ("selfies") and other images before placing them on social-media sites. Remember, for example, the accusations of political bias over *Newsweek* magazine *not* having retouched Sarah Palin's cover photograph in October 2008, just weeks before that year's presidential elections. Andrea Tantaros, a Republican media consultant, described the picture on *Fox News* as "mortifying." "This cover is a clear slap in the face of Sarah Palin. . . . Why? Because it's unretouched. It highlights every imperfection that every human being has. We're talking unwanted facial hair, pores, wrinkles." Tantaros continued: "*Newsweek* has done so many favorable covers of Barack Obama [then the Democratic presidential candidate] that make him look presidential, that are clearly retouched—he looks flawless."[3]

Well-conceived and carefully printed photographs—the products of processes and materials both biological and chemical (trees, ink, metals, etc.) and subject to time's progression (aging and decay)—now become exceptional in an era of screen-based image overabundance and ephemerality. They can also have a different resonance: the connection between a paper photograph and the landscape that it depicts is more palpable, given that they share a comparable materiality and processes; they decompose similarly, for example, evoking a similar temporality. A digital image of a landscape on a screen—really a compilation of code—can remain a comparative abstraction that provokes different thoughts; while easily linked to a specific time and place via the camera's time stamp and GPS, these are conceptual overlays.[4]

Given photography's loosening dependence on its status as a recording device, its vocabulary is in need of expansion—the photographer must increasingly emphasize the role of interpretation rather than that of transcription. John Szarkowski's comment in the 1978 volume *Mirrors and Windows* is germane: "During the first century of his existence, the professional photographer performed a role similar to that of the ancient scribe, who put in writing such messages and documents as the illiterate commoner and his often semiliterate ruler required. Where literacy became the rule, the scribe disappeared."[5] But writers did not. Similarly, photojournalists and documentary

photographers—who have been largely constricted to the repetition of various tropes, images that reference each other in an incestuously small field—need an approach in which the essential recording function does not stop at the secretarial.

In the late 1970s I showed a portfolio of my own photographs to John Loengard, a longtime *Life* magazine photographer who was at that time also serving as the (then) monthly magazine's picture editor. He looked through my black-and-white images of delegates, candidates, and others at the 1976 Democratic National Convention that had been held at Madison Square Garden (Jimmy Carter won that year's presidential nomination), and pointed out one image that he particularly liked. Eschewing all the photographs that were focused on a particular, revealing moment, he selected a picture of a number of delegates just sitting in their seats.

There was no one specific emotion expressed among them, no single adjective that could describe what was going on, no resolution of the various elements in the photograph that made it about something specific. In fact it was the one photograph in the portfolio for which the viewer had to work *hardest* to make up his or her own mind as to what was going on. To me it had seemed my least successful photograph—even as its author, I was not sure what it was about. But staring at that photograph, which remains in my memory more than three decades later, I eventually understood that the photographer need not explain clearly, but can share his or her impressions with other viewers who might be able to help to figure it out. Images containing ideas not yet sufficiently explicated, based on the photographer's knowing or sensing that something of importance is happening, can be construed as invitations to a reader to join in the search for meanings. Thus the image becomes, in a sense, open source. It is not always the one who was there with the camera who is certain of what is going on, nor should it always be necessary to pretend.

Like the juggler who impresses us with multiple balls in the air, too many to keep track of, the photograph can benefit from remaining unresolved and, as a result, it will be less didactic; it is not there primarily to prove a point. In its ambiguity the image refrains from what might be called a quantum collapse of possibility. As such, the photograph cannot be explained in a caption—indeed, many photographs are expendable once the caption is read—nor can a caption resolve all its potential meanings. The visual must be taken on its own terms. (Gilles Peress speaks of trying to make the viewer "surrender" to the photograph, rather than glancing away.) And as in the quantum double-slit experiment in which light exhibits both wave and particle properties until observed—at which point, according to certain interpretations, it collapses into one state—the photograph stays open-ended enough to encourage multiple interpretations by the reader; it is as if the photographer has observed the situation and not observed it at the same time.

Magnum cofounder George Rodger saw the photographer, somewhat similarly, as playing a double role: "You must feel an affinity for what you are photographing. You must be part of it, and yet remain sufficiently detached to see it objectively. Like watching from the audience a play you already know by heart."[6] Although it is not really possible to see "objectively," the tension of being both insider and outsider simultaneously is potentially enormously productive, allowing the open-minded photographer to function along the translucent membrane where the two worlds overlap.

The widely held assumption that photographs are, or should be, easy to read, does not help stimulate greater sophistication among image makers concerned with the photograph's mass appeal (nor does the absence of visual or media literacy in school curricula). In the field of photojournalism the visual vocabulary has particularly stagnated, with national contests rewarding many of the expected clichés, and international competitions and some of the well-meaning workshops establishing standards, mostly implicit, so that work by indigenous photographers comes to resemble imagery by foreign standard-bearers. Rather than discuss and value differences as providing new ideas for an expanding set of approaches, even in a weakened field a conformity reigns that constricts possibility. (Imagine, for example, if a writer like Gabriel García Márquez were required to resemble Don DeLillo in his prose—or vice-versa.)

While an enormous battle to uncover and legitimize the differences among photographies from all parts of the world has been fought now for several decades, with photography festivals dedicated to Latin American, Asian, East European, and African photography, globalization has resulted in photographs that look more alike and use similar visual strategies, no matter where the image is made or who makes it. Whereas photographs from certain parts of the world once evoked different senses of time (that of the decisive moment versus that of magic realism, for example), or referenced cultural signifiers that were obscure for many viewers, now imagery appears to be more homogenized and, as a result, seems to demand less scrutiny: much of its mystery is gone. A peasant in Peru and one in China may be depicted as similarly resilient and oppressed, even though their economic and political contexts are very different; the photographers making the nearly identical imagery might well come from vastly different social or cultural backgrounds as well.

Christian iconography is a frequent reference, notably of course the Madonna and Child and the Crucifixion (see Dorothea Lange's famous 1936 photograph known as *Migrant Mother*, and Samuel Aranda's 2012 World Press Photo winner from Yemen, or the image of the hooded man standing on a box at Abu Ghraib prison, with arms outstretched as if crucified, among numerous examples). Or contemporary photographs closely imitate others that were iconic in another time: the raising of the flag at Iwo Jima by Joe Rosenthal, a powerful symbol made several years into World War II, was virtually

repeated a few hours after the attacks of September 11, 2001, in Thomas E. Franklin's well-known photograph of firefighters raising an American flag at Ground Zero—an almost immediate signaling of "resurrection," even before the import of the devastation had been registered, let alone digested. Both images were made into U.S. postage stamps. (It is also interesting how readily people seem primed as subjects to reenact certain photographs today, recalling them as memes.)

How does one get beyond what former photojournalist Simon Norfolk characterized as the medium's oversimplification? "Photojournalism is a great tool for telling very simple stories," he has noted. *"Here's a good guy. Here's a bad guy. It's awful.* But the stuff I was dealing with was getting more and more complicated—it felt like I was trying to play Rachmaninoff in boxing gloves."[7]

How then can photographic complexity be amplified to deal with an increasingly complicated world? How is it possible to assert a photograph's various meanings or its culturally specific signifiers, or to utilize other media synergistically to evoke deeper meanings? What works best to engage the reader? (Advertisers know much more about this than documentarians.) To what extent is each photograph fictional or nonfictional, or do these terms not apply? (Stephen Ferry, known for his documentary work in Latin America, calls it "non-fiction photography.")[8] If these terms are helpful, might we mark a primarily fictional photograph with a thicker frame, say, or provide an accompanying symbol when the photograph itself has been manipulated beyond an acceptable norm?

Gigapan's website, for example, engages the public by encouraging viewers to make online "snapshots," in effect fragments of the gigapixel (billions of pixels) panoramas presented; comments are added from observers who may be able to shed light on certain details. For one panorama of a Guatemalan outdoor market, the significance of certain kinds of indigenous clothing that people are wearing is explained; the viewer is first attracted by the busy, colorful image and then, with the aid of the snapshots and comments (which indicate what other readers have focused upon), is able to better understand both the fragments and what the larger panorama is about.[9]

Or, in an effort to contextualize their own imagery, might photographers be encouraged to enter metadata that an interested reader can find by placing the cursor on each of the photograph's four corners? In such a scheme the bottom-right corner might contain credit and copyright or Creative Commons information, along with a caption and any indication that the image was manipulated (if that is the case); the bottom left could then contain testimonies by photographer, subject, or other implicated parties who could add to or contradict aspects of the photograph; the upper left could show other still or moving imagery that gives information about what was happening before and after that moment, or elsewhere; and the upper-right corner might link to other websites or sources for more details. Success here comes from more than looking

at the image when an interplay of various voices is enabled, including that of the photographer, the subject, other witnesses, and analysts. In this approach the reader would gradually learn to expect more meanings from the reading of each individual photograph, even from those *not* explicitly contextualized.[10]

The same may be said of the ways in which a photographer "reads" the situation that he or she is photographing: one who is open minded enough to wait for a situation to reveal itself—rather than one who expects to confirm preconceived ideas in the photograph—may be a bit startled by the images that he or she produces, and may learn from them. (In Eugen Herrigel's 1948 book *Zen in the Art of Archery*, highly recommended to me by Henri Cartier-Bresson—and which I have always taken as an allegory for his strategy as a photographer—there is a description of the way in which the arrow and the target may meet without the archer's purposeful aim.) By not looking for stock characterizations (celebrities are flattered, the poor are always victims) or settling on the usual symbols to represent a given crisis (child with swollen belly to designate famine, and so on) the subject can, at least at times, implicitly enter a nonverbal dialogue of sorts with the attentive on-site observer. The resulting photograph, as Avedon had wanted for "The Family," may then be, in a sense, *given*, as well as *taken*.

Importantly, the subject has agency. German philosopher Martin Buber's discussion of relationships as being of two kinds is helpful: He proposes an "I-Thou" relationship as a connection between essential beings in which the other becomes one's whole world, transcending categories (as in love, for example, or a deep reflection that envisions depth and texture and light and shade and amazement and history and future in what one might have previously understood as simply an "oak tree"). Buber contrasts this to the "I-It" dynamic, in which the other is viewed as no more than its category ("starving child," "pretty woman," "brutal dictator").[11] The latter set of relationships, which can be quite demeaning, may well describe the majority of journalistic photographs that are published: they tend to support such categories more than they upend them.

Around the time that I began working at the *New York Times Magazine* in late 1978 as the picture editor, there was a discussion in the National Press Photographers' journal of a frontal photograph of a young woman running naked from her burning house, which in the image was shown behind her. Should one publish it? What was the point? At the *New York Times* we tried, not always successfully, to operate under our own variation of the Golden Rule—if you yourself were the one shown in that photograph, or it was your sister or mother or wife, would you publish it? The question forced one to consider some of the rights of the subject: unless there was some overriding news value to the photograph, there was no reason to print a picture of someone nude running from a burning house. (An alternative question

was also useful—would any editor want to be responsible for that subject, or any other, feeling so exposed as to return to the burning home to find a towel to cover him- or herself?)

On the other hand, Huynh Cong "Nick" Ut's earlier, widely viewed photograph of another nude female fleeing a fiery inferno—Phan Thị Kim Phúc, a young girl who had been napalmed in Vietnam—transcended the personal and became a critical reference point for those trying to bring the war to a conclusion. The image, made in 1972, would have been considerably less resonant and easier to reject if it were made as a close-up of the child: the photograph would then have been open to accusations of exploitation and sensationalism, considering its focus on a naked girl. But by showing the Vietnamese troops, other children, the long road behind her, and the sky covered in towering smoke, the photograph forces one to read it both for what it explicitly says— something horrible is happening here—and for what it implies: that the war itself is not only at times barbaric but also out of control. However, if published today online, how long would it be before this image became a casualty of a frenetic news cycle and of a culture of appropriation, replaced by newer images perhaps in minutes, or contested and possibly altered by those riled by its symbolic power, transformed by artists, used in an advertisement, or grotesquely placed somewhere on a pornographic site?[12]

Nick Ut's stance, given other discussions about whether a photographer should physically intervene, straddles an ethical middle ground. In an interview given forty years after the event, he described the circumstances of the photograph to a Los Angeles television station: "I keep shooting, shooting pictures of Kim running. Then when she passed my camera, I saw her body burned so badly, I said, 'Oh my God, I don't want no more pictures.' She was screaming and crying. She just said, 'I'm dying, I'm dying, I'm dying,' and, 'I need some water, bring water.' Right away, [I] run and put water on her body. I want to help her. I say no more pictures, I want to help Kim Phuc right away."[13]

Photojournalist Horst Faas and curator Marianne Fulton recounted the story of the photograph's publication in the online forum *Digital Journalist*:

> An editor at the AP rejected the photo of Kim Phuc running down the road without clothing because it showed frontal nudity. Pictures of nudes of all ages and sexes, and especially frontal views, were an absolute no-no at the Associated Press in 1972. While the argument went on in the AP bureau, writer Peter Arnett and Horst Faas, then head of the Saigon photo department, came back from an assignment. Horst argued by telex with the New York head-office that an exception must be made, with the compromise that no close-up of the girl Kim Phuc alone would be transmitted.
>
> The New York photo editor, Hal Buell, agreed that the news value of the photograph overrode any reservations about nudity.[14]

But that photograph also made Phúc's life miserable. "First time when I saw that, I wish that picture not taken because that little girl, I feel ugly and embarrassed," she has said.[15] Phúc was unable to continue in medical school due to her public-relations value for the new Vietnamese government. Later, having moved to Canada and become a spokesperson for the United Nations, she was happier about the effect of that image on her life, and grateful for her own role—despite living in pain every day from what the napalm did to her. In a June 2, 2012, piece for ABC television, David Ono accompanied Nick Ut back to the site of the original photograph four decades after it had been made. He quotes Phúc: "I'm so thankful that he took that picture. I can use that suffering to help other people because I know as you know there are so many people in this world suffering."[16] (Interestingly, Ut's older brother, Huynh Thanh My, was a wire-service photographer, "searching for that magic picture that would turn the world against the war and stop the killing," Ono writes. Wounded in the Mekong Delta in 1965, Huynh Thanh My was treated in a field hospital that was overrun by Vietcong soldiers, and Huynh was executed. The fourteen-year-old Nick Ut then decided to become a photographer and, following in his brother's footsteps, also wished to make a picture that might have the power to stop the war. His photograph of Kim Phúc comes perhaps as close as any image ever has to having such an effect.)

This image has presented difficulties for certain former soldiers. Ono interviews one Vietnam veteran, Jim Nolan, who was haunted by a young woman and baby whom he mistakenly killed when ordered to clear out a hole (he recounts how they were hidden, afraid of the Americans, and did not respond to him calling before he threw in a grenade), and for whom the photograph of Phúc reopened a nightmare. In Ono's interview, Nolan says: "To me personally, it's a reminder of the horror and of the collateral damage, the woman and her baby. The fact that a lot of the villages we shot into didn't just have VC in them, they also had women and children and that there was a lot of civilian casualties. We would just count their bodies as VC. This picture just brings back a lot of those memories of the chaos of war."[17] Nolan never talked to his own children about the war, not wanting them to think of their father as a killer. After decades unable to articulate what happened, he began teaching a course at the University of California, Santa Barbara, in which veterans can tell their stories.

The photograph *Tomoko Uemura in Her Bath*, made in 1971 by W. Eugene Smith to publicize the horrors of mercury poisoning, shows the naked subject's badly distorted limbs and her inability to care for herself. This image, too—although quite romantic in its version of purifying maternal love—was highly intrusive to its subjects. Again resembling the Madonna and Child, the image was one of the few that created a larger awareness of environmental degradation. But in a desire to more fully engage the subjects of the photograph in the life of the image, Aileen Smith, Eugene's wife—who

held the copyright of the photograph after his death—decided in 1997 that it should no longer be seen. Twenty years had passed since Tomoko's death at the age of twenty-one from fetal mercury poisoning (known as Minamata disease). The family had asked that the picture never be published again, and she agreed.

Aileen Smith subsequently wrote about her decision in a letter cited in 2000 by Smith biographer Jim Hughes:

> Generally, the copyright of a photograph belongs to the person who took it, but the model [subject] also has rights and I feel that it is important to respect other people's rights and feelings. . . . The photograph "Tomoko is Bathed by her Mother" [an alternate title] will not be used for any new publications. In addition, I would be grateful if any museums, etc., who already own or are displaying the work would take the above into consideration before showing the work in the future.[18]

The many intrusions on their lives due to the photograph's fame had become too much, as well as the rumors that the Uemura family was profiting from it. And their daughter had since died. "The photograph went on to become world famous and as a result we were faced with an increasing number of interviews," Tomoko's father, Yoshio Uemura, wrote in a letter. "Thinking that it would aid the struggle for the eradication of pollution, we agreed to interviews and photographs while the organizations that were working on our behalf used the photograph of Tomoko frequently. . . . Rumors began to circulate throughout the neighborhood claiming that we were making money from the publicity, but this was untrue. . . . We never dreamed that a photograph like that could be commercial."[19]

Aileen likewise felt it was time to let the Uemuras' daughter rest, and for her parents not to be compelled to think of Tomoko "each time going out to the world, naked, showing everything of her polluted body." She recounts that Tomoko had already served another exceedingly important role: she was thought of as a "treasure child" by her parents, for having sufficiently absorbed the mercury in her mother's body so that her six younger siblings were not born with Minamata disease. Aileen also proposes an idea that has become particularly germane to discussions about the medium: "If all subjects and viewers in the world knew that each photograph that is seen in the world is a result of careful deliberation, not an accident of mass production, the power of photography would soar."[20] Today, however, it is very difficult to control an image's dissemination; *Tomoko Uemura in Her Bath* is still easily available online.

Given this complex history and the growing literature surrounding photographic practice, there is now much more to build upon than the old reductive call to photojournalistic

action, "f8 and be there." Digital media will also prove, over time, to be profoundly different from analog media, even if during this transitional period digital media are largely imitating the modes that preceded them. In my 2008 book *After Photography*, I referred to "digital photography" as being a term like "horseless carriage"; the latter was a comfortable way to refer to the emerging automobile, even if over time the automobile would have impacts vastly different than those of the horse-drawn carriage (the building of suburbs, malls, global warming, and on and on). Similarly, *digital photography* is certainly a transitional phrase for the image-based media that will evolve.

It is not an accident, for example, that code-based media emerged as we began to rethink of ourselves as code-based, made up as we are of DNA—digital media will increasingly reference the genotype, while analog photography prioritized the phenotype, among other differences. It is also crucial that the discrete segments of the digital (think of pixels) are capable of approximating a quantum universe, with its discrete packets of energy, as much as the continuous-tone analog approximated a Newtonian one. If "the medium is the message," as Marshall McLuhan famously argued, then digital media are preparing us for a considerably more profound revolution in consciousness than would be indicated by thinking of pixelated photography as simply a more efficient version of the analog medium.

Digital media, as a result, will not merely simulate an older style of photography, but strategies will also emerge that are more capable of depicting an evolving universe. Rather than attempting simply to imitate previous media while offering an increase in efficiency, digital media, including their visual aspects, will eventually involve a more flexible, integrative "hyperphotography" that takes advantage of the many potentials of digital platforms, including links, layers, hybridization, asynchronicity, nonlinearity, nonlocality, malleability, and the multivocal. The results may at first resemble gimmickry, but eventually they will be transformative.

The broader field of visual journalism—encompassing not only photography, video, and digital imaging, but a host of other strategies such as hypermedia, geo-positioning, augmented reality, and simulations—allows for a wider-ranging approach in which the action photograph is only one component. With input by more contributors than just the professional eyewitnesses, who themselves assume various levels of detachment and involvement as both photographer and contextualizing metaphotographer, there is the potential for enormous rhetorical flexibility and insight.

In the case of the coverage of war, for example, there are now far more voices available than before, and they are encountered in disparate places. Digital devices are filled with photographs made by soldiers themselves; there are images from civilian populations on Twitter feeds, photographs on the individual websites of photojournalists

and in books, the Wikileaks dispersal of enormous quantities of documents, individual blogs and Facebook pages that feature diaries and reporting by various insiders and outsiders, as well as a growing pool of useful information available on the Web from a variety of journalists and specialists.

"Watching Syria's War" is an example of one new mode of considering war visually (page 92). The *New York Times* has created a site to track "the human toll of the conflict" as the country further destabilizes, acknowledging that conventional journalistic, eyewitness coverage on the ground is exceedingly difficult to accomplish. Online videos gathered from various sources are contextualized by posts attempting to establish their credibility and meaning. One item (from the site's December 21, 2012, entry), begins: "This video is said to show two Syrian ballistic missile launches in the town of Nasiriya, one at night and one during the day. Soldiers in the daytime clip can be heard counting to twelve before launching the missile and then applauding as it arcs through the air toward an unknown target." To put each video in context, the site includes sections titled "What We Know" and "What We Don't Know" (e.g., "It is not clear when or where this video was taken, and so we do not know if these missiles were launched as part of a past training exercise or during the conflict. We do not know who filmed this video, but activists on Twitter speculate it was filmed and spread by an army defector"). There is also a section for "Other Videos," as well as one called "Tweets Related to this Video." It's a slow, difficult process, but the *Times* is apparently aware that imagery describing many future events will largely be made and disseminated by people living through them, requiring that others learn how to sift through their output for a more complete sense of what is going on.[21]

And, as social media have repeatedly shown, digital platforms can help to foster community. The greater engagement of the reader and various kinds of specialists in assessing meaning, the amplified role of the subject in producing the imagery, and the larger framework made available, including space for dialogue—all this makes the mediation more collaborative in ferreting out any conclusions. It is a partial reinvention of the oral tradition, in which a group actively shares what may be contradictory insights as many contribute to both the narrative and its interpretation.

Digital-image capture is being used to subvert and transform power balances in the producer/viewer/subject triad, and to examine issues in ways that were previously impossible to accomplish, using a combination of sources—imagery by people holding cameras is only one of them. But while the evidence of a thousand cameras depicting the same events may be compelling, it can become nearly irrelevant if there is no way of filtering the results to give the mass of imagery some coherence. And there are ways of doing so. For example, one might choose to scan a color-coded map assembled by a search engine to find *only* images produced from the cameras belonging to inhabitants

of a given location, determined by GPS tracking, indicating that the photographers have been in the community long enough to have an informed sense of what is going on. Or one could select images by GPS *only* from those who photograph during the week and not just on weekends, or from those who photograph primarily in their own neighborhoods. Or one might choose, if the data is available, from among those who self-identify as members of a certain group, or who are pegged as professional journalists, and so on. Then the viewer can also act as an independent curator, pointing out to others what might be relevant and for what reasons (it is this latter role that may well emerge as the most important).

Rather than continued reiterations of previous media—rather than the screen being used as if it were as two-dimensional and static as a paper page, for example—unprecedented ways to tell stories should emerge. One considerable step in this direction was the *New York Times'* multimedia feature "Snow Fall: The Avalanche at Tunnel Creek," written by John Branch and published at the end of 2012.[22] (*Times* editors seem recently to be making a greater commitment to the journal's online presence.) With "Snow Fall," the reader advances through six sections in a linear fashion via a suspenseful text, while atmospheric video is added to each segment to evoke the snow and cold on top of the mountains, maps and slide shows of archival images appear, a simulation of the avalanche is presented, and video interviews are included at specific moments in which persons mentioned in Branch's text speak. Rather than just illustrating and confirming one another, each of the media adds layers to an understanding of the developing tragedy and its aftermath. The project attracted millions of viewers.

What particularly distinguished the *Times'* multimedia piece were the ways in which it sparingly unfolded a dramatic series of events. When linear narratives are desired in online slide shows (and for the time being slide shows remain the visual default), they, too, should be created so that each image adds to the reader's experience, building in substantive ways upon those that precede and follow it. Photographs can be placed, for example, so that the center of interest in each image varies. This encourages the viewer's gaze to wander, to remain active, searching the entirety of each subsequent image for meaning, and not just quickly settling on the same similarly placed—usually central—fragment and moving on (unless the sameness is part of the photographer's strategy). As a picture editor and curator I have often found that exactly the same set of images can be perceived as either without interest or scintillating, depending upon the order in which they are presented, without viewers being aware of the reason for their response. Whereas cinema emphasizes sequence and editing and the concept of montage, photography has often been seen—including by photographers—as a collection of single images that can be presented in nearly any sequence, denying both the synergies that come from an intensifying visual rhythm and a coherent narrative.[23]

Much crucial experimentation is being done by people operating in other fields—from conceptual artists to video-game designers—creating models that documentarians can then borrow from and, if they choose, further transform. Those working as data visualizers, for example on mapping, on imaging from outer space, on brain scans, or with nanotechnology, employ a sense of scale and perspective that is often unavailable to the photographic witness. (Over a decade ago, on a visit to the Massachusetts Institute of Technology, I heard the suggestion that with a satellite hookup the photographer at work could be simultaneously photographed from outer space for another point of view.) And the many artists who have experimented with new visual forms may be consulted (as fiction writers were touchstones for the New Journalists) as to different ways of telling stories or expressing sets of issues.

The work of Sophie Calle, for instance, might serve as an inspiration for those interested in playing with roles and collecting evidence differently. Among many other projects, the conceptual artist became her own multiple subject: playing the part of a stripper in Paris's Pigalle; having herself followed by a detective, and then displaying the photographs that he made without him knowing that she knew. Calle also made photographs, accompanied by her writing, based upon encounters with people whose names she had found in an address book that she picked up on the street (she photocopied it and mailed it back to its owner) in order to create, without his knowledge, a "metaportrait" of the man it belonged to, Pierre D. (In one such meeting, Calle noted: "In a bar in Montparnasse . . . she tells me 'It was during the week following his mother's death that his hair turned white.'")[24] For her 1981 project "L'Hôtel/The Hotel" Calle took a job as a hotel maid in Venice, so as to browse through and photograph the possessions of the rooms' various occupants as a means to figuring out their situations (happy lovers? dissatisfied family?). Building a portrait in unusual and at times intrusive ways, creating narratives that can be approached like games, she went far beyond the conventional photograph of a subject posing for the camera.

In a somewhat similar vein, a few years ago the Colombian online publication Semana.com introduced diverse personalities—a soccer coach, a minister of agriculture—via online images of them that encouraged the viewer to click on various body parts and pieces of clothing to learn more. The minister of agriculture's tie was used as an entryway to learn about his sense of style, his pocket to learn about his financial perspective, his Achilles tendon to find out about his self-perceived weaknesses. Rather than another humdrum profile of a government bureaucrat, this one animates his personality, and encourages the reader to explore.

II

A number of years ago, a photographer widely celebrated for her magazine work confided that she felt the only spontaneous imagery left in editorial photography was made by paparazzi and war photographers. Everything else, she said, was more or less set up. The point was that publications use photographers to get the image that they want, rather than to discover what might be there.

Today, however, many celebrities seem to know how to control the paparazzi (Madonna's successful strategy to discourage them is said to be wearing the same kind of clothing every day so that there is little demand for updated pictures of her). One is left also to wonder how spontaneous the photography of war actually is. With professional photographers increasingly banned, embedded, reliant on fixers, forced to travel in groups for their own safety, often not speaking the language or understanding the culture, with little financial support for long-term work, and with editors looking to quickly attract the reader's attention, much of war's depiction has evolved into an unfortunately predictable spectacle, lacking the requisite nuance and depth.

Responding to the needs of the twenty-four-hour news cycle, many photographers are forced to frequently send imagery by satellite feeds after quickly editing their own work in the field. (During the Vietnam War photojournalists generally shipped their undeveloped film once a week for the newsmagazines, and might not see their own photographs for months. The uncertainty of *not* immediately seeing the photographs can also be freeing.) Today's often frenzied way of working in the field diminishes opportunities to engage others in conversation, to hang out and reflect on what is happening without thinking of the next photograph. Filmmaker and photographer Wim Wenders argues that this is also the result of working digitally: "I want to listen to the place, I want to immerse myself into it. If I could look at the picture on the screen [the camera back], the dialogue would be over."[25]

Many of the war photographs published are made in very similar styles (I am still amazed when I see an image that seems intimate and unique, only to find very similar versions of the same scene from other photographers who were all traveling together): some editors simplify the imagery selected to the time-honored tropes of "good and evil," or "us and them," and others emulate the imagery from previous wars, or from the movies that characterized them. One might like a better sense of who the people are who live there, or of the landscapes and geography, or of the political or religious leadership, or of anything other than the killing and destruction that are so often the

focus. And so would, if they had their druthers, many of the photographers risking their lives to witness what is going on.

Yet this vivid simplicity is of course what the public is purported to want. As a picture editor, I have been asked by the top editor of a major newsmagazine for a more "colorful" version of a devastating picnic explosion that had been photographed in shades of somber gray, and have heard a colleague speak of having chosen a photograph of tribal elders in Afghanistan for the front page of a major newspaper soon after the September 11 attacks primarily because "it looked biblical." Such an editing process does not much encourage photographers to enlarge their visions in favor of complexity, or to take risks in the narratives that they employ.

With the repetition of visual clichés, wars and conflicts tend to merge, losing their specific histories, including any sense of what may be at stake; at the same time, attempts at peace and rebuilding are usually considered much less photogenic. In Iraq, for example, little insight was provided on the differences between and among Shias and Sunnis as the United States invaded; just so, few readers are now led to know much about the Alawites in Syria, or class differences in Egypt, or the impact of Hezbollah in Lebanon, or the many successful repulsions of powerful invaders by Afghans that make the goals of the United States there seem like an enormously destructive folly. And why do we rarely know much about these people *before* they are at war?

In 2003, despite the enormous quantities of intense, painful imagery available in a tumultuous, violent world, one of photography's major critics, Susan Sontag, could not find a magazine or newspaper image that she would consider *antiwar*. In her book *Regarding the Pain of Others*, she expressed concern about the "perennial seductiveness of war," and wondered: "Could one be mobilized actively to oppose war by an image (or a group of images)?" Sontag responded to her own question not with a photograph or series of photographs made by a journalist or documentarian, but with a single image, simulated and digitally composited, seen primarily in museums and galleries, in which actors played the parts of soldiers: Jeff Wall's 1992 *Dead Troops Talk (A Vision after an Ambush of a Red Army Patrol near Moqor, Afghanistan, Winter 1986)*. Sontag called Wall's enormous work, a nearly one-hundred-square-foot montage mounted on a light box, "exemplary in its thoughtfulness and power."[26] (It also costs a fortune to own: in 2012 the piece sold for $3.6 million at auction.)[27]

Or there is the perspective of Chilean conceptual artist Alfredo Jaar, a producer of images who went to Rwanda and refugee camps soon after the 1994 genocide: "I came back with thousands of images of horror. And also with the realisation that it was not possible to show the material. I felt that it wouldn't make any difference to show these images because I feel people here have lost the capacity to see, they have lost their capacity to be affected. This is due to the relentless bombardment of images we suffer every day

and how it completely de-contextualises everything."[28] When invited to exhibit work in Sweden on public advertising spaces in 1994, Jaar chose to show only the word *Rwanda*.

Can photographs keep readers engaged with a larger frame; can they serve to actively mobilize people against war? Tim Page, a photographer who rode around on his motorbike during the war in Vietnam, where he was severely wounded, was asked to write a book that would, once and for all, take the glamour out of war. His response: "Jesus! . . . Take the glamour out of war! How the hell can you do that? You can't take the glamour out of a tank burning or a helicopter blowing up. It's like trying to take the glamour out of sex. War is good for you."[29]

But it would seem that even a display of such violence can lose its power both to galvanize the public and to interest editors. At the very end of 2012, the results of surveys on the top news stories of the year were announced. Missing from the list were America's two major wars: the eleven-year-old war in Afghanistan, and the global "war on terror." Similarly, when the Associated Press polled its editors and news directors working in the United States, only the conflicts in Libya and Syria were considered to be among the year's top news stories. Yahoo's listing of the leading news items likewise did not mention the war in Afghanistan, nor did another list that reflected what Yahoo users searched. Why? The theory seems to be that the lack of attention is due to "both the national news media's scant coverage of the war and the public's disengagement with it"—a syndrome that has been referred to as "war fatigue."[30]

What then does a photographer do in terms of new tactics to engage the public, particularly if the national news media do not cover such critical conflicts sufficiently? Besides dramatic pictures of the battlefront, what other kinds of images are being made? Is there an emerging set of strategies that can approach the coverage of war in ways that will stress its importance even to disaffected viewers?

Basetrack was an experimental social-media project, tracking about a thousand Marines in the 1st Battalion, Eighth Marines, during their deployment to southern Afghanistan in 2010–11. A small team of embedded photographers, including project founders Teru Kuwayama and Balazs Gardi, used primarily iPhones along with a Facebook page to connect Marines to their families (page 93). They curated a news feed alongside their own efforts, employed Google Maps as an interface, wrote posts in addition to photographing, all with a view "to connect[ing] a broader public to the longest war in U.S. history." It is an example of photographers joining forces to make a larger statement, and intent on involving their audience in the discussion. Trying to establish transparency in the process, they created an editing tool for the military to censor photographs and texts that might put soldiers in danger, while letting viewers know that segments had been blacked out. The military was also asked to supply reasons for the censorship, which were then made visible when a viewer placed the cursor

over the blacked-out section. It was a relatively effective system, until in 2011, when the Facebook discussion became too difficult for the military to handle. (According to Gardi, a good deal of the content that military officials found problematic was about relatively minor matters, such as parents asking why their sons and daughters had to wear brown socks and not white socks on patrol.)[31] The photographers were "uninvited" a month before the troops' deployment ended; now only the Facebook page is still active, with curated news and continuing audience discussions.

In large part the project was created out of frustration with mainstream media: "It wasn't just the military that was discouraging us from making meaningful pictures," says Kuwayama. "The magazines we worked for—or gave our pictures to—clearly didn't want them, either. We would come back from an embed, where we'd been in the fight of our lives, and we would get these absurd reasons about how that wasn't interesting enough to publish or wasn't right for that week."[32] Family members, not surprisingly, responded quite differently; for example, one mother's response on Facebook: "It has truly saved me from a devastating depression and uncontrollable anxiety after my son deployed. Having this common ground with other moms helped me so much and gives me encouragement each day."[33]

For an earlier, similarly conceived project, photographer and writer Brian Palmer went to Iraq for six weeks to follow the 24th Marine Expeditionary Unit. Beginning in 2004, it was published on the Web at PixelPress.org[34] as "Digital Diary: Eyewitness to Iraq"; his observations appeared weekly, so that families in the United States could (as with Basetrack) follow and try to understand the lives of their loved ones serving in Iraq. A chess game between an American soldier and an Iraqi translator, a "turkey object" that was served for dinner, the transformation of a civilian Goth to an institutional Marine, all evoked the life of the war in ways that were intimate and at times useful, without the focus on the battlefield. With links via Marinemoms.com and other sites, the "Digital Diary" provided an extra set of eyes overseas. Rather than photographs of strangers for strangers, they became more like a family album of one part of a community, to be shared with others who did not make the trip.

And when a young woman's boyfriend was killed in Iraq, a photograph of the soldier became essential as the last testament to his existence. At PixelPress we received a note from the woman's mother: "I saw the article, 'Digital Diary Witnessing the War,' last week and was hoping to see it again. Is there any way I can get a copy of it? My daughter's boyfriend was with that unit and she did not get an opportunity to see the diary. Unfortunately he was the young Marine who was mentioned in the 6th week because he was killed." This form of journalism was far from disinterested for everyone involved—Palmer went back to Iraq twice more with the same unit, and made a film of his experiences, *Full Disclosure* (2010).

The late Tim Hetherington's "Sleeping Soldiers" is a three-screen installation of photographs, video imagery, and sounds, with photographs of soldiers asleep intertwined with videos of battle scenes that Hetherington had just documented (between 2007 and 2008, he was embedded with U.S. soldiers of the 173rd Airborne Brigade Combat Team at Outpost Restrepo, in the Korengal Valley of northeastern Afghanistan). This was a rare attempt to imagine the soldier's unconscious as it begins to process the violence in which the person has just participated.[35] Hetherington also made a self-questioning, James Joycean, impressionistic video, *Diary* (2010), on the disjointed life of a war photographer, including images of his young niece in England and of riding in a jeep with unnamed fighters, the sounds of gunfire and a rotating ceiling fan, scenes in Liberia and in Afghanistan, an answering machine providing a tenuous link with discordant realities.[36] Like "Sleeping Soldiers," it melds states of consciousness, some extreme, involved in documenting and fighting wars—providing perspectives far beyond war's conventional framing. Hetherington, along with photographer Chris Hondros, was killed the following year while covering the war in Libya.

Suzanne Opton's images of soldiers were distributed on billboards in eight American cities between 2008 and 2010. For her project, titled "Soldier," her aim was "to look into the face of a young person who had seen something unforgettable"; with this goal in mind, she asked nine members of the U.S. military between tours of duty to place their heads on hard tables. While she arranged her 4-by-5 camera and lights, the soldiers posing for her tended to let down their guards. "Some of them look serene and some of them look shell-shocked," says Opton. "They're all terribly vulnerable."[37] With the images, the photographer provides information as to the number of days they have served, and where, in a stripped-down caption: "Soldier: Birkholz—353 Days in Iraq, 205 Days in Afghanistan." Subsequently, Opton worked on "Soldier + Citizen," a project contrasting her photographs of American servicemen with images of Iraqi refugees, with interviews by Susan Sachs. Along the lines of Opton's "Soldier," Dutch photographer Claire Felicie, inspired by her son's deployment in Afghanistan to know more about the effects of war on those fighting, made triptychs of direct, close-up portraits of twenty young members of the Netherlands Marine Corps, before, during, and after they served a six-month tour in Afghanistan—her 2009–10 project is aptly called "Marked."

Jennifer Karady, as mentioned previously, also revisits the trauma of violent conflict in her collaborations with soldiers, working with each for a period of a month to restage calamitous events in civilian life that they experienced in war; she views the procedure as potentially therapeutic. In her process she helps to make the circumstances somewhat more comprehensible to family members and friends who did not experience them, as well as linking the great majority of citizens not directly involved in the

war to some of its enduring aftermath. In one staged photograph, retired sergeant Mike Sprouse stands in uniform in front of a large tire lying by the side of a road. He says:

> After coming back home, you think about Afghanistan and how it was driving there compared to here. Occasionally it will go through your mind, driving down the road, to look out for IEDs. It's an instinct that is hard to turn off. When I went to drill last month, going to Winchester on 81, it happened. And it was just a tire from a tractor trailer recap up ahead. It doesn't happen every day. I could go a couple of weeks, a month and not see it. But driving down the road, something's going to click in your mind.[38]

Like Karady's project, Monica Haller's collaborations with veterans and their families were undertaken in part to be of service to them, but also to assertively share the pain and confusion with a larger world. As Riley Sharbonno puts it in Haller's *Riley and His Story* (2009): "Many events during my time in Iraq were too complex, too horrific, or beyond my understanding. There were simply too many things I witnessed there on a given day to process, so I stored them as photos to figure out later. Pictures create a concrete reality. At least I know these things happened. They continue to serve that purpose." But it is even more complicated than that: "Photos provide the chain of events that lead your mind into a state where it is okay to kill somebody. If you don't remember the sequence of events that took you there, you can believe you were a monster."[39]

Nina Berman's photographs of terribly wounded returning American soldiers similarly bring some of the horrors of war home in order to provoke a debate. In presentations she gave in tandem with a wounded veteran, Berman showed her images to American high-school students from the poorer communities that are often targeted by military recruiters. Students were particularly shocked to learn of the poor quality of long-term medical care provided for those with serious injuries, a potential deal-breaker for some thinking about enlisting. (A series of these images was published in 2004 as *Purple Hearts: Back from Iraq*.) But it is Berman's 2006 wedding portrait of returning veteran Marine Sgt. Ty Ziegel and his fiancée Renee Kline that may be the most iconic image of the legacy of the Iraq War on U.S. soldiers and civilians alike. The photograph was made on assignment for *People* magazine; although never published there, it gained prominence after being selected for a World Press Photo award. In the image, Ziegel, after nineteen surgeries, his facial features nearly missing on melted skin, stands in his dress uniform next to his high-school sweetheart, Renee, nearly twenty-one, wearing her wedding dress and looking somewhat stunned; having waited for someone who looked quite different from this man to come back to her, she holds a red bouquet.

There are many other documentary projects concentrating on the soldiers themselves, particularly on those who have been severely injured or killed. Unlike the constricted position of the "embed" overseas, domestically there is more freedom for a photographer to circulate and, presumably, a sense that their fellow citizens may better grasp certain of the wars' legacies through their impact on U.S. soldiers and their families.[40] Ashley Gilbertson's "Bedrooms of the Fallen" combines images of the rooms of soldiers who have died with information about what happened to them; Andrew Lichtenstein's "Never Coming Home" documents their funerals in both a book and a piece on MediaStorm (created with Zac Barr and Tim Klimowicz). Eugene Richards's *War Is Personal,* published in 2010, explores rage, depression, injuries, and death in the profoundly disrupted lives of fifteen veterans and their families. The book ends with a searing afterword from Dr. Andrew J. Bacevich, a former career officer in the U.S. Army and a critic of America's occupation of Iraq, where his own son, also an Army officer, was killed:

> To lose your only child in a war is to have a gaping hole torn in the center of your life. The wound is irreparable. I have given up trying to make sense of it all. I am unable to distinguish between "senseless" death and death that occurs to advance some "good cause." In the political realm, blighted with fraudulence and immodesty, I find myself hard-pressed to make the case that good causes even exist for war. Those who disagree—keen to succor the afflicted or to advance the cause of freedom in some dismal land on the far side of the globe—mostly propose to do so by sending someone else's kid into harm's way. To which I say: send your own kid.[41]

A focus on the fates of specific soldiers may also offer a way to circumvent the glamour of war, if there is such a thing. This is not a new idea. In June 1969, *Life* magazine showed simple identity photographs of the 263 American soldiers killed in one week in Vietnam, a war that had been distinguished by some of the most varied and difficult images of conflict ever made. The magazine's managing editor, Ralph Graves, later remarked that "in his remaining tenure as editor he had never run anything as important or powerful."[42] (The project foreshadowed Maya Lin's similarly stark Vietnam War Memorial.)

In an Internet update of this idea, the *New York Times'* ongoing visual database "Faces of the Dead" shows identity-style photographs of American war casualties (page 94). Here one can click on one of thousands of pixel-like squares to call up an image of a U.S. soldier killed in Iraq or Afghanistan; the thousands of dead are all contained implicitly within the same rectangle, all made to seem part of a single body. One can also search for the war dead by last name, hometown, or home state. Along the same lines, the *Washington*

Post publishes "Faces of the Fallen" (which is, according to their website, updated at least weekly), with photographs from news services, local newspapers, and family members.[43] (It would be a worthy project to try and depict casualties fighting on the other side in Iraq and Afghanistan in such a manner, as well as civilian deaths, or those killed and injured in the never-ending "war on terror," or the swelling numbers of Americans dead due to gun violence.)[44]

At times a less emotionally engaged, more clinical approach may indeed be preferable to expose the gravity of a situation, especially the enormity of disasters, crime scenes, and the like where any other graphic device might seem unworthy. George Rodger famously gave up war photography after he found himself, at the end of World War II, "getting the dead into nice photographic compositions" at a newly liberated concentration camp, not able to live with the confluence of satisfactory aesthetics and horror.[45] Gilles Peress, who also photographed mass graves, responded indirectly to Rodgers's conundrum, and that of many others, when comparing himself (as we have discussed) to a police photographer whose "work is much more factual and much less about good photography. I'm gathering evidence for history, so that we remember."[46]

In a less-adorned space that relies more upon the vision of the camera lens itself, the hyperbolic style of much editorial photography is avoided. It is a contributing reason why matter-of-fact photographs from official archives of police departments, science labs, and government agencies can be particularly illuminating. Unpretentious in their banality, they can at times more effectively penetrate a viewer's defenses than imagery that has been made intentionally to shock, horrify, or even to create empathy—like the SS photographs of massacres during World War II, or the identity photographs of Cambodians about to be executed under Pol Pot.

Some photographers of conflict, like those on Basetrack, prefer to embrace other, more populist styles, using cellphones and apps rather than conventional cameras. Benjamin Lowy (who received the ICP Infinity Award for Photojournalism in 2012) and *New York Times* photographer Damon Winter, for example, have been recognized for their use of cellphones with Hipstamatic apps to give a more intimate, at times almost nostalgic look at the lives of soldiers and the conflicts around them. Many in the photojournalistic community deride their approach for trivializing or stylizing war, making the photographs less transparent while emphasizing the mediation itself— and as a consequence, acknowledging the photographers' idiosyncratic authorship (or, one might counter, giving the lie to the delusion of "photographic objectivity"). Jean-François Leroy, head of the annual Visa pour l'Image photojournalism festival in Perpignan, told the *British Journal of Photography*: "As long as you don't have control over the image, I don't believe it has any value. No one can pretend that the photographer retains control over his images when using Hipstamatic. I find that this type

of application tends to standardise photography—you're not shooting your image, you're shooting a Ben Lowy image."[47]

Magnum's Christopher Anderson's take differs from Leroy's. As he said to the *British Journal of Photography* in 2012, the app provides

> a visual language that makes sense to a new generation. And perhaps, what us old guys see as real photography is just an outdated visual language that cannot communicate the reality of Syria today because it is just too exotic to a certain generation of viewers. Most of the discussion I have heard around the Hipstamatic phenomenon in the war zone seems to centre on how these photographers are aestheticising war with their iPhones. But I think it could be argued that they are doing just the opposite. They are making photographs less sophisticated in order to better communicate to an audience to whom photographer's photography just doesn't translate. And maybe all of us purists are really just the old-guard that doesn't get what these kids are up to these days.[48]

Others have moved toward more classic, even antique traditions, making static, imposing images that have more of a sense of ritual and of duration than the fractional second of the shutter's release often allows. Consider, for example, Luc Delahaye's "History" series, which envisions events usually treated as transient with a more formal importance, or Simon Norfolk reimagining the photographs by nineteenth-century British photographer John Burke, while retracing his journey in Afghanistan. (There is much to learn from nineteenth-century war photographers such as Felice Beato and Roger Fenton—particularly their ways of exploring the aftermath of battles as a means of establishing conflicts' import; they were technically unable, of course, to photograph the action itself.) Norfolk is adamant about the need to understand the history of Afghanistan's long struggle with colonialism in order to begin to comprehend what is going on today. Photojournalists, in his view, generally come up with images limited to particular actions rather than trying to explore the specificities of Afghan culture—including a tradition of intense resistance to foreign invaders, and, among many other less-told stories, the emerging field of "narcotecture," the "poppy palaces" built with vast amounts of drug money.

Artists Adam Broomberg and Oliver Chanarin have taken perhaps the most conceptual approach. Embedded with British troops in Iraq, they refused to accept the constricted role of embeds forced to work under the authority of the military; instead, they simply exposed their much-traveled photographic paper to the sun. The Broomberg-Chanarin collaboration, and the photographs of distant spy satellites and secret military bases by Trevor Paglen, share ground with Ariella Azoulay's 2010 series "Unshowable Photographs/Different Ways Not to Say Deportation." For this project,

discussed earlier, Azoulay created drawings of photographs from the early years of the Israel-Palestine conflict—the International Committee of the Red Cross had forbidden her to exhibit the actual prints—that remind readers of how much remains largely invisible due to various filters at work. (In our era of Wikileaks, however, this may not be very surprising.)

The Photographer: Into War-Torn Afghanistan with Doctors Without Borders is Emmanuel Guibert's graphic novel/photo-journal documenting photographer Didier Lefèvre's harrowing trip into Afghanistan in 1986, while the country was under Soviet occupation. (First published in France as the three-volume *Le Photographe* between 2003 and 2006, the book appeared in English in 2009.) Next to a simple black-and-white photograph of a man walking, the text reads: "We cross the pass at night. We stop on the side of the mountain, in ruins that more or less shelter us. We huddle against the old stones, after having shared a hard-boiled egg among ten people." The next frame is a color drawing of a man huddled in a blanket: "By dawn we all feel as stiff with cold as the horse's corpse we saw the day before." The story unfolds, intensifying the photographs' meanings, while their straightforward presentation in turn grounds the drawings.[49]

Using only documentary photographs, Gilles Peress's *The Silence*, on the 1994 genocide in Rwanda, also used a fictional device, imputing an entire book's worth of images recounting a legacy of horror, presented clinically as evidence, to the memories of one man accused of war crimes. The volume, divided into three sections—"The Sin," "Purgatory," and "The Judgment"—opens with the following words, laid out like lines of poetry: "rwanda/kabuga 27 may 1994/16h:15/a prisoner, a killer is presented to us,/ it is a moment of confusion, of fear,/of prepared stories./he has a moment to himself." Then we see the first photograph in the book: a man staring straight ahead. Reaching the last page of the book, 150-some pages later, we are again presented with an image of this man, now looking at the camera—only three minutes have passed: "rwanda/ kabuga 27 may 1994, 16h:18/ as I look at him he looks at me."[50]

Of course, now much of the photography of war is being made by people who are in the midst of the fray. "Photographs by Iraqi Civilians, 2004" a project initiated by the Daylight Community Arts Foundation, was a comparatively small-scale attempt to show the Iraqi people through their own photographs. (For examples of this work, see photos by Hamed Hasan Salman and Ahmed Dhiya on page 95.) Made with only ten disposable cameras (distributed by an Iraqi), images that resulted include a visit to the dentist, a student at the university, children playing, road workers, and a man and wife who named their child Amerika. Rather than showing a society dominated by bombs and fanaticism, the imagery, presented with captions in Arabic and English, allowed

viewers a nearly banal, if at times surprising, realization of the common humanity of others. The project, curated by Ambreen Qureishi and myself a year after the U.S. invasion, was exhibited in New York (and coincided with the 2004 Republican National Convention in the city). The small exhibition led to "Photographs by Iraqi Civilians" being featured on CNN worldwide, showing how a marginal, relatively inexpensive project can sometimes fill a void to which mainstream media, due to problems of language, culture, and oftentimes danger, may have little access.[51]

It is, however, the soldiers themselves who have made many of the images that define contemporary war, including some of the most brutal and controversial—from the infamous photographs made at Abu Ghraib prison to other examples of soldiers posing with dead bodies and body parts, or urinating on the corpses of Taliban fighters. There are also many more everyday images of troops exercising, engaged in wrestling matches, and helping civilians—from handing out free schoolbags and soccer balls to posing with smiling families. Many U.S. soldiers keep their own families and friends updated on their daily lives with personal blogs. Some of the imagery was published in *This Is Our War: A Soldiers' Portfolio, Servicemen's Photographs of Life in Iraq*, which first appeared as a portfolio in the magazine *GQ*, and then as a 2006 book, after tens of thousands of photographs were collected from an open call; the project was initiated by journalist Devin Friedman. In film, *Bad Voodoo War*, a 2007 production by Deborah Scranton, is based upon video captured by soldiers of the National Guard in Iraq, each of whom was given a camera by the director.

For *This Is Our War*, the decision was made not to use the "trophy" images submitted, which were judged too grotesque for publication. But many horrifying "trophy" photographs made by soldiers have been published online. One conceivable rationale for this is the precedent set by Ernst Friedrich's *Krieg dem Kriege!/War Against War!*, published in Germany in 1924 as a ferocious and shocking (but ultimately unsuccessful) protest against violence, including nightmarish images of soldiers disfigured in battle (Friedrich also founded the Antikriegsmuseum—the antiwar museum—in Berlin, which was shut down by the Nazis in 1933 and reopened in 1982). But one suspects that pacifism is not the driving force behind all such efforts. One notorious site, Nowthatsfuckedup.com, for a time offered free access to pornography in return for posting soldiers' imagery from the war, much of it grisly. In 2004 the site's webmaster, Chris Wilson, whose idea was to post photographs that people sent in of wives and girlfriends having sex, and later of nude female soldiers (the Pentagon subsequently blocked access to his site from military facilities in Iraq), created a barter system for soldiers—he is alleged to have had tens of thousands of customers in the military— who were unable to access pornographic pictures due to problems with their credit cards being rejected.

"U.S. Soldiers Swap Gore for Porn," an outraged, eloquent response to this endeavor, by Chris Thompson, was published in *East Bay Express* (Oakland, California) in 2005. It might be read as a response to Sontag's 2003 claim that no photographs (other than a single work by Jeff Wall) make an antiwar statement: "No one can stop soldiers from posting pictures of eviscerated corpses for all to see," writes Thompson, "and no one should ever again be able to feign ignorance of war's human cost." He concludes: "Americans have thousands of media outlets to choose from. But they still have to visit a porn site to see what this war has done to the bodies of the dead and the souls of the living." (The site was, in fact, subsequently closed down by the government in Florida: would-be users are now redirected to the Polk County Sheriff's office and the message "The Polk County Sheriff's Office now maintains this URL to prevent further transmission of obscene material.")

Thompson's arguments may also serve to provoke a discussion on the pros and cons of citizen journalism, as well as on the expanding visual culture of violence:

> At Wilson's Web site, you can see an Arab man's face sliced off and placed in a bowl filled with blood. Another man's head, his face crusted with dried blood and powder burns, lies on a bed of gravel. A man in a leather coat who apparently tried to run a military checkpoint lies slumped in the driver's seat of a car, his head obliterated by gunfire, the flaps of skin from his neck blooming open like rose petals. Six men in beige fatigues, identified as U.S. Marines, laugh and smile for the camera while pointing at a burned, charcoal-black corpse lying at their feet.
>
> The captions that accompany these images, which were apparently written by soldiers who posted them, laugh and gloat over the bodies. The person who posted a picture of a corpse lying in a pool of his own brains and entrails wrote, "What every Iraqi should look like." The photograph of a corpse whose jaw has apparently rotted away, leaving a gaping set of upper teeth, bears the caption "bad day for this dude." One person posted three photographs of corpses lying in the street and titled his collection "DIE HAJI DIE."[52]

Thompson cites the Chairman of the Joint Chiefs of Staff Richard Meyers's argument that releasing the full selection of images of the abuse of prisoners at Abu Ghraib would only serve to enrage the Muslim world, and would propel many to join al-Qaeda. "But none of these," writes Thompson, "can compare with the prospect of American troops casually bartering pictures of suffering and death for porn."

Thompson also includes a defense of these photographs by one soldier, who argues that their enemies might be "taught a lesson" via an image war: "I had just finished watching the beheading of one of our contractors that was taken hostage over in Iraq," the soldier reports. "I figured since that was all over the Web, maybe these pictures

would make some potential suicide bomber think twice after seeing what happens AFTER you pull the pin." The soldier concludes: "I will not defend the people who have posted pictures of dead, innocent Iraqis, but in my opinion, the insurgents/terrorists that try to kill us and end up getting killed in return have absolutely no rights once they are dead."[53]

The reader, it seems, has descended far deeper into the hell of war than professional media will almost ever permit.

But there are also soldiers who, despite war's destructiveness, can illuminate their own thoughts and feelings in much more complex ways, placing their experiences on a spectrum that bridges sentiments less foreign to the civilian. Benjamin Busch, who was twice deployed to Iraq as a Marine Corps officer, writes of his own responses, and of a moral imperative that emerges from the photograph:

> I remember taking one photograph in Ramadi, my only battle or aftermath photograph though I could have taken many I suppose. It was to try to remember the conditions for what I felt, and later to see the conditions and remember the feeling. My friend had just been killed and his body bag lay beside his burning vehicle. We could not put it out and he was much smaller in the bag than he had been moments before. We hadn't been able to get his dead gunner out from underneath the wreckage yet and the sun was going down, the shooting over. We had lost whatever it was we had been fighting, never knew it was waiting for us, not sure now what it was even about. I was waiting for a military tow truck to lift the ruin and free the body and there was a long pause where we were left with nothing but dust, fire, and loss and I took a picture. . . . In one more minute it would have been my vehicle, my death. I may have taken the image as a kind of exploration, premonition, and escape from my own demise. A proof of life in that I was not, myself, in the photograph. That is what I would have looked like. Small, charred and left in a black bag with some of my uniform melted to me, my legs severed. I still haven't written to his wife. I show the image in my exhibit sometimes, although I have refused to sell it, with its victims nameless. It is context for all of my war images. So I don't know anything, really. Just that photographs can be observers too. They can sometimes watch us.[54]

The question, then, of how to combine all these photographs by both observers and participants alike, in order to try to better explain what is going on, raises perhaps the most urgent challenges confronting the digital media revolution: who, or what, acts as filters, and how is such filtering accomplished, and how transparent can it be? A harrowing barrage of the grotesquely dead will succeed neither in explaining war nor in condemning it, and once seen those kinds of images are difficult to show again to viewers who have previously been summarily repulsed. Nor is it sufficient to show the conflict as being implemented according to some mythic abstractions. In either case, the reader's role

as citizen is severely compromised: he or she is disconnected from the swirl of events, reduced to a mere voyeur—and war seems to be fought as if on another planet.

The approaches in the projects described above may not yet constitute an effective resistance to war, but they are on their way to creating enough alternative perspectives to delegitimize much of war's seductive excitement. The enormous, persistent reservoirs of pain that these sustained endeavors evoke may bind them as effective counterweights to war's glorification. They provide viewers with more intimate spaces in which to grieve, to understand something about those involved—on all sides—as individuals, to see them as members of families and neighborhoods, to understand that pain is both physical and psychic, and to begin to grasp how we all have been changed by our society's large-scale preoccupations with violence. In the United States, where there is no draft and wars are fought by a small minority, these images encourage others to engage in a calculus in which the meager accomplishments of such conflicts can be held up against the wanton devastation that remains. Through many of these images war has, in a sense, managed to come home.

There are also numerous photographers who continue to believe that the graphic, confrontational, often excruciating imagery of war's battlefront constitutes a statement against it, even if the results are not immediate. James Nachtwey, for example, one of the premier photographers of conflict of the last few decades, has described his own motivation: "I was driven by the idea that a picture that revealed the true definition of war would be an anti-war photo. . . . Images fueled resistance because they not only reported history but also changed history. When an image enters our collective conscience, change [becomes] possible and inevitable."[55]

A problem, as always, is what kind of change? And how inevitable? If the change is positive, how can we speed it up? How can we, in the best circumstance, strive to make images that might even help to diminish, or avoid, a conflict in the making?

NOTES

1. Charles Baudelaire, from "The Salon of 1859," first published in the *Revue française* (Paris), June 10–July 20, 1859; cited in *Charles Baudelaire, The Mirror of Art*, ed. and trans. by Jonathan Mayne (London: Phaidon, 1955).

2. This was the focus of my previous book, *After Photography* (New York: Norton, 2008).

3. Andrea Tantaros, *Fox News*, October 9, 2008, cited in "Sarah Palin: *Newsweek* Criticised for Unflattering Cover," *Telegraph* (London), October 10, 2008. http://www.telegraph.co.uk/news/worldnews/sarah-palin/3171956/Sarah-Palin-Newsweek-criticised-for-unflattering-cover.html.

4. See, for example, Joan Fontcuberta's *Datascapes: Orogenesis/Googlegrams* (Seville, Spain: PhotoVision, 2007).

5. John Szarkowski, *Mirrors and Windows: American Photography since 1960* (New York: Museum of Modern Art, 1978).

6. George Rodger, from a letter to his eight-year-old son, Jonathan, in Chris Boot, *Magnum Stories* (London: Phaidon, 2004).

7. Simon Norfolk, quoted in Geoff Manaugh, "War/Photography: An Interview with Simon Norfolk," "BLDG" blog, November 30, 2006. http://bldgblog.blogspot.com/2006/11/warphotography-interview-with-simon.html.

8. See stephenferry.com.

9. See the Guatemalan market image at http://gigapan.com/gigapans/5.

10. Luminate (luminate.com) is one company that has begun "making images interactive," as the website puts it, so that as a viewer moves a cursor across a photograph the hidden metadata come to the surface. This function is being used by a number of advertisers and celebrity publications; a partnership with Getty Images was announced in January 2013.

11. Martin Buber's *Ich und Du* was first published in German in 1923, and in English as *I and Thou* in 1937, trans. by Ronald Gregor Smith (Edinburgh: T. & T. Clark).

12. Polish artist Zbigniew Libera did, in fact, create a "spin" on Ut's famous photograph with the 2003 image *Nepal*, from his series "Positives." In Libera's image, among many other modifications from Ut's original, Kim Phúc has been replaced with a laughing, nude Caucasian woman.

13. Nick Ut, in "'Napalm Girl' Photo from Vietnam War Turns 40: David Ono Hosts Special, 'Witness: Power of a Picture,'" KABC-TV, Los Angeles, June 12, 2012. http://abclocal.go.com/kabc/story?section=news%2Fworld_news&id=8686842.

14. Horst Faas and Marianne Fulton, "How the Picture Reached the World," *Digital Journalist*, n.d. http://digitaljournalist.org/issue0008/ng4.htm.

15. "Kim Phuc, 'Napalm Girl' in Iconic Vietnam War Photo, Discusses Life-Changing Moment," KABC-TV, Los Angeles, May 8, 2012. http://abclocal.go.com/kabc/story?section=news/world_news&id=8654265.

16. Phúc, quoted in ibid.

17. Jim Nolan, quoted in ibid.

18. Aileen Smith, quoted in Jim Hughes, "Tomoko Uemura, R.I.P.," *Digital Journalist*, 2000. http://digitaljournalist.org/issue0007/hughes.htm. Hughes is author of the 1989 biography of W. Eugene Smith, *Shadow and Substance: The Life and Work of an American Photographer* (New York: McGraw-Hill, 1989).

19. Yoshio Uemura, quoted in Hughes, "Tomoko Uemura, R.I.P."

20. Aileen Mioko Smith, "The Photograph: *Tomoko and Mother in the Bath*," AileenArchive.or.jp, July 5, 2001. http://aileenarchive.or.jp/aileenarchive_en/aboutus/aboutphoto.html.

21. "Watching Syria's War," ed. by Liam Stack, NYTimes.com, ongoing and updated regularly. http://projects.nytimes.com/watching-syrias-war. Another recent effort to "separate news from social media noise" is Storyful (storyful.com), which bills itself as "the first news agency of the social-media age."

22. John Branch, "Snow Fall: The Avalanche at Tunnel Creek," *New York Times*, December 23, 2012 (print). http://www.nytimes.com/projects/2012/snow-fall/#/?part=tunnel-creek.

23. Keith Smith, in his *Structure of the Visual Book* (first published in 1984, now in its fourth edition), gives a wonderful example of how a drawing of a woman *preceded* by a drawing of a knife, and then the same drawing of her *followed* by that of the knife, have two very different meanings: when the knife is shown first, it is a woman who may soon be stabbed from behind; when the knife follows, this is a woman getting ready to prepare a meal.

24. From Sophie Calle's *L'Homme au carnet/The Address Book*, 1983. The project was first published in serialized form in the newspaper *Libération* over the course of a month in August–September 1983. *The Address Book* was published in its entirety in English by Siglio in 2012.

25. Wim Wenders, in Markus Weckesser, "Interview with Wim Wenders: A Sense of Place," *Foam*, Summer 2012.

26. Susan Sontag, *Regarding the Pain of Others* (New York: Farrar, Straus and Giroux, 2003).

27. See Christie's New York, "Post-War and Contemporary Art" auction (lot 27), May 8, 2012. http://www.christies.com/lotfinder/photographs/jeff-wall-dead-troops-talk-5559203-details.aspx.

28. Alfredo Jaar, in *Camera Austria*, 2004, referenced in Guy Lane, "Alfredo Jaar: Picturing Silence," *Foto8*, August 19, 2008. http://www.foto8.com/new/online/blog/609-alfredo-jaar-picturing-silence-.

29. Tim Page, quoted in Harold Evans, "Reporting in the Time of Conflict," *Newseum War Stories*, n.d. http://www.newseum.org/warstories/essay/romance.htm.

30. Brian Stelter, "Media Decoder: Among Top News Stories, a War Is Missing," *New York Times*, December 30, 2012. http://mediadecoder.blogs.nytimes.com/2012/12/30/among-top-news-stories-a-war-is-missing/. "The Pew Research Center, which polls the public's interest in news stories weekly, asserted that there was so little interest in the overseas conflicts that they were not represented in their list of the year's top 15 stories."

31. See "Debate com Balazs Gardi" at https://www.youtube.com/watch?v=amHQEmsH_Uw.

32. Teru Kuwayama, quoted in Michael Kamber, "Covering Marines at War, Through Facebook," *New York Times* "Lens" blog, December 21, 2010. http://lens.blogs.nytimes.com/2010/12/21/covering-marines-at-war-through-facebook/.

33. Cited in Cory Bergman, "Everybody's a Journalist on Basetrack's Facebook Page," LostRemote.com, December 28, 2010. http://lostremote.com/everybodys-a-journalist-on-basetracks-facebook-page_b13832.

34. PixelPress is an organization founded in 1999 that has collaborated with various humanitarian organizations (on such projects as the campaign to end polio and another supporting the Millennium Development Goals), as well as hosting a website with a range of documentary projects. I am its cofounder with Carole Naggar, and its director.

35. Hetherington and journalist Sebastian Junger made a feature-length documentary film of their experiences there, *Restrepo* (2010).

36. Hetherington's film *Diary* may be seen in its entirety online; it is accessible at http://inmotion.magnumphotos.com/essay/diary-host.

37. Suzanne Opton, from an interview with Jim Casper, LensCulture.com, n.d. http://www.lensculture.com/opton.html.

38. Mike Sprouse, quoted in Jennifer Karady's "Soldiers' Stories from Iraq and Afghanistan," http://jenniferkarady.com/soldier_stories1.html.

39. Riley Sharbonno, quoted in Monica Haller, *Riley and His Story* (Paris and Värnamo, Sweden: Onestar Press/Fälth and Hässler, 2009/2011).

40. See for example *Unembedded* (White River Junction, Vt.: Chelsea Green, 2005), a group project by four independent photographers (Kael Alford, Rita Leistner, Thorne Anderson, and Ghaith Abdul-Ahad, the last a deserter from the Iraqi army when Saddam Hussein was in power). The project concentrates on issues in Iraqi society that would have been difficult to explore photographically while embedded. Lori Grinker's book *Afterwar: Veterans from a World in Conflict* (New York: de.Mo Design Limited, 2005) is an important multiyear exploration in many countries of the damage that people endure after wars are over. See also the various projects produced with grants from the Aftermath Project to photographers who reveal, as their website puts it, "the other half of the story of conflict—the story of what it takes for individuals to learn to live again, to rebuild destroyed lives and homes, to restore civil societies, to address the lingering wounds of war while struggling to create new avenues for peace." http://www.theaftermathproject.org/.

41. Andrew J. Bacevich, afterword, in Eugene Richards, *War Is Personal: A Chronicle of the Human Cost of the Iraq War* (Long Island City, N.Y.: Many Voices, 2010).

42. David Halberstam, *The Powers that Be* (Champaign: University of Illinois Press, 2000).

43. "Faces of the Dead," NYTimes.com, ongoing. http://www.nytimes.com/interactive/us/faces-of-the-dead.html#/. "Faces of the Fallen," WashingtonPost.com, ongoing. http://apps.washingtonpost.com/national/fallen/.

44. One important mapping project concentrating on civilian deaths is *RedEye*'s ongoing "Homicide Map of Chicago." http://homicides.redeyechicago.com/date/2012/12/.

45. George Rodger, cited in Fred Ritchin, "What Is Magnum?," in *In Our Time: The World as Seen by Magnum Photographers* (New York: Norton, 1989).

46. Gilles Peress, quoted in *U.S. News and World Report*, October 6, 1997. The larger quotation is cited in chapter 2 of this volume.

47. Jean-François Leroy, quoted in Olivier Laurent, "Photojournalism Foundation Uncertain after Hipstamatic Lays Off Staff," *British Journal of Photography*, August 20, 2012. http://www.bjp-online.com/british-journal-of-photography/news/2199714/photojournalism-foundation-uncertain-after-hipstamatic-lays-off-staff. A new Hipstamatic "GoodPak" digital filter for photojournalists, developed with Lowy's input, was said to be in the works, but given financial instability, Hipstamatic's future plans are less clear.

48. Christopher Anderson, quoted in Olivier Laurent, "What Will the Hipstamatic Foundation for Photojournalism Do for the Industry?," *British Journal of Photography*, July 25, 2012. http://www.bjp-online.com/british-journal-of-photography/news-analysis/2194232/what-will-the-hipstamatic-foundation-for-photojournalism-do-for-the-industry.

49. Emmanuel Guibert and Frédéric Lemercier, *Le Photographe*, 3 vols. (Paris and Marcinelle, Belgium: Dupuis, 2003–6); in English as *The Photographer: Into War-Torn Afghanistan with Doctors Without Borders* (New York: First Second, 2009).

50. Gilles Peress, *The Silence* (New York: Scalo, 1995).

51. See also Geert van Kesteren, *Baghdad Calling: Reports from Turkey, Syria, Jordan and Iraq* (Rotterdam: Episode, 2008). In this project van Kesteren combines his own photographs with hundreds of cellphone and digital photographs by Iraqi refugees.

52. From Chris Thompson, "U.S. Soldiers Swap Gore for Porn," EastBayExpress.com, September 28, 2005. http://www.eastbayexpress.com/ebx/us-soldiers-swap-gore-for-porn/Content?oid=1079165.

53. Ibid.

54. Benjamin Busch, e-mail message to the author, January 6, 2010. As a commentary on nineteenth-century photographer Felice Beato's images of war, a slightly longer version of Busch's statement was published in Fred Ritchin, "Felice Beato and the Photography of War," in Anne Lacoste, *Felice Beato: A Photographer on the Eastern* Road (Los Angeles: J. Paul Getty Museum, 2010).

55. James Nachtwey, quoted in Sophia Johnston, "Nachtwey Discusses War Photography," *Dartmouth,* April 26, 2012. http://thedartmouth.com/2012/04/26/news/nachtwey.

PLATES

Cover and opening pages of *Rolling Stone*, issue no. 224, October 21, 1976.
"The Family," featuring sixty-nine portraits by Richard Avedon, opened
with *John DeButts, Chairman of the Board, AT&T, New York City.*

Gilles Peress, cover and pages from the publication *Telex Iran: In the Name of Revolution* (Aperture, 1983)

James Balog, (left) *Trift Glacier, Switzerland, 2006*; (right) *Trift Glacier, Switzerland, 2011*, both from the series "Extreme Ice Survey"

James Balog, (left) *Trient Glacier, Switzerland, 2006*; (right) *Trient Glacier, Switzerland, 2011*, both from the series "Extreme Ice Survey"

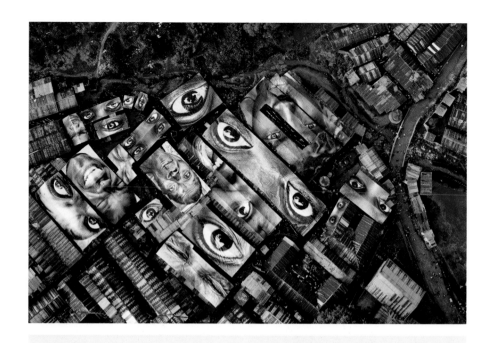

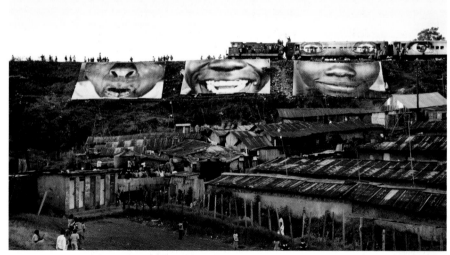

JR, (top) *Action in Kibera Slum, Rooftops View, Kenya,* 2009;
(bottom) *Action in Kibera Slum, Train Passage 1, Kenya,* 2009, both
from the series "28 Millimeters, Women Are Heroes"

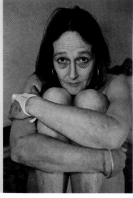

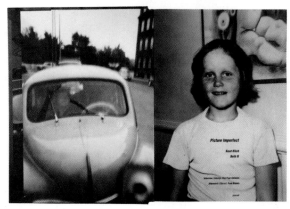

Cover and pages from the publication *Picture Imperfect* by
Kent Klich with Beth R. (Journal, 2008)

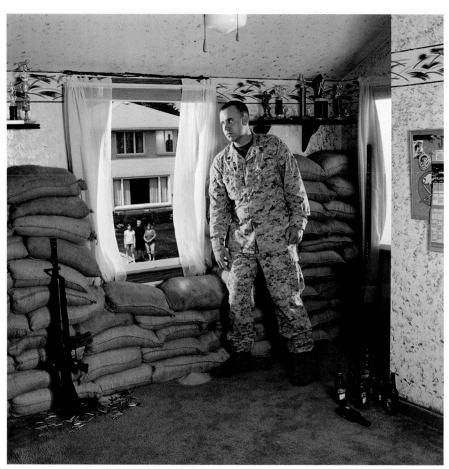

Jennifer Karady, *Former Sergeant Jeff Gramlich, U.S. Marine Corps Infantry, 3/6 Lima Company, veteran of Operation Iraqi Freedom and Operation Enduring Freedom, with parents, Eileen and Larry, and sister, Jackie; Buffalo, NY, from the series "Soldiers' Stories from Iraq and Afghanistan,"* 2011

James Reynolds, 2008, from the series "Last Suppers"

Celia A. Shapiro, (top left) *Harry Charles Moore—05/16/97*; (top right) *John Rook—09/19/1986*; (bottom left) *Timothy McVeigh—06/11/2001*; (bottom right) *Larry Wayne White—05/22/1997*, all from the series "Last Supper," 2001

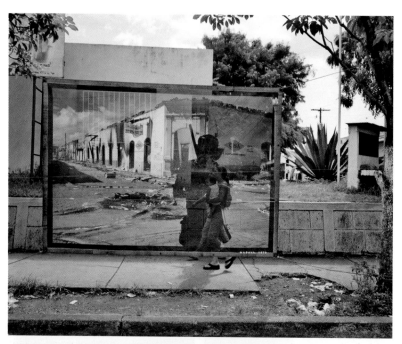

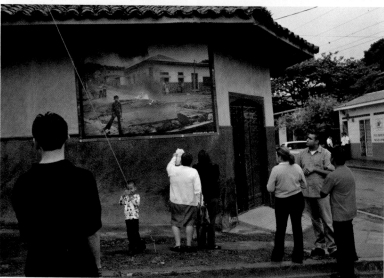

Susan Meiselas, (top) *Nicaragua. Masaya. July 2004.*;
(bottom) *Nicaragua. Matagalpa. July 2004.* Both from the project "Reframing History," Nicaragua mural project installation based on original photographs taken in 1978 of the popular insurrection against the Somoza regime

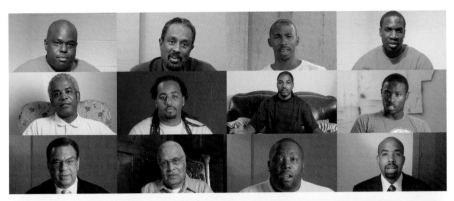

Chris Johnson, Hank Willis Thomas, Bayeté Ross Smith, and Kamal Sinclair, (top) digital still, 2012; (bottom) five-channel video installation view, Oakland Museum of California, January 21–July 8, 2012, both from the project "Question Bridge: Black Males"

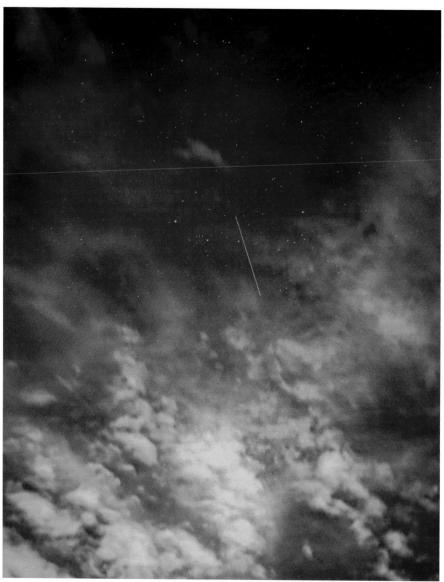

Trevor Paglen, *KEYHOLE 12-3 (IMPROVED CRYSTAL) Optical Reconnaissance Satellite Near Scorpio (USA 129)*, 2007

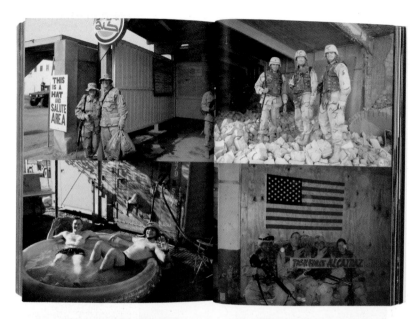

Well, his assistant manager was his best friend. So, here's this other Iraqi contractor who had been very sympathetic to our cause. He and his family had been beat up pretty bad under Saddam's government and he was putting his life on the line, too, to work for us.

But now we killed his best friend. So every time we saw him, his eyes were bloodshot and you could see he was heartbroken and furious and confused. He was still super professional. But... It's got to be tough. If another country came to take over the U.S. and I was working for them here and they killed my best friend, it would be hard to be friends with them still.

Pages from the publication *Riley and His Story* by Monica Haller in collaboration with Riley Sharbonno. Photographs by Riley Sharbonno, 2003–4, designed in collaboration with Matthew Rezac (Onestar Press/Fälth & Hässler, 2011)

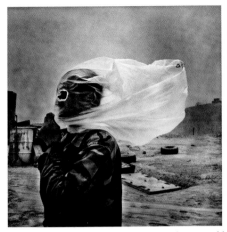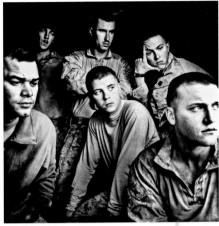

Balazs Gardi, (left) *An Afghan National Army soldier protects his face from a sudden dust storm at Combat Outpost 7171 in Helmand Province, Afghanistan, on October 28, 2010*; (right) *U.S. Marines attend a briefing prior to an upcoming military operation in Patrol Base Talibjan, Helmand Province, Afghanistan, on November 4, 2010*, both from the Basetrack project

Teru Kuwayama, (left) *U.S. Marines in Southern Afghanistan*, 2010–11; (right) *Untitled, Afghanistan*, 2010–11; both from the Basetrack project

Each United States service member who has died in Iraq or Afghanistan and has been identified by the Defense Department is represented in an interactive rectangle, "Faces of the Dead," in the online version of the *New York Times*, http://www.nytimes.com/interactive/us/faces-of-the-dead.html?_r=0#/copes_gregory_t.

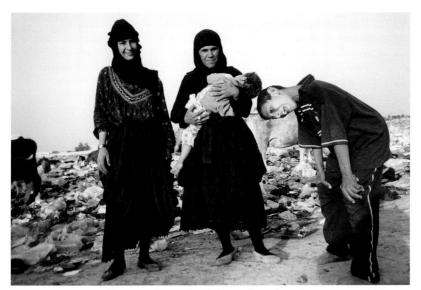

Hamed Hasan Salman, *Hamed Salman's family live in the garbage dump with more than 500 families. Every family has cows that live with them.* Baghdad, 2004, from the project "Photographs by Iraqi Civilians," initiated by Daylight Community Arts Foundation

Ahmed Dhiya, *Abd-Allah, an Iraqi child, is disabled and very sick . . . there is a device in his head to separate the blood from the fluid that collects in his head . . . there is an opening in his back . . .* Baghdad, 2004, from the project "Photographs by Iraqi Civilians," initiated by Daylight Community Arts Foundation

Gustavo Germano, (left) *Omar Darío Amestoy, Mario Alfredo Amestoy,*
1975; (right) *Mario Alfredo Amestoy, 2006,* both from the series "Ausencias"
(Absences), Argentina, 2006

Gustavo Germano, (left) *Roberto Ismael Sorba, Jorge Cresta, Azucena Sorba,*
1968; (right) *Jorge Cresta and Azucena Sorba, 2006,* both from the series
"Ausencias" (Absences), Argentina, 2006

Gustavo Germano, (left) *Maria Irma Ferreira, Maria Susana Ferreira,*
1970; (right) *Maria Susana Ferreira, 2006,* both from the series "Ausencias"
(Absences), Argentina, 2006

CHAPTER 4
Other Alliances

I

On September 11, 2001, anonymous men, invisible, saying nothing, self-immolating, took over our screens. Manipulating the press as many others had been doing long before, the hijackers acted almost as if according to a Hollywood plot in which they were playing the nefarious villains, blowing themselves up against the bluest skies. The sensationalized action-film fictions had become grotesquely real and, just like the hooded hostage-takers who had orchestrated the Munich massacres of 1972, these protagonists remained faceless, an anonymous, nearly spectral counterpoint to the Facebook era, with its proliferating identities, soon to come.

Read as if from a script, their attack on New York City's World Trade Center Towers could be viewed as an attack on the prerogative to expand and reproduce—the ambitious creation of a globalized world that, like the twinned towers themselves, was meant to replicate itself and impose its cloned values elsewhere.

An initial response to the attacks in the United States was to embrace symbols more consonant with the American way, not its globalized face. President George W. Bush's advice, as Thomas Friedman put it in the *New York Times*, was to tell "a few of us to go to war and the rest of us to go shopping."[1] The nonstop imagery of the burning buildings as a funeral pyre, on television screens everywhere, became a mantra from which some symbolic good would have to be rescued. Some of the most intimate grief was expressed on the small posters that sprouted seemingly everywhere from people searching for the missing—flyers that quickly became tattered on the walls and poles to which they were stapled. By comparison, an image of the symbolic raising of the American flag at the ruins of the World Trade Center seemed forced, too quickly asserted before the magnitude of the destruction had even begun to register.

The undergraduate students in my New York University documentary photography class in the fall of 2001 (many of whom lived in dormitories in the buildings' shadow) acknowledged when we met soon after that they had refused to make pictures on September 11—all of them felt the events of the day were so overwhelming and so awful that to photograph would have been to take advantage of the horror, and would serve to distance themselves; they wanted to be present, to feel what they were witnessing. One student did admit to making a few pictures, but only to look at decades later, she said, to remind herself that she had been there.

Did anyone else refuse to photograph? I asked the question months later of a group of Magnum photographers at a panel discussion I was moderating at a Manhattan bookstore. The photographers were then going to sign their new book, *New York: September 11*.[2] Burt Glinn, one of the older Magnum members in attendance, responded indignantly. We are photographers, after all, he said: our job is to go *toward* the tragedies that others flee.

The professionals, however, were of course by no means alone in turning their lenses toward the tragedy. Subjects of the news—numerous people who were directly affected by the attacks—had made their own imagery. Many displayed it in a vacant boutique on Manhattan's Prince Street, not far from the site of the Towers, in an exhibition/sale titled *Here Is New York: A Democracy of Photographs*, which opened just two weeks after the attacks. The images were printed and hung in the makeshift gallery on clotheslines, without any indication of who had made each one. Visitors could buy an ink-jet print of any photograph selected—they all cost twenty-five dollars—with the money going to help those victimized by the attacks. Not until paying at the cash register would the new owner find out who had authored the image—a professional, an amateur, a famous photographer, a fireman, a neighbor, a friend.

The image that was selected most frequently for purchase was a color photograph of the World Trade Towers when they were still standing, as seen from the air above, majestically rising through the clouds. (It was made by Katie Day Weisberger, a student at NYU, flying over the city in April 2001, months before the attacks.) A nostalgic memory prevailed of what *had been*, and not of what happened on September 11.

Rather than joining in the image wars, those who patronized *Here Is New York* thus made the choice of an older image showing the Towers as if in heavenly repose—a peaceful reflection on what was no more. It was a way to celebrate, and to mourn, what had been lost. The exhibition (later a book of the same name)[3] became a magnet for all kinds of New Yorkers to gather, to give each other support, and to grieve; without that personal contact and the charitable contributions endowing it with such a strong sense of purpose, the exhibition would have been less intimate, less sharply felt.

These images were made for the most part by New Yorkers, people whose lives would continue to be deeply affected by the events that they had photographed. One

New York Times staff photographer spoke at that time of how, coming home from covering conflicts elsewhere, he could always take a shower and leave the chaos behind; now, he said, there was no way to make a similar psychological escape. In that temporary gallery space the photographs became a memorializing family album made by and for those who had suffered.

This was in contrast to the more sensational, traumatizing imagery published widely in the press. The spectacular, repeating images of the explosions themselves, an almost continuous loop on television, as well as the pictures of people falling helplessly to their deaths, were particularly upsetting for many residents—one was no longer looking at the faraway "other" in the image, but at neighbors and friends; voyeurism was not an option. (*Here Is New York* provokes a question: might we cover more conflicts, both domestic and foreign, as "family albums" of sorts, so that their impacts on the entire social fabric are made manifest?) Rather than an angry response to an enemy, or a view from the outside of its most horrific aspects, the collective exhibition of work became part of an attempt to understand, to weep, and to remember—a similar impulse drove the "Not in Our Name" demonstrations enacted soon after by New Yorkers against possible revenge attacks by the United States government.[4]

At PixelPress's online publication we had made a similar call from our New York office for imagery and written texts in the days following the September 11 attacks, and put the contributions online. Many who responded were people watching from abroad, non-Americans, and their contributions from a distance were often more metaphorical, alluding to sadness and loss: a black-and-white image of an empty bench from a Swedish photographer, a sequence of photographs of only dust from an Israeli photographer, a picture of someone looking at a tourist postcard of the World Trade Towers from a Guatemalan, numerous posters of the missing that were animated as if by an eternal flame—this last was contributed by an American. A few weeks later we were inundated with images of American flags.

Trying to send out a message before the U.S. government began bombing Afghanistan soon after the attacks, we placed two formally similar, side-by-side images on our homepage: a photograph by Doug Kanter of a solitary figure in front of the World Trade Center ruins in lower Manhattan, next to one by Sebastião Salgado from Kabul of buildings destroyed as a result of its long wars, again with a solitary figure in front. While reminding viewers that the Afghan government was not responsible for the attacks, the photographs also suggested that there was little point in bombing a country that had already been devastated by violence. Several major media outlets linked to the homepage, although none made any similar comparisons.

A year later, on the first anniversary of September 11, we published a photograph of the Pentagon after it had been attacked, and a strikingly similar image of the government

headquarters in Santiago, Chile, after its attack—also on September 11, but in 1973—when the Socialist administration of Salvador Allende was violently overthrown. Our attempt was to use imagery to connect with tragedies in other parts of the world, in this case two that had happened on the same date but decades apart, both to empathize and to build links, rather than continuing to focus on U.S. victimization as unique.

The reluctance of other media outlets to contrast photographs in a similar manner may be a sign of a limited taste for visual adventure in the press, or a sign that such juxtapositions may be considered too politically charged—like John Heartfield's anti-Nazi collages of the 1930s. But it also makes it difficult to articulate nonlocal connections, which the Web and digital media accomplish so easily via links. Without the use of such juxtapositions it can be challenging to visually connect those in power with their policies, the 1 percent with the 99 percent, or the actions of one or more governments and their effects on the planet (global warming, for example). War is generally shown to us as occurring on the fields of battle, but is not shown originating in centers of power—governments, corporations, religious institutions, and so on. Each activity is seen in relative isolation, and those responsible are not held accountable.[5]

It is unlikely that most photographers would have access to situations as different as a corporate boardroom and a labor union's inner workings, or a candidate's inner circle of advisors and those who would be most affected by their policies. Philip Jones Griffiths's 1971 *Vietnam Inc.* is one of the few projects that undertook such contrasts, aided by his doggedness in photographing in Vietnam for two and a half years. In the book Griffiths positioned an image of a woman terribly disfigured by napalm alongside a portrait of a bomber pilot, for example, and inserted one of military planners with their computer printouts, as they attempted to conjure up reasons for optimism in a war that was clearly not progressing all that well. Now the locus of the battle may be thousands of miles away from the actual fray, in a complex in Colorado from which people routinely operate the drones flying halfway around the world, conducting surveillance and, at times, killing people. Or, as Simon Norfolk recently asserted, having photographed both literal battlegrounds and various war technologies, including a supercomputer that designs and models nuclear explosions: "That computer is as much a battlefield as a place in Afghanistan is, full of bullet holes."[6]

The iconography created by the American government to win people's hearts and minds post–September 11 utilized a cheaper symbolism. The flight-suited President George W. Bush prematurely declaring "Mission Accomplished" on an aircraft carrier, the orchestrated toppling of a statue of Saddam Hussein, and the U.S. president shown in Iraq holding a Thanksgiving Day turkey for the troops in a version of the Great Provider (even while the soldiers lacked adequate body armor and explosion-proof vehicles), all were perceived as strained attempts to impose new realities. They

followed Secretary of State Colin Powell's speech to the United Nations, showing aerial imagery that wrongly purported to reveal Iraqi weapons of mass destruction, in the effort to garner support for an invasion. Eventually the government's own image campaign—including the "embedding" of professional photojournalists with battalions and requiring them to sign contracts about when and where their images could be shown ("basically being like somebody's dog who is being taken out to Central Park for a walk around with the collar on," as Don McCullin sardonically put it)[7]—was upended by the bizarre partylike photographs by soldiers themselves of prisoners being tortured at Abu Ghraib prison, and other gruesome imagery made by members of the military.

It is curious, then, given the difficulties of waging an effective image war, that the U.S. government decided to withhold the photographs and videos that testified to the killing of Osama bin Laden, the mastermind of the September 11 attacks, a moment that was supposed to represent something of a resolution to a nation's pain. On May 4, 2011, President Barack Obama said: "It is important to make sure that very graphic photos of somebody who was shot in the head are not floating around as an incitement to additional violence—as a propaganda tool." He continued: "That's not who we are. . . . You know, we don't trot out this stuff as trophies. . . . We don't need to spike the football."[8]

The government's statement was remarkable in the history of images. The photograph once was used as proof for so many things—a school graduation, a wedding, becoming a parent, a crime, or a visit to the World Trade Towers. For many, the photograph was deemed more reliable than memory. But the president of the United States would not use a photograph to prove the death of Bin Laden, a man who had been hunted for a decade. House Intelligence Chairman Mike Rogers concurred with the president's contention that the photographs could complicate matters for U.S. troops serving in Iraq and Afghanistan. "The risks of release outweigh the benefits," Rogers said in a May 4, 2011, statement. And furthermore: "Conspiracy theorists around the world will just claim the photos are doctored anyway."[9]

Obama noted reassuringly: "Certainly there's no doubt among al-Qaeda members that he is dead. . . . And so we don't think that a photograph in and of itself is going to make any difference. There are going to be some folks who deny it. The fact of the matter is, you will not see Bin Laden walking on this earth again."[10]

If we are no longer of the opinion that "a photograph in and of itself is going to make any difference," then why make photographs? And if too contested, too inflammatory, too malleable, too questionable, too much part of an image war to be useful to the public as evidence of a very major event, what good are photographs, anyway?

II

There is another sector of society, however, that is enthusiastic about the ability of photographs to make a substantive difference. Numerous humanitarian organizations have in recent years incorporated a more extensive use of photography in getting their messages out and in engaging the public, with guidelines emphasizing the kinds of photographs that they think are effective and appropriate, particularly those that underline the dignity of their subjects. And many photographers, concerned about the feasibility of publishing work in the press—and if they do, to elicit a response that is helpful to those depicted—are grateful for the chance to collaborate with NGOs and other similar organizations.

Don McCullin's photographs of brutality and starvation in Biafra in the 1960s are considered a turning point in the growth of human-rights organizations: his work attracted the attention of Bernard Kouchner, a founder of Doctors Without Borders, the Nobel Prize–winning organization that was established after Kouchner and others went to Biafra to see for themselves the suffering there. According to Kouchner, it was McCullin's imagery that "marked the start of a collaboration between press and medics, without which humanitarian efforts are doomed to fail."[11] (There has also been considerable discussion about to what extent humanitarian organizations were cynically manipulated by Biafra's leadership, which was concerned more with personal aggrandizement than with curtailing their people's suffering, in what McCullin and others have characterized as a man-made famine.)[12]

McCullin's 1969 photograph foregrounding a starving albino Biafran child, the single image that had affected Kouchner so dramatically, was a milestone as well for the photographer, as was that entire day during which he encountered numerous children in terrible distress: "It was beyond war, it was beyond journalism, it was beyond photography, but not beyond politics," McCullin wrote in his 1990 autobiography, *Unreasonable Behaviour.*

> This unspeakable suffering was not the result of one of Africa's natural disasters. Here was not nature's pruning fork at work but the outcome of men's devil desires. If I could, I would take this day out of my life, demolish the memory of it. But like memories of those haunting pictures of the Nazi death camps, we cannot, must not be allowed to forget the appalling things we are all capable of doing to our fellow human beings. The photograph I took of that little albino boy must remain engraved on the minds of all who see it.[13]

Fifteen years later, Sebastião Salgado's 1984–85 work with Doctors Without Borders, covering the famine in the Sahel region of Africa, was a similarly influential moment in photographic advocacy. Working in Chad, Ethiopia, Mali, and Sudan, over the course of fifteen months (far more extensively than many journalists, who came for only days), Salgado created black-and-white imagery of those in refugee camps that was lyrical, dignified, and even romantic, for which the work was harshly condemned by a number of critics—an interesting twist, given the contemporary emphasis by NGOs on the dignity of those suffering. But his imagery was very useful to Doctors Without Borders in a variety of ways, including the raising of people's awareness as to the enormity of the crisis. In France, Salgado's *Sahel: L'Homme en détresse* (Man in distress) was published in 1986, and direct-mail proceeds went to Doctors Without Borders; it then appeared in Spain as *Sahel: El fin del camino* (The end of the road).

Although there was no publisher or exhibition venue at the time for the Sahel work in the United States (judged to be too depressing, it appeared as a book only twenty years later, in 2004, as *Sahel: The End of the Road*), the images were later featured in a major segment of a midcareer retrospective of Salgado's work titled *An Uncertain Grace*.[14] (The messenger had been elevated, if not the message.) I curated that 1990 exhibition, which originated at the San Francisco Museum of Modern Art; when it subsequently traveled to New York's International Center of Photography, Doctors Without Borders used the occasion to open their North American headquarters, and the organization's president, Rony Brauman, came from Paris to speak at the exhibition. (However, it was forbidden to put the telephone number of Doctors Without Borders on the wall at the New York exhibition for those who, having seen the distressing imagery, might want to be of some help; a telephone number, we were told by ICP, was not appropriate for a museum wall.)

Another group of images, by James Nachtwey, was also credited with bringing global awareness to famine, this time by the International Committee of the Red Cross. The ICRC had invited Nachtwey to come to Somalia in 1992, and the editors of the *New York Times Magazine*—although they had not assigned the work—decided to publish the photographs after seeing them. (This is a proactive, collaborative strategy that has been used with considerable success by many NGOs.) "We needed to find something to turn the tables," said Jean-Daniel Tauxe, a senior staff member of the ICRC. Tauxe argued that the photographs published in the *Times Magazine* "brought the immediate attention of the U.S. government, followed by the U.K., France, and the entire world. We enjoyed tremendous support and when months later the UN and UNOSOM . . . came to the rescue we could proudly say that 1.5 million people survived thanks to what is and will remain the largest ICRC operation since World War II. James's pictures made the difference."[15]

In his introduction to *Humanity in War*, a 2009 volume commemorating the 150th anniversary of the Red Cross, Nachtwey agrees that such collaborations are a major goal: "Although it has not always been regarded like this, the fact is that documentary photography and humanitarian work exist symbiotically: one of the primary functions of photography is to complement and support the work of humanitarian agencies."[16] Nachtwey, though, has some criticisms of the ICRC's relationship to photographers, writing that prior to the famine in Somalia it had often been "an uneasy one." He states:

> I can remember occasions when a request for access to a certain situation, or for information that might help point my work in the right direction, was coldly refused or received with thinly disguised hostility, as if photography would have somehow corrupted or diminished or endangered the work of the ICRC, rather than supported it. . . . There also seemed to be a sense that photographing a suffering person was, by definition, a form of exploitation, when in fact nothing could be further from the truth. There seemed to exist the proprietary notion that only the efforts of a humanitarian organization could possibly be of any benefit, as if creating mass awareness and mobilizing public opinion was without value.[17]

Jakob Kellenberger, the ICRC's president, argues on the organization's behalf that its "policy on photographing its work has always been determined by whether a photograph could help the victims of war and other situations of violence. Some of the sensitive work of the organization, such as visits to certain prisons or during prisoner exchanges, rules out the use of a camera."[18] Nachtwey notes, however, that the ICRC began to adopt a more flexible approach with the 1992 famine in Somalia, for two basic reasons: "First, there was no central authority to impose conditions on humanitarian organizations. Second, it was clear that when pictures were published, aid and funding were mobilized. . . . It had finally become accepted that photography was useful and in harmony with the goals of the ICRC."[19] Like other humanitarian organizations, apparently the ICRC understood that imagery by a respected professional could advance the organization's cause, especially given that the mainstream press could not be counted on to do the job.

There are many documentary photographers who agree with Nachtwey's assertion of the symbiotic relationship between their own work and that of such organizations. Working with NGOs is also thought to fill some of the vacuum (both moral and financial) left by the reduction of editorial assignments. In a 2008 article titled "NGOs to the Rescue," writer Judith Gelman Myers noted that the NGO sector was the eighth largest economy in the world—worth more than a trillion dollars a year[20]—but warned of some limitations: "As productive as collaborating with an NGO can be, it usually

means the photographer is working in the service of the NGO's specific goals, which can dictate where the photographer goes, what he or she shoots, and which images will ultimately be displayed."[21] There are also photographers who, alternatively, work on their own long-term projects—sometimes for years, cobbling together funding from various sources—whose work is then published by an NGO because it turns out to be in agreement with the organization's initiatives; this eventual collaboration generally allows the photographer more control over his or her own voice.

Organizations attempting to reach broader audiences try different approaches. "Can campaigning photography motivate people into action?," John Novis, head of photography for Greenpeace International, asks rhetorically. "In an image saturated society there are still cases where this has been evident. Photography does have this power. . . . Greenpeace has had many campaign victories, but it is reasonable to ask whether there would have been so many without the associated remarkable images."[22] Wayne Minter, audiovisual manager of Amnesty International, has a similar perspective: "Images are important for grabbing people's attention and getting them to do something, whether it's buying a soft drink or changing the world."[23]

Who makes the imagery? It varies. "Nowadays we are as likely to use a shot from a renowned, skilled, highly trained professional using state of the art capture, processing, and image filing equipment, as we are to use one from a cheap mobile phone in the hands of a teenager in Kabila," Minter stated in 2009. He notes that for Amnesty (as for many other NGOs), it is not always "appropriate, practical or affordable to use professional photographers. We've been increasingly training up our own researchers in both basic and specific uses of photography that are appropriate to their research, e.g. forensic, sensitive subjects, arms documentation, etc., and have had some encouraging results."[24]

Photographers consider their relationships with humanitarian organizations in a variety of ways. For many, such collaborations can be helpful in providing information and logistical access, as well as credibility, in regions of the world that are difficult to traverse on one's own. They can also amplify the impact of what is produced. Photographer Marcus Bleasdale is a frequent collaborator with nongovernmental organizations and a former banker, whose work with Human Rights Watch on the exploitation of gold miners in the Democratic Republic of Congo was exhibited in Geneva to the financiers of Africa's gold industry, "to show them the effects of their actions on the general population."[25] He recently noted: "The work I have done over the past twelve years for Human Rights Watch is not about financial reward but about how effective we can make the work we produce . . . photographers and NGOs/advocacy groups make great partners. They have the power to influence policy makers and that allows the work a much more powerful voice."[26]

It is a two-way street. Stephen Mayes, director of the VII agency, argues that the photographer brings a great deal to the table as well: "While the value of an individual image is declining, the value of the work is still there. Today, the value resides with the photographer. He or she has become the brand." This, according to Mayes, has important implications both for the financial survival of the photo agency and for the NGO: "We believe we can increase our revenues by working closely together with organisations that share these values. We've done so with the 150th anniversary of the Red Cross. The reason this organisation chose VII was not just because of our great photographers, but because of the credibility and integrity these photographers brought with them."[27]

Of course, these kinds of collaborative projects require that the photographer be in general agreement with the goals and policies of the sponsoring agencies, and assured that his or her role as witness will be, in the main, respected. Whereas journalistic publications may seek out the spectacular image of suffering so as to increase the drama, NGOs and other aid organizations tend to have different standards. Some of these pose challenges to the collaborating photographers, including the need at times to be complicit in the "branding" of an organization so as to further its fundraising objectives.

Those on the staffs of aid organizations are often sensitive to the potentials for conflict between the photographer's vision and their own. Amnesty's Wayne Minter is direct about the organization's goals for photographs: "Amnesty uses images as propaganda for human rights, and propaganda against human rights violations. So the index of effectiveness is whether, or by how much, an image has promoted human rights, or prevented a violation. Not an easy thing to describe or measure."[28] Along with the familiar mandate that images "should portray human dignity and positive action in the face of human rights violations," Amnesty's extensive guidelines specify that one should "not use photos purely to shock or disturb," and that "every effort will be made to ensure that individuals in photographs are identified, or not, according to their expressed wishes." They also indicate, in an apparent response to widespread contemporary practice, that "content will not be manipulated in images used or published by AI, except where it is considered necessary to protect subjects from recognition."[29]

Obviously, photographers too come up with their own codes of ethics—both for their own imagery and for their working relationships—that may be quite nuanced. While many of these rules are unspoken, Jeremy Sutton-Hibbert, a freelance photographer who has worked closely with Greenpeace, eloquently describes his approach to maintaining integrity:

> Do I feel my photography is ever compromised by having to shoot, and to perhaps bend the truth, to satisfy my client's objectives, to meet their campaign

issues and goals? It is an issue which worries me, I'm aware of it, it is always in my head when I'm out there on assignment. But whilst Greenpeace does pay my wages, and I have certain obligations as I would with any paying client, I stay true to myself, I stay true to the story as I see it and understand it. . . . If I can do that, and never transmit images which unfairly represent the situation as I personally, not Greenpeace, saw it, then I can sleep at night, knowing I've been as truthful as possible with my work. Of course once the imagery is out on the news wires, into the public domain and into the hands of others, then I can only hope that it is not abused.[30]

Cognizant of the contested role of media in advocacy, NGOs and other humanitarian-aid organizations have over the years developed detailed guidelines for best practices. There is a general mandate now, for example, that photographers avoid typical depictions of victimization (such as the "flies-in-the-eyes" images of starving African children) and concentrate on pictures that both respect their subjects and reflect a sense of their agency. The influential Red Cross-Red Crescent "Code of Conduct" states: "In our information, publicity and advertising activities, we shall recognise disaster victims as dignified humans, not hopeless objects."[31] Similarly, a 2006 voluntary "Code of Conduct on Images and Messages," formulated by Dochas, the Irish Association of Non Governmental Development Organizations, begins with three guiding principles: "Choices of images and messages will be made based on the paramount principles of: Respect for the dignity of the people concerned; Belief in the equality of all people; Acceptance of the need to promote fairness, solidarity and justice."[32] The code follows with a list of preferred approaches to follow "where practical and reasonable within the need to reflect reality." (Dochas also published a twenty-page "Guide to Understanding and Implementing the Code of Conduct on Images & Messages.")[33]

In part such codes are a reaction to previous efforts to depict those suffering, particularly Africans, as nearly helpless in their victimization. They also offer a response to how the Disasters Emergency Committee (an umbrella group of British agencies) analyzed the NGO response to the 2001 earthquake in western India: "[We have] detected a tendency amongst some aid agency staff in the UK to regard public sympathy as a commodity to be exploited rather than a perception to be developed."[34]

A three-year study titled "Mediated Humanitarian Knowledge: Audiences' Responses and Moral Actions," published in Britain in 2012, warned against creating images that reinforce the "patronising paradigm of the 'powerful giver' and 'grateful receiver,'" and urged photographers to depict "beneficiaries of international support as resilient empowered agents who can make real changes to their lives and communities." The study cites a statement by one NGO member: "In telling the story of the starving child, whose situation demands action, the language and images we choose must speak

of both the plight and of the power and potential of individuals, communities and nations to be agents of change in their own development."[35]

Britain-based aid group Oxfam refers to the dilemma as between portraying need and dignity. In its "Little Book of Communications," an in-house publication that appeared several years ago, Oxfam urges: "Don't portray 'victim' or helplessness." This mandate is printed under what is called a "harrowing image" of an obviously very ill child, followed by the suggestion: "Wouldn't a photo of someone administering care be a more powerful and engaging image?" Referencing a photograph that was on one of its own collection tins from the 1960s, Oxfam advises its staff: "Don't use the 'needy African child'—in the 21st century we should be able to present people with more dignity and respect." On the facing page is an explanation: "Images of 'needy,' vulnerable people—especially in emergency work, may generate the cash in the short-term, but they can often perpetuate the negative opinion that a poor country's problems will never be solved. This doesn't help the efforts of countries that are seeking international investment, and a stronger voice in global decision-making processes."[36]

There are, however, indications that something is not working in the larger media environment, and even "cash in the short-term" may be harder to come by. A 2012 survey for Oxfam found that negative images of Africa in the United Kingdom may not help efforts to increase food aid because "three out of four people [are] desensitized to images showing hunger, drought and disease."[37] While three-quarters of the more than two thousand people surveyed felt that it would be possible to end hunger in Africa, only one-fifth felt that they could actively participate in accomplishing this goal. Nor was it just the depiction of Africa: "Respondents to the survey said over-exposure to negative media and advertising portrayals of Africa and developing countries in other parts of the world was 'depressing, manipulative and hopeless.'"[38] On the other hand, of course, many people will likely be less inclined to give funds to those consistently depicted as self-reliant.[39]

For the photographer making pictures, distress and agency are not an easy combination. And while the NGOs' intentions are often highly commendable, the repetition of any single descriptive approach can create a straitjacketed sense of humanity, the anti-stereotype becoming as reductive as the stereotype it is supposed to be battling. Some photographers find this frustrating. Veteran social-documentary photographer Eugene Richards undertook a multiyear project to photograph people who are essentially locked up and forgotten in psychiatric hospitals (he was working under the auspices of Mental Disability Rights International). Richards has voiced his take on the situation:

> In so many photographs of the disenfranchised, subjects are shot to look wise and dignified, as if there is something ennobling about suffering. We like these

images for their optimism—all that serenity makes the squalor more palatable. But all too often, when people are locked up, they lose their dignity. Psychiatric patients rarely look transcendent—mostly, they seem frightened, vacant, miserable. But shooting honest, brutal images presents another problem: That can be too much to bear. . . . Once you meet the patients, they're not so easy to push out of your mind. If you go into the children's ward, you'll hear kids screaming, banging their heads against the wall. Those could be your children. That's the part I can't show you. [40]

There are also more nuanced discussions in the institutional advocacy world, including in the guidelines of UNICEF. They argue against the representations of "generic" situations that helped define them in the past, including those that had been used in their own branding: "'On-brand' imagery is much more than close-ups of smiling children. If a smiling close-up is too cute, or otherwise diminishes a child's inherent dignity, it is likely 'off-brand' for UNICEF."[41] A larger and still more complicated topic in the UNICEF guidelines is that of the difference between "negative" and "positive" imagery. UNICEF notes that the enormous numbers of "suffering child images since at least the 1940s" have not been helpful:

A constant diet of this emotional turmoil leads to numbness and a rejection of the images (they lose meaning). Or, it can provoke a perversion of initial sympathies into a compulsion to continue viewing this suffering (if only to understand or extract meaning from it). The image can then become sensationalistic, and thus, exploitative rather than helpful. In both instances, the real child tends to get lost, replaced by an object—what the photograph literally is. This process of objectification also weakens our sense of shared responsibility for the conditions that have created this distress.

This is not all the fault of the conventional media, UNICEF suggests: "Relief agencies have done as much to create this climate as have the news media."[42]

On the other hand, UNICEF's guidelines assert that more positive imagery can also objectify, particularly given the consumer-oriented environment: "Making consumers 'feel good' has become a calculated ingredient in marketing. Consequently, in an increasingly market-oriented environment, images of happy children are used to sell almost everything, contributing to a distortion of genuine sentiment about children." Authenticity in the depiction of children, UNICEF seems to be arguing, is undermined by either the consistently pathetic and victimizing photographs of the past or the one-sided, upbeat imagery of contemporary consumer society.

There are also concerns about the issue of distance—rights and protections in image use are "most commonly overlooked or ignored when depicting subjects in faraway

countries." Furthermore, the rationale that the imagery will not be viewed in the subject's home territory, UNICEF states, "is no longer viable in an era of global travel, satellite television and the Internet." However, the organization "is also quite aware that they do not control the depiction of these children in the press."[43]

Like UNICEF, WITNESS, a twenty-year-old organization that has pioneered the training of people throughout the world to use video cameras to tell their own stories of human-rights abuses, is sensitive to many of these issues, including the revictimization of people via imagery. WITNESS often updates its advice and warnings to those working in the field, including a recent tutorial about the use of the "blur" device to protect identities. In an April 2012 blog post titled "How to Film Protests: Video Tip Series for Activists at Occupy Wall Street, in Syria and Beyond," activists were urged to be careful:

> Now more than ever we need to ensure that the footage that we capture as activists incorporates essential information like the exact date, time and location so it may best be used by the media, as evidence, and for advocacy. Additionally, we need to pay special attention to the unique safety and security risks that we face as filmmakers and activists, as well as risks to those we capture in our footage. For example, in Syria we've seen the general practice of filming protesters from behind to ensure they are not identifiable when footage is played back at a slower rate. This is exactly what the Iranian government did during the Green Revolution in order to identify protesters, frame by frame.[44]

Another post, of May 2, 2012, addresses the latter point further: "In Iran, during the political protests of 2009, the government posted photos and videos from demonstrations that were shared on social media sites like YouTube, then circled suspected dissidents' faces in red and asked viewers to write in to identify by name those people whom they recognized."[45]

UNICEF, facing similar issues in its advocacy work, has published a series of guidelines on protecting visual identities of children at risk of further victimization. Donna DeCesare, a highly committed documentary photographer, has worked with UNICEF's senior photography editor, Ellen Tolmie, to develop a set of strategies to represent children without allowing anyone else to know who the individuals are, although in many cases readers are not cognizant that the subjects' identities are being expressly protected. In a section titled "When to Protect Visual Identities," UNICEF outlines its policies:

> In instances where publication of an image may put a child at risk even if the name is changed or omitted, it is advisable not to publish the image at all. UNICEF has clear guidelines for reporting on children's issues, advising that children should not be identified, either visually or by name, if they are:

- victims, or perpetrators, of sexual exploitation . . . ;
- HIV positive;
- charged or convicted of a crime;
- current or former combatants, IF being so identified puts
 them at risk of future reprisals.

The guidelines go on to add an even more farsighted distinction, noting that child soldiers holding weapons must also be protected from identification through photographs, in anticipation of their eventual rehabilitation.

> This latter policy was adopted to avoid the often sensationalistic use of images showing armed child soldiers acting or posing as aggressors. While armed child soldiers are threatening and dangerous (and are often drugged or otherwise desensitized to the damage they can do), as children they are also de facto forced combatants. UNICEF's role is to promote recognition of their status as children and coerced victims, recognition that is harder to achieve if they are visually represented in sensationalized ways.[46]

There have been other, more assertive approaches as well. Oxfam's "Little Book of Communications" asks for symbolic or "iconic" images as a means of focusing the public's attention. In language that reflects the thinking of Western journalistic publications, it references one of the famous 1989 photographs from Tiananmen Square, this one by Associated Press photographer Jeff Widener, of a lone man confronting tanks: "When people think 'Tiananmen Square,' invariably, the image that comes to mind is this one. It captures exactly what the event was about—the 'underdog' facing the might of an authoritarian regime. Look for strong images like this—it's worth taking a risk when dealing with emotive issues and subjects. Don't shy away from 'showing it like it is.' People will feel a sense of injustice and will respond."[47] (Parenthetically, this imagery has long been banned in China, meaning that a sizeable portion of the world's people do *not* have it in mind. And soon after these pictures were made, the Chinese government argued on state television that the imagery shows their soldiers to have acted in a civilized manner: "Anyone with common sense can see that if our tanks were determined to move on, this lone scoundrel could never have stopped them. This scene recorded on videotape flies in the face of Western propaganda. It proves that our soldiers exercised the highest degree of restraint.")[48]

Not surprisingly, certain of the guidelines proposed by humanitarian organizations are clearly self-promotional—some more explicitly than others. The United Nations Development Programme, in a section called "Reaching the Outside World," makes it clear what is expected of the imagery it uses: "Photographs must show people

who have benefitted from our work. Images of destroyed buildings or landscapes or machinery without people are virtually useless, especially for advocacy or fundraising. Photographs of meetings or of staff sitting around a table or standing in a room are also not useful. The best photographs show specific actions (such as unloading supplies or building homes) and direct interaction with the people UNDP assists." And additional advice: "For tips on strong images, see UNICEF's Imagery."[49]

All these policies, while they have much in common, may be applied in various ways. In 2005 I worked with the United Nations Population Fund (UNFPA) to create a photography exhibition titled *Chasing the Dream*, concerning the UN's Millennium Development Goals to enable young people around the world to pursue their lives as fully as possible. We were given a number of image-related interdictions, including a prohibition against photographs of groups of people in economically underdeveloped countries sitting down (this would apparently denote passivity). There was also an internal website that explained the organization's aims. Echoing the focus on self-branding of organizations in so many sectors of society, the directive under "Photography Usage" was "to represent reality with an underlying sense of possibility, and to thereby convey a mood of confidence in UNFPA's mandate and effectiveness." Rules under "Photography Usage"—with examples of "good" and "bad" photographs (the latter summarily X'ed out)—were equally prescriptive, asking that images "focus on individuals and their potential as free and independent people," "show movement rather than stagnation," and noting that "the viewers' response should be of empathy and individual interest, not pity." Whatever the motivations, portrayals restricted by a template may not only ultimately reduce the complexity, and humanity, of those depicted, but also contribute to short-circuiting a collaboration before it has even begun.

Word choices were also contested: for example, we were not to use the word *hell* to describe what happened to a young woman sold unknowingly into sexual slavery (we replaced it with *inferno*, deemed less upsetting to certain factions at the UN). An engaging photograph of a black doctor, seen from behind, taking off his stethoscope while examining a Jamaican teenager who had contracted HIV, was banned because the doctor might somehow be construed as having been whipping his patient with the stethoscope (a perspective that I still cannot understand). Much depends, as with all guidelines, upon how one interprets what specific photographs represent.[50]

The images that were much more easily—nearly unanimously—accepted for *Chasing the Dream* were those made by the young people themselves. The first photograph of real joy that I remembered ever having seen from a refugee camp, of two broadly smiling brothers photographed by a sibling in the Kyangwali Refugee Settlement Camp in Hoima, Uganda, was used as one of the show's lead images in the lobby of the United Nations' New York headquarters. After all, as it was explained to me, that particular

refugee camp had excellent facilities and offered a marked improvement in material living conditions, considering where the children had been living previously. And, as I thought about it, I realized the children had no need to depict themselves as miserable so as to acknowledge their plight or to solicit more aid. They did not feel the need to embrace—they may not have even been aware of—the Western stereotypes and presumptions that such guidelines so stridently oppose. Shamimu, the photographer of the image mentioned above, captioned it quite simply: "I like my brothers."

While the show's opening was a rousing success, with UN Secretary General Kofi Annan addressing the overflow crowd, one was still left to wonder what was left unsaid on those walls—both that evening at the United Nations, and in similarly well-meaning shows put on throughout the world.

Others function with different rules. Photographer Eric Gottesman traveled to Ethiopia in 1999 on a fellowship. While there he worked, in collaboration with an NGO, with people who were HIV-positive, and also gave cameras and film to children who had lost parents to AIDS. Intensely stigmatized and afraid of being identified in his photographs, people would not allow Gottesman to photograph them until he switched to Polaroid film so that they could immediately verify that their faces were not being shown. If they objected to an image, Gottesman would then destroy the negative.

The children's photographs, along with his own, were accompanied by their letters directed to their absent parents; this collection traveled to several locations in Ethiopia by pickup truck. A few of the children (and their grandmothers) went with the exhibition to engage visitors in discussion. The intention was that people would gather around the circular installation for a coffee or tea ceremony and discuss the AIDS epidemic and the stigmatization of HIV-positive people in a setting that was rooted in their own tradition. The project was called "Abul Thona Baraka: A Traveling Coffee Ceremony."

Responding to questions sent to him by Leo Hsu for *Foto8* in 2008, Gottesman pointed out multiple issues that are useful for those working collaboratively in the context of human rights.[51] He describes his first visit with a gathering of AIDS-affected children living in a group home in Addis Ababa. After he explained his project to them, Gottesman recalls: "They agreed to work with me on the condition that their work would be used to help other kids like them; they defined their audience very early on in the project." This group forms the basis of Sudden Flowers, as the children later named their photography collective.

Gottesman found that the "teaching" process went both ways with these children, and that they were quickly leaping beyond the particulars of what he had shown them how to do, selecting images that were "not necessarily the ones I would pick, but . . .

I just assumed that I needed to look longer at the ones they chose and educate myself about what I am missing." He recalls:

> At first, I thought they were acting as typical kids playing with cameras: snap-shots, mugging. It was not until I saw this one image, the one of the dream of the house catching on fire, that I realized that something more profound was happening. I realized this because that image was made using a double exposure technique, something which I had not taught them. When I saw that picture, and after I learned more about Ethiopian art and culture, I came to understand that they were learning to master the medium of expression that I brought to them. They understood how to use the camera, and the results were beyond the representations of Ethiopians, of Africans, that I had previously seen.

Their collaboration was flexible: sometimes they made the pictures, sometimes he did; sometimes, Gottesman says, "they would direct it like a scene of a film and then I would trip the shutter on the camera." There was nothing cut and dry about the process or the roles of the group, as he described it, and he feels that this freedom was crucial to the project's success:

> I have often seen images from [other collaborative] projects that undercut the good intentions of the projects' initiators by falling back into the old stereo-types and power dynamics that the collaborative process intends to avoid. There are questions like: Who is editing this material? Where is it being shown? For what purpose? It bothers me when these projects use a pseudo-democratic rhet-oric to describe the act of handing out cameras, as though distributing cameras alone is "empowerment" or "giving voice to the voiceless." When I see this kind of stuff, I become listless; the process is so much more complicated than that.

The key, then, was not simply to have the children photograph, but to involve them in the process throughout:

> In our project, the children talked less about making "good" or "right" pictures than they did about what the process means to them. The images and texts that come out of this project are very personal, very embodied in lived experience, unlike the "witnessed" images of photojournalism. As a result, the children talk about the psychological impact of this project on them. As well, they express their desires to see the process change as they change, to incorporate, for instance, images of them laughing as well as representations of them mourning.

The many photographers who have provided children with cameras have generally done so to enable a more profound self-representation on the children's part, and are

often also trying to advocate on their behalf. Wendy Ewald, who long taught at Duke University (where Gottesman studied), is an acknowledged pioneer in the arena of such collaborations, with a focus on self-representation. Beginning in the 1970s, she asked children from ages six to fourteen in Appalachia's coal country to photograph themselves, their families, and their fantasies and dreams; the resulting images, published in *Portraits and Dreams* (1985), were hugely revelatory about the children's inner lives, as well as their fears and aspirations. Ewald's work with children and families—which has continued over the years in projects based in Latin America, India, South Africa, Saudi Arabia, Holland, Israel, and the United States—opened the way for many others to explore similar terrain; she also trains teachers, and has authored guides such as *I Wanna Take Me a Picture: Teaching Photography and Writing to Children* (2002). Along with Elizabeth Barret, she is as of this writing collaborating with her Appalachian students, some three decades later, on a new project, "Portraits and Dreams: A Revisitation."

Another ambitious collaboration is Fotokids, set up in Guatemala by Reuters photographer Nancy McGirr, initially with six children between five and twelve years old who lived and worked in Guatemala City's enormous garbage dump (originally the project was called "Out of the Dump"). Now the program, which began in 1991, offers workshops for young people throughout Guatemala and in Honduras who photograph in their own harsh environments, often quite lyrically and sympathetically. Although at first the students had very low expectations for their working lives as adults, McGirr urges them to broaden their horizons: "We would visit people who worked in different careers, a TV cameraman, a librarian . . . and they would photograph them and ask them questions about what they did. They would also photograph themselves in that person's role."[52] Several hundred have studied with Fotokids over the last two decades; some have gone on to find jobs in photography and design, and others as teachers and administrators.

Filmmakers Zana Briski and Ross Kauffman's 2004 documentary *Born into Brothels*, about Briski's work teaching photography to children in the red-light district of Calcutta, made the public more conscious of such endeavors when it won an Academy Award for Best Documentary Feature. In 2002 Briski started the foundation Kids with Cameras to encourage similar projects elsewhere. Showing the children with whom she worked in India that one can make several portraits of the same person from different perspectives was, she says, a key realization for the young photographers, stimulating them to become more innovative in their approaches. (Due to the popular success of *Born into Brothels*, one of her former students in Calcutta, Avijit Halder, was eventually able to attend New York University to study film; he graduated in 2012.)

In 2000 David Jiranek, a successful theatrical producer, founded "Through the Eyes of Children: The Rwanda Project," as a way of giving something back. Though Jiranek

died in an accident in 2003, the project continues to provide photographic workshops to children living in the Imbabazi orphanage in Gisenyi, survivors of Rwanda's 1994 genocide. These young people have come up with their own vision of contemporary Rwanda (more intimate and optimistic than the work of most photojournalists), with prints of their work sold to support their high-school education and those of the other children in the orphanage (as of 2012, thirteen young people from the orphanage are enrolled in universities or have graduated). When the United Nations was commemorating the tenth anniversary of the Rwandan genocide, these children's photographs were chosen for the United Nations lobby at the New York headquarters.[53]

Such projects appear to be more fulfilling for the children involved, and more revelatory in the imagery produced, when the emphasis is on giving them the freedom to articulate their own visions, not on introducing photographic classics from other cultures with the expectation that they will imitate them.

But in even the best-intentioned projects, those that are purposefully and meticulously collaborative, there may well be unforeseen consequences. The introduction of modern, sometimes expensive technologies can inflame jealousies and create other problems, and the children's new roles as observers may destabilize certain familial and community relationships. The social and psychological hurdles to be surmounted require considerably more of the workshop leaders than simply teaching how to make pictures.

Such problems are not, of course, confined to children; working with adults may have its own difficulties. One documentary photographer speaks with enormous regret of the outcome of a particular project. After having carefully confirmed the captions and consulted with her subject—a woman who had been raped in her home country— the photographer allowed the images to be shown in a public space. Her subject had given her approval, gratified that the pictures and captions were to be presented as part of a series on the situation of refugees. But once the exhibition was up, this woman found herself, to her surprise, painfully shunned by her own immigrant community. It can be difficult, if not impossible, for anyone—even the person depicted—to gauge all the potential ramifications of an image's release.

In her 2010 book *The Crisis Caravan: What's Wrong with Humanitarian Aid?*, journalist Linda Polman, skeptical of the politics of aid organizations, revisits the crisis in Biafra that McCullin had photographed and points out how, by basically taxing eager international-aid organizations, Biafra's leader, Chukwuemeka Odumegwu Ojukwu, used his people's suffering to enrich himself until finally, "nearly two years and perhaps two million deaths later, most from starvation, the game was up."[54] But some of Polman's most nightmarish criticism is about more recent history: "Partly as a result

of media attention, Sierra Leone became the beneficiary of the largest UN peace mission and—in terms of dollars per head of population—the largest humanitarian aid mission anywhere in the world at the time. Around 300 INGOs [international non-governmental organizations] rushed to the little country." Referring to the amputees whose limbs had been cut off in the country's war, she quotes an INGO staff member in Freetown: "It's never been so easy to collect money as it is with the pictures of these poor devils."[55]

It turns out that, as has happened elsewhere, the subjects of those pictures were being exploited in a most horrifying way. Their limbs were being amputated *for* Western cameramen, so that the media would have something to show that, in turn, would force the international community to pay attention and provide aid. As one older rebel leader told Polman: "You people looked the other way all those years. . . . There was nothing to stop for. Everything was broken, and you people weren't here to fix it." He told her that some rebels began to create "cut-hands gangs" because "it was only when you saw ever more amputees that you started paying attention to our fate. Without the amputee factor, you people wouldn't have come."[56] He was asking, along with his old companions, to be thanked for helping his country.

The *New Yorker*'s Philip Gourevitch, in a review of Polman's book, continued the story:

> Three years after Polman's visit to Makeni, the international Truth and Reconciliation Commission for Sierra Leone published testimony that described a meeting in the late nineteen-nineties at which rebels and government soldiers discussed their shared need for international attention. Amputations, they agreed, drew more press coverage than any other feature of the war. "When we started cutting hands, hardly a day BBC would not talk about us," a T.R.C. witness said. The authors of the T.R.C. report remarked that "this seems to be a deranged way of addressing problems," but at the same time they allowed that under the circumstances "it might be a plausible way of thinking."[57]

The image war in which we are enmeshed is so intensely visible that it is difficult to perceive. From the purposeful anonymity of the hooded men holding athletes and trainers hostage at the Munich Olympics of 1972 to the faceless men who flew airplanes into the World Trade Towers in 2001 to those who hacked off limbs in Sierra Leone in search of more international attention and aid, there is no question that the perpetrators of violence are increasingly aware of how to manipulate the media. Like others seeking the media spotlights, they have learned how to make the cameras turn in their direction when it suits their purposes. Humanitarian organizations, along with other institutions, have also turned to imagery to publicize their own usually extremely

legitimate concerns and, frequently while doing so, to put their efforts in a good light— a self-aggrandizing tendency accentuated by the proliferating numbers of humanitarian organizations competing for limited amounts of funding.

All these many distortions, along with the erosion of the mainstream press, make it much harder for a reader to have a reliable sense of what is going on in faraway places without a large amount of crosschecking and extended research. This in turn provides an enormous opening for those documentary photographers who have the fortitude, desire, and resources to work independently, as well as for citizen journalists and other locals, including children with cameras, who wish to make their own statements. Of course, if the independent documentarians do not have the funds to support their efforts, or if they are dependent upon institutions intent on subverting their work for other ends, or if they take too many shortcuts in their own research, then their projects, too, can be short-circuited. And the work of citizen journalists, as we have seen, can also be skewed by their own agendas, privileging advocacy over witnessing, often lacking a broader perspective.

If the hope is to encourage further experimentation and collaboration, among outsiders as well as insiders, professionals as well as nonprofessionals, there need to be ways to evaluate the credibility of the work that each of them may produce so that readers have a better idea of what they can trust, and why. NGOs seeking to engage others in their efforts to alleviate humanitarian crises will also benefit from a citizenry that is better informed, able to participate with less fear of manipulation. Worthy projects (and there are many), networked together, can provide a larger vision of events and, simultaneously, stimulate a broader societal conversation while encouraging further inquiries. And maybe, just maybe, there will be individuals and institutions generous and farsighted enough to help support these efforts to create more comprehensive ways of knowing, and of understanding.

NOTES

1. Thomas Friedman, "Obama and the Oil Spill," *New York Times* Op Ed, May 19, 2010. http://www.nytimes.com/2010/05/19/opinion/19friedman.html?_r=0.

2. *New York: September 11*, introduction by David Halberstam (New York: PowerHouse Books, Nov. 1, 2001). A number of Magnum photographers were in New York for a regularly scheduled meeting when the attacks occurred.

3. *Here Is New York: A Democracy of Photographs*, ed. by Alice Rose George (New York and Zurich: Scalo, 2002).

4. On the notion of "not in our name": Bruce Shapiro, executive director of the Dart Center for Journalism and Trauma, has written of his feelings of rage when, after being one of those wounded in an unprovoked knife attack in a New Haven café, he was re-victimized by his own image. In his essay "One Violent Crime," published in the *Nation* (April 3, 1995), Shapiro describes seeing footage on television of himself in pain on an ambulance gurney after the attack, and realizing: "My picture is being shown on the news to illustrate why Connecticut's legislature plans to lock up more criminals for a longer time. A picture of my body, contorted and bleeding, has become a propaganda image in the crime war."

5. An example of this disjunction is the ban on showing flag-draped coffins of the returning U.S. dead, which began in February 1991, during the first Persian Gulf War. President George H. W. Bush had been embarrassed two years earlier during the Panama invasion when, without his knowledge, the three major networks showed two live feeds side by side: a jocular Bush at a press conference the day after the invasion on one side, and a second screen showing coffins containing the remains of American soldiers arriving at Dover Air Force base. The outcry this juxtaposition caused—whether the pairing was fair or not—speaks to the potential impact of such comparisons.

6. Simon Norfolk, in Geoff Manaugh, "War/Photography: An Interview with Simon Norfolk," BLDG BLOG, November 30, 2006. http://bldgblog.blogspot.com/2006/11/warphotography-interview-with-simon.html.

7. Don McCullin, interview with the author, New York City, September 2008.

8. Barack Obama, quoted in Mark Landler and Mark Mazzetti, "Account Tells of One-Sided Battle in Bin Laden Raid," *New York Times*, May 4, 2011. These quotes in the *Times* were taken from Obama's interview with Steve Kroft on CBS's *60 Minutes*, which released a transcript a few days before it was broadcast on May 8, 2011. http://www.cbsnews.com/8301-18560_162-20060876.html.

9. "Chairman Rogers Opposes Public Release of Osama Bin Laden Photos," U.S. House of Representatives statement released May 4, 2011.

10. Obama, interview with Kroft, *60 Minutes*, May 8, 2011.

11. Bernard Kouchner, quoted in Marie-Monique Robin, *The Photos of the Century* (Cologne: Evergreen/Taschen, 1999).

12. See, for example, Linda Polman's *The Crisis Caravan: What's Wrong with Humanitarian Aid?* (New York: Metropolitan Books, 2010), among other critiques.

13. Don McCullin, with Lewis Chester, *Unreasonable Behaviour: An Autobiography* (London: Jonathan Cape, 1990).

14. The accompanying publication was Sebastião Salgado, *An Uncertain Grace* (New York: Aperture, 1990).

15. Jean-Daniel Tauxe, quoted in *The New York Times Magazine Photographs*, ed. by Kathy Ryan (New York: Aperture, 2011). See "Somalia, 1992: The Casualties," photographs by James Nachtwey, *New York Times Magazine*, December 6, 1992.

16. James Nachtwey, quoted in Caroline Moorehead, *Humanity in War: Frontline Photography since 1860*, *New Internationalist* (Geneva: ICRC, 2009).

17. Ibid.

18. Jakob Kellenberger, quoted in ibid.

19. Nachtwey, quoted in ibid.

20. See Jane Nelson's "The Operation of Non-Governmental Organizations (NGOs) in a World of Corporate and Other Codes of Conduct," Corporate Social Responsibility Initiative, Working Paper no. 34

(Cambridge, Mass.: John F. Kennedy School of Government, Harvard University, 2007). "Research undertaken over a ten-year period in 26 countries by the *Johns Hopkins Comparative Non-Profit Sector Project* has revealed that non-profit organizations account for some 31 million employees in these countries (19.7 million paid employees and the equivalent of 11.3 million full-time volunteers). This represents about 7% of the workforce and 1 out of every 8 service sector workers. If the non-profit sector in these countries were a separate national economy, it would be the 8th largest in the world with US$1.2 trillion in expenditures." http://www.globalcitizen.net/data/topic/knowledge/uploads/20121025131340852281_workingpaper_34_nelson.25.pdf.

21. Judith Gelman Myers, "NGOs to the Rescue," *Popular Photography*, December 16, 2008. http://www.popphoto.com/how-to/2008/12/ngos-to-rescue.

22. John Novis, "Campaigning Photography," February 2008, a statement sent in response to author's query.

23. Wayne Minter, quoted in Amnesty International's *Wire*, November/December 2012.

24. Wayne Minter, e-mail message to the author, April 2009.

25. See Morag Livingstone, "Photojournalists Seek New Audiences to Affect Change," *Photo District News*, April 2, 2006.

26. Marcus Bleasdale, e-mail exchange with author, January 9, 2013.

27. Stephen Mayes, quoted in Olivier Laurent, "Independent Thinking," *British Journal of Photography*, August 23, 2010. http://www.bjp-online.com/british-journal-of-photography/report/1729221/independent-thinking.

28. Minter, e-mail message to the author, April 2009.

29. *General Photographic Principles of Amnesty International*, revised March 1, 2012.

30. Jeremy Sutton-Hibbert, response to a query by John Novis, prompted by an e-mail exchange between Novis and myself. Sutton-Hibbert's message was forwarded to me in early 2008.

31. "Code of Conduct for the International Red Cross and Red Crescent Movement and Non-Governmental Organizations (NGOs) in Disaster Relief," accessible at http://www.icrc.org/eng/assets/files/publications/icrc-002-1067.pdf.

32. Dochas, The Irish Association of Non Governmental Development Organisations, "Code of Conduct on Images and Messages," 2006. http://www.dochas.ie/Shared/Files/5/Images_and_Messages.pdf.

33. Dochas's "Guide to Understanding and Implementing the 'Code of Conduct on Images & Messages'" can be downloaded as a pdf: http://www.dochas.ie/Shared/Files/5/Guide_To_Code.pdf.

34. See Ruth Gidley, "NGOs Still Fail Standards on Appeal Images," AlertNet, January 14, 2004. http://www.trust.org/alertnet/news/ngos-still-fail-standards-on-appeal-images.

35. "Mediated Humanitarian Knowledge: Audiences' Responses and Moral Actions," Birkbeck/University of London, published 2012. http://www.bbk.ac.uk/psychosocial/our-research/research-projects/mediated-humanitarian-knowledge.

36. "The Power of Images," from Oxfam Great Britain's "Little Book of Communications," an internal guide for staff, can be accessed at the HAP (Humanitarian Accountability Partnership) website: http://www.hapinternational.org/pool/files/oxfam-gb-little-book-of-communications.pdf.

37. "Africa Image Harming Aid Effort, Says Charity Oxfam," *BBC News*, December 26, 2012. http://www.bbc.co.uk/news/uk-20842827.

38. Ibid.

39. See *Imaging Famine* (http://www.imaging-famine.org/), a research project that began with a 2005 exhibition, curated by David Campbell, D. J. Clark, and Kate Manzo, held at London's Guardian and Observer Newsroom and Archive and visitor center. It is an intelligent and highly relevant exploration of the depiction of famine in the media since the nineteenth century.

40. Eugene Richards, "Out of Mind, Out of Sight: A Photo Essay of the Psychiatric Hospitals the World Forgot," *Mother Jones*, March/April 2009.

41. While many of UNICEF's guidelines are available internally only for staff, "Documenting Abuses While Protecting Children at Risk" (2012), authored by Ellen Tolmie and Rebecca Fordham, can be accessed at http://www.unicef.org/protection/57929_55452.html.

42. Ibid.

43. Ibid.

44. Chris Michael, "How to Film Protests: Video Tip Series for Activists at Occupy Wall Street, in Syria and Beyond," blog post, WITNESS.org, April 30, 2012. http://blog.witness.org/2012/04/how-to-film-protests-video-tip-series-for-activists-at-occupy-wall-street-in-syria-and-beyond/.

45. Teresa Eggers, "Are News Photography Standards Out of Touch with the Cameras-Everywhere World We Inhabit?" blog post, WITNESS.org, May 2, 2012. http://blog.witness.org/2012/05/news-photography-ethics/.

46. UNICEF, "Documenting Abuses While Protecting Children at Risk."

47. Oxfam, "Little Book of Communications." For a discussion of the photographs of the man in front of the tanks, see the *New York Times* "Lens" blog: http://lens.blogs.nytimes.com/2009/06/03 behind-the-scenes-tank-man-of-tiananmen/.

48. Cited in the 1995 documentary film by Richard Gordon and Carma Hinton, *The Gate of Heavenly Peace*. A similar explanation is said to have been provided for the imagery in an exhibition at the Military Museum of the Chinese People's Revolution in Beijing, along with a burned tank that was put on display.

49. The UN Development Programme's "Reaching the Outside World." http://web.undp.org/comtoolkit/reaching-the-outside-world/outside-world-core-concepts-photography.shtml.

50. For *Chasing the Dream*, photographs were made by Diego Goldberg and texts written by Roberto Guareschi profiling eight young people from around the world, each highlighted as grappling with issues related to one aspect of the Millennium Development Goals. The two Argentines also conducted short workshops for the youth in the eight places they visited, asking them to photograph what they liked or did not like; the resulting imagery and text then constituted the other major section of the exhibition and website created by PixelPress for the UN. The idea was then to have the spouses of the leaders of more than a hundred countries in attendance for the September 2005 Millennium Summit visit the exhibition, guided by Nan Annan (UN Secretary General Kofi Annan's wife). Unfortunately, due to the need for extra temporary offices, the exhibition space was unavailable during the three-day summit.

51. This and the following quotes by Eric Gottesman are from Leo Hsu, "What Is Their Ground Is His Figure: Eric Gottesman on Collaboration," *Foto8*, April 2, 2008. http://www.foto8.com/new/online/blog/406-what-is-their-ground-is-his-figure-eric-gottesman-on-collaboration.

52. Nancy McGirr, quoted in Ana Caistor-Arendar, "Fotokids—Out of the Dump," Opendemocracy.net, November 13, 2009. http://www.opendemocracy.net/5050/ana-caistor-arendar/fotokids-%E2%80%93-out-of-dump.

53. See "Through the Eyes of Children: The Rwanda Project." http://www.rwandaproject.org/. See also L.E.A.D. Uganda, an organization to help "forgotten children" become leaders, founded by photographer Stephen Shames: http://www.leaduganda.org/. Foundation Rwanda, founded by photographer Jonathan Torgovnik, has, among other goals, an aim to help with the funding of the education of some of the estimated twenty thousand children born of rape during the Rwandan genocide. http://www.foundationrwanda.org/.

54. From Polman, *Crisis Caravan*.

55. Ibid.

56. Ibid.

57. Philip Gourevitch, "Alms Dealers," *New Yorker*, October 11, 2010.

CHAPTER 5
Of Healing and Peace

After a number of journalists had spoken at a 2012 conference in New York sponsored by the Dart Center for Journalism and Trauma titled "Generation Iraq: Journalists Confront America's War," a young Egyptian woman in the audience asked if the photographs that had been shown, many of them of violence, would be helpful as the Iraqi people try to heal themselves and resolve their own longstanding conflicts. The two prominent young photographers on the panel, both of whom had authored well-received books on the Iraq war, were flummoxed; one asked for extra time before responding, and then suggested that the question should be directed toward an academic, not toward the photographers themselves. No answer was forthcoming.

But the question directed at the photographers, posed another way, is extremely pertinent: Is there a photography of peace? As we ponder the end of America's involvement in Iraq, the potential end to a decade of conflict in Afghanistan, and the tumultuous revolutions of the Arab Spring, should there be some thought given to how photography can be helpful to those trying to move beyond the conflicts that were so vividly depicted? There are enormous numbers of photographic books and exhibitions on the conduct of war, but might we begin to pay equivalent attention to the multiple, perhaps less visually spectacular, efforts that go into the making of peace?

Beyond pictures that show war's horrors as a warning to avoid violence (but may also seduce), of what would a photography of peace consist? Or, to enlarge the question, rather than wait to photograph the damage caused by the latest megastorm, how could one contribute to ways to avoid such storms, or diminish their potential impacts? Rather than photograph people dying unnecessarily from disease, is there imagery to be made that can help to proactively prevent such outcomes? Rather than wait for the next shooting deaths in America's homes and streets, is there any way for images to

help facilitate saner gun policies? As photographer and writer Robert Adams has put it: "The job of the photographer, in my view, is not to catalogue indisputable fact but to try to be coherent about intuition and hope."[1]

Why don't we have a more developed photography that explores in some depth the move from pain to its resolution, creating reference points for those striving to move forward, rather than continually searching for, and dwelling on, the cataclysm—reminding us of traumatic moments for the sake of the visceral shock? Why do so many young photographers want to become photographers of war when nearly every one of them, I have little doubt, prefers peace?

A number of photographers have been thinking about such questions, devising various strategies in a hybrid of journalism, documentary, and human rights; a few have even set up foundations to try and address issues that they have identified in their work as photographers. Many, although not always the most celebrated, have been creating new work, or using existing imagery tactically, to try to heal, to resolve conflicts, and at times even to prevent new disasters. A proactive photography that helps avoid an apocalypse, or minimize one, is obviously preferable to one that is most energized in the depiction of disasters.

Created in 1996 for the *New York Times* by Gilles Peress and myself, "Bosnia: Uncertain Paths to Peace" originated in the very early days of the Web, at a time when it seemed that a new media platform required different approaches—in this case, avoiding the spectacular imagery of war and focusing on the possibilities of making peace among Serbs, Croats, and Muslims. After four years of conflict, the various sides had recently signed the Dayton Peace Accords. The project was also an early attempt to use the Web in a more participatory manner—to engage readers in creating their own narratives, as well as having the subjects contribute differing perspectives on what had occurred.

Much like the journalist who arrives at the airport or train station, knowing neither which way to go nor what story to explore, visitors to the "Bosnia" website were required to create their own journey by selecting images without knowing where they would lead. In contrast to a book or magazine, the website offered no way of quickly flipping forward to assess the path. Each click of the cursor would land the reader on a screen with new perspectives and unknown possibilities, leading somewhere else. While the photographer initially had center stage on this project—it was up to him to articulate the pertinent links among the many possible images—the reader was then responsible for their reassembly. And in creating a conversation among photographer, subject, and thousands of readers (many of them from that region of the world), the site would pose a challenge to the *New York Times'* overarching authority as the ultimate arbiter of what is going on.

Certain image strategies tested the previous limits of photography: the essay opened with an uncaptioned, rephotographed snapshot of a Muslim family in which each face had been obliterated by a drill bit; that disfigured snapshot, the attentive reader would find out only later in his or her journey, was almost all that was left when this family was able to return home after the war. Grids of uncaptioned images were offered, to encourage the reader to reject more decisively any linearity of the story by clicking on any image to go to another part of the reportage. (The small degree of resulting chaos seemed slight compared to what had actually been going on in Bosnia.) The reader could take trips and side trips through photographs, text, sound, and video, participate in various discussions, look at maps, a bibliography, a glossary, links to other sites, a copy of the Dayton Accords, and other archival material provided by the *Times* and National Public Radio. A navigable 360-degree panoramic image placed the viewer inside a Serbian cemetery filled with empty holes where bodies once were; many caskets had been dug up by relatives convinced that the dead might otherwise soon be desecrated by vengeful enemies. The idea was to re-create some of the eerie disconnect of what it was to stand in the middle of that cemetery, where many of the relatives, fueled by alcohol, were unburying family members. Another panorama placed the viewer on a former frontline.

The discussions that arose from the project were quite volatile and at times excruciatingly revelatory. While there were problems setting up computer access in postwar Sarajevo for people to participate, the larger challenge was that the discussion groups were dominated by some of the most racist and vitriolic comments ever to have appeared in the *New York Times*. There were fourteen forums with differing subjects (introduced by UN Ambassador Madeleine Albright, CNN's Christiane Amanpour, and human-rights leader Aryeh Neier, among others), many of which were dominated by pro-Serbian commentators abroad who felt their cause was vilified by the conventional media. (One commenter, accusing the *Times* of a pro-Muslim slant, suggested that the newspaper must be owned by Saudi Arabia.) The groups, despite entreaties for civility, were often so rampantly hostile that one learned, more than from any news report, how extensive, irrational, and personal the contested claims could be.

Not all our desires for the site were realized. One idea was to automatically keep track of readers' movements, so that more mixing of pathways through the essay could occur based upon previous choices. Thus, for example, a reader who continually chose photographs depicting Serbs might be directed to look at more depicting Muslims. Or conversely if someone selected pictures of Serbs they might then find it *impossible* to select images of Croats or Muslims, mirroring in a suggestive way the single-minded ethnic battles that had been fought. Most of all, in hindsight, it would have been interesting and useful to find a way to continue the project over a number of years,

collaborating with those living in Bosnia so that they could further the discussions and the documentation on their own terms, perhaps finding ways to advocate more successfully for reconciliation among the formerly warring parties that were, at that time, beyond our scope.

A potentially productive update would be an approach like that of Chris Johnson and Hank Willis Thomas's "Question Bridge" (discussed previously), in which the subjects of the work might reflect among themselves, asking each other questions about the war, how they survived it, and offering their takes on the ethnic conflicts that emerged and what to do about them. There is also a recent platform called Cowbird.com, pioneered by Jonathan Harris, an invitation-only site for storytelling that encourages the use of photography, sound, and text for people to recount tales from their own lives. It finds similarities and connections between one person's stories and those of others, locating overlaps among people ("a vast, interconnected ecosystem") who might otherwise have considered themselves quite disparate. It has a "Saga" section where people can collaborate with others to tell stories relating to major events that affect millions— a useful tool for some emerging from conflicts. As with many of Harris's projects, the vision is both practical and transcendent. Online, when the project was initiated, he stated: "Our short-term goal is to pioneer a new form of participatory journalism, grounded in the simple human stories behind major news events. Our long-term goal is to build a public library of human experience, so the knowledge and wisdom we accumulate as individuals may live on as part of the commons, available for this and future generations to look to for guidance."[2]

If some such system were applied to the wars in Iraq and Afghanistan, to gun violence in the United States, or to violence against women in India, it might be useful to see how participants on various sides would be enabled to recontextualize and update the reporting, including the photographs online and elsewhere. What interconnectedness might also be identified by such a system between soldier and civilian, or American and Iraqi, or Sunni and Shia? It then might be possible to see if the question raised at the Dart Center panel on "Generation Iraq," as to whether the photojournalistic imagery from the conflicts—now commented upon, contextualized, and contested, as well as paired with more self-representational images—could be helpful in moving in the direction of peace.

Sometimes resistance to a conflict can emerge as it is happening. There are, as we have seen, numerous soldiers taking up cameras to photograph their own concerns—and their intimate understanding of the vicissitudes and repercussions of conflict sometimes renders images of resistance to what they perceive as injustice. The longstanding Israeli-Palestinian conflict has been contested by a group of young, frustrated, and anguished

Israeli soldiers who in 2004 founded the organization Shovrim Ha'shtika, or Breaking the Silence. They launched a photographic exhibition about their military service among Palestinians, *Bringing Hebron to Tel Aviv*, which now travels internationally. The exhibition is composed of their snapshotlike photographs of the day-to-day reality of service in Hebron, accompanied by the soldiers' own narratives. One intent is to make viewers in Israel realize that what is happening close by—but frequently treated as if in a parallel universe—can be sordid, and is poisoning their own society, including some of its most idealistic young people.

The uncomplicated directness of the photographs in *Bringing Hebron to Tel Aviv* adds to their persuasiveness. A banal image of rows of hanging keys that were seized from Palestinian drivers who had been stopped for breaking curfew is contextualized with the information that the keys' confiscation was against official Israeli policy—and also that the act could be difficult for teenage soldiers, who were asked to take away the car keys of people the age of their own parents. A picture of a young Palestinian boy seen through the scope of a sniper's rifle is addressed by a soldier who expresses his revulsion at the ease with which, out of boredom, he began to aim at just anyone, including children, particularly as this soldier had spent a number of his teen years as a youth leader. There is also a database of testimonies by Israeli soldiers collected on Breaking the Silence's website.[3]

Then there are several extensive projects aimed at rehabilitating societies after major conflicts. The 2006 book *A People War: Images of the Nepal Conflict, 1996–2006* emerged from work by Nepali journalist Kunda Dixit: it is intended as a photography of healing that poses the question "At what cost liberation?" The project was a response to his country's debilitating ten-year war, in which some fifteen thousand people were killed, many more were widowed or orphaned, and millions were forced to flee their homes. Working with Shahidul Alam from Bangladesh and Shyam Tekwani of Singapore, Dixit selected 172 photographs from approximately three thousand that were submitted (there was also an informal traveling exhibition that reached thirty-two districts and was seen by 350,000 people).

Interestingly, Dixit proposes that the book's truly iconic photographs may be recognized only in the future, when more is known: "Somewhere inside this book," he writes in *A People War*, "is the picture that will, years hence, be the defining moment of this conflict. A picture that brings together the suffering and bereavement that was heaped on top of a people who were already suffering from poverty, injustice and neglect. The book does not have pictures of actual battles, partly because most of them took place at night. But that is not what war journalism is supposed to be anyway, it should be about how war affects ordinary people."[4]

Like much of the work addressing transitional justice as societies try to emerge from civil wars and state-sponsored violence, *A People War* is also meant to serve as a

warning: "It proves the peoples' conviction that violence is a dead-end and we must all individually and as a nation work to ensure that Nepal never goes through such horror again," says Dixit. Two other books were published after it, *Never Again* (2008), with testimonies including those of visitors to the exhibition, and *People after War* (2009), which tracks the lives of those who survived it, some of them pictured in the first book. The trilogy, collectively titled "A People War," is to become a permanent exhibition on a floor of Madan Puraskar Pustakalaya in Patan Dhoka, an important Nepalese archive established in 1955, with more photographs and people's testimonies to be added. There are also said to be plans to make the exhibition the nucleus of a future Centre for Peace and Reconciliation through Photography.[5]

Sometimes photographs from conflicts help in the indictment of those responsible for war crimes—consider the photographic evidence used against Nazi leaders at Nuremberg, and more recently the inquests establishing responsibility in Northern Ireland for the deaths during 1972's "Bloody Sunday." Pamela Yates's 2011 documentary *Granito: How to Nail a Dictator* focuses on the leaders of Guatemala's genocide against its Mayan population in the 1980s, while combing archives for evidence. In a mass e-mail sent out on June 29, 2012, the film's producer, Paco de Onís, notified audiences about the film's update:

> *Granito: How to Nail a Dictator* has a new ending—the dictator, General Efraín Ríos Montt, was brought up on charges of genocide in Guatemala and placed under house arrest, so his appearance in court is now in our film. Ríos Montt is the first former head of state in the Americas to be charged with genocide—an amazing moment for all victims and *granitos* out in the world fighting to defend human rights and bring justice to perpetrators of mass atrocities. And we're proud that footage from *Granito* reinforced the prosecution's argument that Ríos Montt exerted command responsibility over the genocide.[6]

This older imagery refutes any denial of the gravity of the accusations, giving those who suffered the ability to point to supporting images. It is no longer, with the potential of their own revictimization, their word against those in power; here is documentation that, while in need of interpretation, still has evidentiary weight. "Granito: Every Memory Matters," an online sister project, also attempts to engage the 70 percent of Guatemalans who are below the age of thirty and know very little about their country's recent genocidal past. The intention is to create a memory bank, and a conversation among generations, with young people using mobile devices to interview older relatives about what they witnessed; included are army documents and police archives of the disappeared.[7] (Susan Meiselas's mural-sized imagery displayed at the same sites depicted in some of her photographs from Nicaragua's Sandinista

revolution also helped to inform the country's younger generation about their country's past.)

The Peruvian TAFOS collective (Talleres de Fotografía Social/Social Photography Workshops) was founded by German photographers Thomas and Helga Müller in 1986. Its objective: to use photography to provide peasants in the countryside—who were under siege by both government forces and Shining Path guerrillas—a means to resist the official iconography imposed by outside authorities. Rather than other powers dictating how to represent their existence (wearing certain traditional clothing was at times banned, for example), the photographers now could determine and record their own identities, and could concentrate on what was important to them. (An amusing incident of table-turning that spoke of the newfound autonomy of these photographers: before the current era of cheap and ubiquitous cameras, a tall, blond photographer visiting from Scandinavia focused on a Peruvian worker in the fields with a long lens; to the visitor's surprise, the Peruvian then produced his own, smaller camera and photographed the tourist in return.)

TAFOS's archive of two hundred thousand negatives was donated to Lima's Pontificia Universidad Católica del Perú and, in cooperation with the university, a compilation of the photographs was published as *País de luz: Talleres de Fotografía Social, TAFOS, Perú, 1986–1998* (Country of light: Social photography workshops, TAFOS, Peru, 1986–1998). In addition, seven hundred books were donated to libraries around Peru as, in Thomas Müller's words, a "returning of the visual memory."[8] Another archive of photographs, including some from TAFOS, was set up by Peru's Truth and Reconciliation Commission from which a compelling exhibition was curated: *Yuyanapaq* (in Quechua it means "to remember"), displaying photographs of two decades of violence. The exhibition remains open to the public, housed in the Museo de la Nación in Lima.

With the growing interest in imagery, archives are playing a bigger role, used as a resource to recall and relegitimize a cultural identity; in some cases the Web may be a helpful platform to research a people's past for those who lived it. Kurdistan was erased from the map after World War I when the Middle East was divided up by the countries that won the war, leaving the Kurdish people without a homeland, the largest ethnic group in the world without their own nation. As a response, Susan Meiselas created a method for the Kurds to crowd-source their own history—and it would become an influential model. After she had gone to northern Iraq to photograph the refugees and mass graves left by Saddam Hussein's brutal 1988 Anfal campaign of annihilation against the Kurds, she was inspired to seek out and copy photographs and other artifacts of Kurdistan from family albums, official archives, and elsewhere, placing what she found on a website: akaKurdistan.com. The site also solicited work for a visual history

from the Kurdish community. Members of the dispersed people were able to comment upon and contextualize the imagery, adding their own stories. A subsequent book, *Kurdistan: In the Shadow of History,* was published in 1997, with Meiselas's own photographs included; it was described in the *New York Times Book Review* as "the family album of a forsaken people, the archive of a nation that has not been permitted to exist."[9]

In an approach that is more personal, Argentine photographer Marcelo Brodsky presented his own 1967 eighth-grade class photograph from the Colegio Nacional de Buenos Aires, annotated with brief descriptions of what happened to each of his classmates, including those who were "disappeared" and killed by the government during Argentina's long military dictatorship (it was published in the 1997 book *Buena memoria* [Good memory]).[10] His own brother was killed, as were schoolmates, and Brodsky himself spent many years in exile in Barcelona. At a commemorative ceremony in 1996, the artist photographed a liminal moment when visitors looked at photographs of fellow students and victims, while including the reflection of their faces: "The photos of the reflected faces are among the most important aspects of my work as they illustrate the instant in which the generations exchange experiences," Brodsky notes. (French artist Christian Boltanski's sculptural works commemorating the lives of Jewish schoolchildren who were deported from France by the Nazis evoke a similar pathos: the artist utilizes found photographs, electric lights, and candles to create installations that conjure a haunting sense of the children's disappearance and death.)

Others in Argentina have also worked to reclaim the past. Lucila Quieto's "Arqueología de la ausencia" (Archaeology of absence, 1999–2001), for example, consists of a series of constructed photographs in which adult children of the disappeared were invited to create a new photographic portrait with their missing parent. In his 2007 project "Ausencias" (Absences), Gustavo Germano rephotographed people in the same locations where they had been photographed decades earlier—although now these people have significantly aged, and in each photograph there is someone obviously missing (page 96). The twinned images evoke the lives never lived by those who had been disappeared, and the lives of the living who have grown older bereft of their loved ones. The loss is doubled.[11]

Marcelo Brodsky continued his investigation of the past with a 2005 book of collected works by essayists and artists, *Memoria en construcción: Debate sobre la ESMA* (Memory under construction: Debate about ESMA—ESMA, Argentina's school for naval mechanics, was used as the country's largest detention and torture site during the dictatorship from 1976 to 1983). *Memoria en construcción* reflected conflicting perspectives on memorialization for ESMA, where some 5,000 people died, and only 150 are said to have survived. In a country that continues to be traumatized by these abuses,

with many contested versions of history and strong voices for it to be left unexplored, ESMA reopened as Latin America's largest human-rights museum in 2008. Numerous street artists have recently taken to creating pieces memorializing those who died there decades before.

The newly reconceived "memorial space" at ESMA is one of many kinds of attempts to come to terms with harrowing events of the past. In fiction, W. G. Sebald's 2001 novel *Austerlitz*, an extraordinary evocation of the difficulties of confronting traumatic memories directly, uses photographs intermittently through the novel's text.[12] The narrative is about the attempt to find a perspective on the past by grappling with it indirectly, waiting for memories to surface, and then testing those memories to see how authentic they might be—with photographs as no more than vague reference points. In *Austerlitz* the photographs might be about the protagonist and what happened to him before his parents sent him on a *kindertransport* to a British foster family to try and save him from the Nazis. Or they might be pictures that the novelist picked up at a flea market that have little to do with the protagonist's quest. It is also unclear whether the more ambiguous images evoke memories better, or worse, than photographs of the actual events. This novel can serve as a complement to the process (mentioned previously) that Riley Sharbonno used, in collaboration with Monica Haller, to try to remember what had happened to him when he served as a medic, when, with too many difficult moments to digest, he "stored them as photos to figure out later."[13]

Some photographers also try specifically to be helpful to communities attempting to resolve their grief after tragedies. Pedro Linger Gasiglia in El Mozote, El Salvador, and Gilles Peress in Srebrenica and Vukovar, Bosnia, as well as others, have photographed the bones, clothing, and other objects from mass graves to help forensic scientists identify victims so that their families can finally know with some certainty what happened to their loved ones. Evoking the survivors' pain, Patricio Guzmán's disturbing 2010 film *Nostalgia de la luz/Nostalgia for the Light* is concerned with the Chilean government's refusal to share the information with family members as to where their loved ones' bodies were dumped when they were forcibly disappeared; the film documents women repetitively searching the landscape, not being told what happened only decades before. At the same time, an observatory nearby allows astronomers to look into the sky and see events that happened millions of years ago.

Photographers, too, experience physical and psychological trauma when they are in the midst of turbulent and violent situations, although many do not like to talk about it. The Dart Center for Journalism and Trauma at Columbia University helps journalists deal with their own experiences, both professional and personal, while offering guidance on how to interview and depict victims of trauma. It is an increasingly dangerous profession: seventy journalists were killed in the field in 2012 (twenty-eight of them

in Syria alone).[14] Sebastian Junger, who worked with the late Tim Hetherington in Afghanistan on the documentary film *Restrepo*, recently launched Reporters Instructed in Saving Colleagues (RISC), to provide freelance journalists with instruction in emergency medical care. Junger was motivated to set up the program after being informed by a combat medic that Hetherington, who was wounded by shrapnel in Libya, might have survived his injury if someone on the scene could have stopped the bleeding for another ten minutes, until he reached a nearby hospital.

The making of photographs has also been a way for photographers to communicate some of their own personal circumstances, and to try to heal. As Peress has asserted: "Photography is something I do to stay sane and to process my relationship to the world. It is a little bit like grieving."[15] Some have been quite open about difficult moments in their own lives. Linn Underhill's 1981 book *Thirty Five Years/One Week*, raw with emotion, is an extraordinarily loving tribute to the life of her sister, diagnosed with cancer, told through photographs, a typewritten narrative, and dictionary entries dealing with the terms related to sickness. Nan Goldin has shared her own tribulations as she depicted the community around her. More recently, Phillip Toledano's website Days with My Father explores his relationship with his aging father, who suffered from short-term memory loss. "After a while," Toledano confides in the viewer, "I realized I couldn't keep telling him that his wife had died. He didn't remember, and it was killing both of us, to constantly re-live her death. I decided to tell him she'd gone to Paris, to take care of her brother, who was sick. And that's where she is now." With a large readership online, *Days with My Father* was published as a book in 2010 (viewers voted for the cover), and produced by MediaStorm as a 2012 film, *A Shadow Remains*.[16]

Concerned about the planet on which we live, some also seek to promote healing out of a sense of responsibility to the next generation. A longtime mountaineer and environmentalist trained as a geologist, photographer James Balog works strategically in an effort to prevent future disasters. "Back when I started, everybody was looking at wilderness," he told me. "That's all you ever heard about. If you were a concerned nature photographer, all you were doing was celebrating wilderness, and trying to make it look beautiful and put that in pictures." He has worked on the intersection of humanity and nature on several projects, including series on animals facing extinction, big game hunting, and very tall trees; currently he is concentrating on ice and how it can be measured as a gauge of global warming.

Balog's "Extreme Ice Survey," begun in 2007, combines his own elegant photographs of ice with imagery made by automatic cameras, so as to let scientists and the public see and measure its disappearance: "We've got these cameras on glaciers all across the

Northern Hemisphere, in really wild, remote places—Greenland, Iceland, Alaska, the Rockies," he explains. "These cameras shoot every hour of daylight, around the clock, as long as it's daylight. We collect from each camera a minimum of four thousand pictures a year, and put those together in time lapses that animate the life of the glacier." And the glaciers are quite alive. "Everybody thinks that glaciers are these big, dead, static objects where nothing happens. Well, guess what? . . . they're reacting to climate all the time. The smaller the glacier, the faster it reacts to the local climate, sometimes in weeks or months."

The work, for Balog and others grappling with the environment, can take an emotional toll. Both as a human being and as a father of two girls, he says, "I just can't stand the thought that it could be our generation that leaves this planet in disastrously damaged condition." But he believes that there is a crucial role for him and for others: "Dealing with climate change is certainly an economic problem, and it's certainly a technological problem and a policy problem. But I've come to the conclusion that the bigger problem is perceptual and psychological . . . I want to use the camera as a vehicle for changing perception, [. . . and to keep people] from avoiding responsibility, and keep them from being complacent."

Balog is also aware that this is not a straightforward process, in part because of the viewers' finite tolerance for difficult images. "If you do a study of endangered wildlife in Africa, you can go and you can photograph piles of slaughtered corpses and bush meat in a market in Brazzaville. But there's a real limit to how much people will want to look at those pictures, and to how much you're going to communicate," he observes. "I've tended to look for an engaging way, not always a beautiful way, to pull people into the subject and make them care about it. And then, at the same time . . . [to] deliver a message behind that beautiful picture that says, 'Things aren't what you wish they were; things aren't what they could be.'"[17]

Sometimes a solution is serendipitous. In 2002 environmental photographer Michael "Nick" Nichols's photographs of Gabon's wildlife were shown in a hotel room to the country's president, El Hadj Omar Bongo, by Nichols's colleague, conservationist J. Michael Fay. Impressed by the beauty of his own country—which, for the most part, he had not seen (much of it is jungle with few roads)—the president then decided to create a network of thirteen national parks.[18]

At other times imagery needs to be employed with more premeditation. Shahidul Alam (whose collaboration with Kunda Dixit was mentioned earlier) is founder of the Drik photo agency and the Pathshala South Asian Media Institute in Bangladesh, as well as of the website Majorityworld.com, the aim of which is to include work by non-Western photographers in the global media market. Alam notes the case of Bangladeshi photographer Munem Wasif, whose project on his country's extensive environmental

problems, including those caused by global warming, was little known domestically. On the other hand, a single, particularly strong image by Wasif concerning the future of jute workers, shown in an open-air space in Old Dhaka rather than at the usual more affluent venues, did make a major impact. In Old Dhaka, where the image could be seen from the perspective of workers afraid to lose their jobs, it had a stronger resonance than it might have had elsewhere.[19]

With the world's highest reported rate of incarceration, the U.S. prison population becomes a cloistered, nearly invisible, separate universe. Lori Waselchuk's "Grace before Dying" (2011) documents the hospice program at Louisiana's Angola Prison, in which prisoners provided personalized care for other inmates in the last stages of their lives. Memorial quilts were also made by hospice volunteers. Her photographs and the quilts themselves were first exhibited at the Louisiana State Penitentiary Museum and hospice chapel, then went on to tour correctional facilities in Mississippi and Louisiana to encourage the integration of hospice programs as part of prison health care. Buses were made available to take visitors to see the prison's cemeteries, along with a larger portion of the massive prison grounds.

Based on seven years of fieldwork, Ed Kashi and Julie Winokur's *Aging in America*, a 2003 book and film, portrays issues surrounding another marginalized sector. The project was widely featured in magazines and as a Web series on MSNBC.com (where more than one million people viewed it), as well as at the 2004 Democratic Convention, where Kashi's photographs were presented. According to Winokur, the film is used in more than five hundred universities, in courses such as geriatric nursing and social work, health policy and financial planning, as well as by long-term care facilities to help train their employees and to inform family members. Why? "Because our materials are so visual, they have helped personalize and dramatize the issues in a way that statistics and policy papers simply can't achieve," she says.[20]

Dutch photographer-and-reporter team Robert Knoth and Antoinette de Jong explored the devastating health effects of nuclear accidents and testing in Eastern Europe between 1999 and 2005. Greenpeace and UNICEF circulated the work in areas where people had been exposed to radiation but were unaware of the potential consequences. In her 2012 testimony before the European Parliament, de Jong stated: "In the children's hospital in Gomel in the south of Belarus congenital defects, cleft palate, no ears, no nose and children with very serious hydrocephaly, have more than quadrupled."[21] An excerpt from their project, titled "Nuclear Nightmares: Twenty Years since Chernobyl," was published online at PixelPress in 2006; it was for a short time one of the 2,500 most viewed sites in the world, and provoked substantial debate in the blogosphere, particularly among young people. Knoth and de Jong's book on those victimized, *Certificate no. 000358: Nuclear Devastation in Kazakhstan, Ukraine,*

Belarus, the Urals and Siberia, was published in 2006, "to highlight that these people were just treated like documents—as if they had no life, and as if they were not living people with a story to tell."[22]

The project, which has been exhibited in full or in part at some eighty locations, including at the European Parliament, the U.S. Congress, and the United Nations headquarters, is said to have had multiple impacts: according to Greenpeace, the provincial government of Tatarstan tabled plans to discuss the building of a nuclear reactor at the same time that the exhibition was getting extensive press coverage; more recently, an agency of the federal government there launched a program to relocate families away from the banks of the Techa River, polluted by radiation; vigorous debates on the safety of nuclear power ensued on the local level; and more sanguine points of view of various international organizations on nuclear safety were seriously contested.[23]

When such collaborative strategies succeed they can be exhilarating, and provide an experience very different to that of working in conventional journalistic media. A year after leaving my position as picture editor of the *New York Times Magazine*, I founded the Photojournalism and Documentary Photography one-year educational program at New York's International Center of Photography. At ICP I received a call from photographer Bruce Davidson, well known for his documentary work focusing on the city's East 100th Street.[24] Davidson asked if my ICP students could help the East Harlem Urban Center to provide photographic evidence that would be useful in court. In underhanded attempts to gentrify the neighborhood, landlords had been letting buildings fall into disrepair so that the tenants (usually Latinos without much money) would be forced to move out. Once the inhabitants were gone, the landlords would repair and upgrade the buildings, and then charge significantly higher rents to newcomers from outside the community. (ICP, on East 94th Street at that time, was located two blocks from East Harlem.)

In black-and-white photographs, the ICP students—half of whom spoke Spanish— showed a falling staircase, a broken boiler, a hole in the roof, and other manifestations of neglect. Then they went further, creating a multimedia slide show that incorporated these cases of dereliction within the larger, more vibrant context of neighborhood life, attempting to show some of what might be lost from gentrification; the show was projected in many local venues, including churches. The slides and sound track were constantly re-edited in response to the comments and criticisms of those who lived in the neighborhood (the music needed to be livelier, we were told, and one portrait of a young man proudly holding his small daughter in their apartment was criticized for its inclusion of a beer bottle on a table, which a resident felt cast aspersion on the entire community as alcoholics).

In contrast to my experience at the *New York Times*, here one could continually test the impact of the work while it was in progress, and solicit responses from the subjects themselves in person—however painful that might sometimes be. A number of city lawyers who needed to know more about the abuses came to our classroom to watch the projection; the East Harlem Urban Center showed it to the mayor's task force on housing development; more mainstream journalists also became better informed through the students' efforts.

And the project went on to have an influence, in more conventional form. After the students' involvement ended, one of the photographers, Joseph Rodríguez, kept working in East Harlem on his own. Switching to color, he photographed every Sunday, and (with the help of Howard Chapnick from the Black Star photo agency) his work was eventually shown to *National Geographic*, which featured it as the magazine's May 1990 cover story, "Growing Up in East Harlem." Ironically, it proved at that time to be too difficult for the organization; the piece contributed to the replacement of *National Geographic*'s editor, Wilbur Garrett. According to a senior editor at the magazine (who spoke on condition of anonymity): "As Mr. Garrett took the magazine in a more realistic direction . . . Mr. Grosvenor [the National Geographic Society president and chairman] wanted it to be like the old days, with a rosy view of the world."[25]

South African photographer Gideon Mendel, who had long documented the effects of apartheid, began in the 1990s to look at another dilemma: AIDS in Africa and its effects on individuals, families, and communities. As Mendel wrote in a piece for the *Guardian* in 2005: "The statistics are terrifying—more than 29 million people across the continent are living with HIV. These days I try to make images of the normality of people's lives."[26] At that time, overall in Africa, only 8 percent of those needing antiretroviral (ARV) drugs were getting treatment—and this was when many in the West were against providing such drugs, skeptical that Africans would be disciplined enough to take their medicines consistently.

Mendel's focus was on Lusikisiki, a poor and underdeveloped Eastern Cape province of South Africa where one third of pregnant women were testing positive for the virus that causes AIDS, a figure suggesting that roughly 10 percent of the area's population overall was infected: a minimum of fifteen thousand people. In Lusikisiki, beginning in 2003, generic ARV drugs were being given to the sickest through a project to distribute medicine called Siyaphila La (meaning "we are living here" in the Xhosa language). Siyaphila La was set up by Doctors Without Borders South Africa, the Nelson Mandela Foundation (Mandela was born nearby), and the local health department, in its first two years placing more than 1,100 people on ARVs at a cost of $270 per person annually.

Mendel made three trips to Lusikisiki in 2004–5 to see how those given treatment were progressing. One boy, Zamo, had already lost his mother to AIDS and his father was very sick; he too was HIV-positive. After a few months of the treatment, Zamo said: "I am stronger. I can play the ball much better now. I talk to my friends about taking the pills, and they are happy to see me stronger. At school, I am finding I can learn better, and often know the answer when our teacher asks a question."[27] Some 10 percent of victims died even with the drugs, often because the treatment was started too late.

Nonetheless, Mendel's ability to show the positive impact of the Siyaphila La program on people living with HIV—rather than focusing only on the disease's destructiveness—provided a model that others could learn from and a reason to begin or expand similar programs. He went back again in 2007 to Lusikisiki, and photographed Nomphilo Mazuza, age twenty-seven, who on Mendel's previous trips had been very sick and emaciated, with almost no functioning immune system. Mazuza's life had been saved and she was now quite healthy; Mendel photographed her posing outdoors with her two young sons. Annemarie Hou, director of communications at UNAIDS, commented on the impact of his work: "While devastation 'sells' it can become a spiral to continue to only show despair—Gideon has been able get people to respond to what is actually happening good and bad. His stories then are shared over and over to help show what is possible. . . . I think it would not be too bold to say his work helped us reach 8 million people on treatment today."[28]

Often what is most helpful, of course, is finding and offering new ways to raise money. "Access to Life" was a collaboration, beginning in 2007, between Magnum Photos and the Global Fund to Fight AIDS, Tuberculosis and Malaria, which continued Mendel's focus on healing. Photographed in nine countries by eight photographers, each working over a period of about four months, the project was intended to demonstrate the efficacy of providing free ARV drugs to those who need them. According to epidemiological surveys, approximately 80 percent of people who had access to the medicine were found to have survived two years later in resource-poor countries, but only a third of those in need of treatment were actually able to obtain the drugs.

The Magnum photographers were hired to collaborate with the Global Fund so that it could raise the requisite hundreds of millions of dollars to continue its much-needed work. (As of the end of the previous year, the Global Fund's bequests to local organizations had already enabled two million people to receive ARV medicines in 140 countries.) The drugs not only saved people from certain death but often allowed them to resume their roles as parents and workers. As Mark Lubell, Magnum's New York director, pointed out, the Global Fund provided financial aid to capable organizations without micromanaging the process for them on the ground. A finely produced book, along with an exhibition and a website showing the results in a powerful visual manner,

would be essential in persuading donors—mostly Western governments—that their money was being put to good use.[29]

The Global Fund's director of communication, Jon Lidén, himself a former journalist, called the "Access to Life" project "a thinking man or woman's approach to success stories," demonstrating some of the complexities of treating people with so many pressures on their lives.[30] But one problem was that the Global Fund producers had to find people under treatment who were willing "to have their faces travel the world"—not a simple proposition given the potential repercussions in places where they might be stigmatized. While the photographers were left alone to shape their stories, coming up with gritty, intimate, often painful imagery, the difficulties of finding people beginning their treatments during a particular week, then to be revisited sixteen weeks later to document their progress, led to some skewing of the results.

While 80 percent of the forty-five people who were visited by the photographers for this project did survive (following the expected average), in three of the nine countries in the study the majority of the subjects who were documented had died within the four-month period during which they were photographed. (In Russia, three out of four people died, although, according to Lidén, on average 90 percent of HIV victims in the country thrive on treatment.) Some of those photographed were already quite sick before treatment began, and had a number of serious health issues other than AIDS. Not wanting to confuse with misleading results from a few cases, the Global Fund was of the opinion (and Magnum agreed) that the book and exhibition would have to be edited somewhat to indicate outcomes that were statistically closer to the general results, so as to be able to say to donors "This works," encouraging them to continue the financing of essential programs.

Working with journalistic media, as Lidén pointed out, may not be any more straightforward. (Philip Jones Griffiths defined a typical editorial assignment shortly before his death in 2008: "We want the photographer to go to country X and illustrate our preconceptions.")[31] Lidén's view was that it was a "marriage, not an exploitation," between photographers and NGOs. Organizations that survive by demonstrating their successes often do accent the positive, and in this case the editorial adjustment was seen as both more factually correct in the larger scheme of things, and necessary in order to ensure that more people live healthier lives.

Examining other, earlier responses to humanitarian emergencies, David Rieff, in his critical 2003 book *A Bed for the Night: Humanitarianism in Crisis*, remarks somewhat sardonically: "The first and greatest humanitarian trap is this need to simplify, if not actually lie about, the way things are in the crisis zones, in order to make the story more morally and psychologically palatable." Rieff cites a provocative remark by Rony Brauman, a former director of Doctors Without Borders, that if the Auschwitz

extermination camp were in operation today it would be referred to as a "humanitarian crisis." "By calling some terrible historical event a humanitarian crisis," Rieff continues, "it is almost inevitable that all the fundamental questions of politics, of culture, history, and morality without which the crisis can never be properly understood will be avoided. And the danger is that all that will remain is the familiar morality play of victims in need and aid workers who stand ready to help if their passage can be secured and their safety maintained."[32]

Aid organizations are of course not the only ones who simplify. Rieff's remarks could easily be applied to enormous numbers of journalistic outlets, including television. At a 2009 panel on "Access to Life" at the New School in New York, MaryAnne Golon, former picture editor of *Time* magazine, enthusiastically presented an excerpt from the project that had been published in *Time*. (Magnum had previously proposed that the magazine devote most of an issue to it.) Responding to a question, she asserted that the primary sponsors of in-depth photographic essays were no longer magazines, but foundations and organizations such as the Global Fund, a trend that has probably only been intensified since then. ("Access to Life" was also a project that few magazines would have been able to afford, or been interested in enough, to assign to photographers.) Given the character of the project as advocacy in support of the Global Fund's mission, one non-Magnum photographer privately remarked that *Time*'s excerpt was no more than an "advertorial."

The day after that panel, the World Bank, which uses a different sponsorship model than that of the Global Fund, released an internal report arguing that projects it had been supporting to fight AIDS had not been very successful:

> A vast majority of the World Bank's projects to combat AIDS failed to perform satisfactorily over the past decade, with the ones in Africa, the region at the epicenter of the pandemic, registering the worst record, according to a new internal evaluation. Seven of 10 AIDS projects that the bank financed around the world — and 8 of 10 in Africa — had unsatisfactory outcomes, according to the evaluation. . . . The projects were typically too complex for the weak or inexperienced bureaucracies carrying them out, researchers found. And coordinating the dozens of donors, nonprofit groups and government agencies involved made delivering results very difficult.[33]

It is doubtful, in the publications of the large numbers of humanitarian organizations working for world betterment, that one would find many images illustrating the conundrums cited in the World Bank report. Nor is the journalistic media always paying attention: one photojournalist working in the Sudan, for example, tells of an unspoken rule among his colleagues not to include the aid organizations' large SUVs

in their photographs, preferring also not to reference the colony of aid workers in air-conditioned offices. In their imagery they wanted to give the impression of a more direct view of the Sudanese themselves—or, one might conclude, to create parallel universes.

Financially, "Access to Life" was reported to be a major success. Later that year, Mark Lubell of Magnum received an e-mail message from the Global Fund letting him know that their project had directly led to the raising of a billion dollars. Lubell was also told that the prime minister of Japan, Naoto Kan, having spent forty-five minutes viewing the exhibition, doubled his country's contribution to the Global Fund to eight hundred million dollars.

Kan mentioned "Access to Life" in a 2010 speech to the United Nations General Assembly. According to a draft of his speech posted online: "Earlier this month, I visited the Global Fund's photo exhibition 'Access to Life,' which was held in Japan. . . . The recent photo exhibition gave me an opportunity to renew my awareness that in Asia, Africa, South America and in many other places in the world, a large number of people affected by AIDS are still losing their lives."[34]

The sentiment of the Japanese prime minister was echoed by communications director Lidén as he stepped down from his post at the Fund in 2012: "During its first ten years, the Global Fund managed to bring the faces and life-stories of individual women, men and children—and the urgency of saving their lives—into the rooms where decisions about billions of dollars are being taken. And the decisions are better because of it."[35]

While the glossy book *Access to Life* was not intended for the shelves of its subjects, the photographers did make them and their predicaments better known. As Judith Butler writes in her 2009 book *Frames of War*: "Specific lives cannot be apprehended as injured or lost if they are not first apprehended as living."[36]

There are many roads to healing and to peace, to rehabilitating wounds that are both psychic and physical, and to preventing further catastrophes of war, disease, and environmental degradation. If these developing strategies are given more attention, then undoubtedly more thinking, more funding, and more experimentation will ensue. There are certainly a multitude of approaches still to be conceived, and there is much depending upon them.

NOTES

1. Robert Adams, *Beauty in Photography: Essays in Defense of Traditional Values* (Millerton, N.Y.: Aperture, 1981).

2. See Jonathan Harris, at http://cowbird.com/about/. The statement cited here is from an earlier outline of the project.

3. Breaking the Silence: Israeli Soldiers Talk about the Occupied Territories, http://www.breakingthesilence. org.il/.

4. Kunda Dixit, *A People War: Images of the Nepal Conflict, 1996–2006* (Kathmandu: Publication Nepalaya, 2006).

5. See http://www.apeoplewar.com.np/.

6. Paco de Onis's e-mail also announced that *Granito: How to Nail a Dictator* and its predecessor, *When the Mountains Tremble* (1983), were to be made available worldwide, in collaboration with the U.S. broadcaster P.O.V., for free online streaming in English and Spanish.

7. See "Granito: Cada memoria cuenta"/"Every Memory Matters": http://granitomem.com/.

8. Thomas Müller, e-mail correspondence with author, January 27, 2013.

9. Susan Meiselas, *Kurdistan: In the Shadow of History* (New York: Random House, 1997; 2nd ed. 2008). See Karl E. Meyer, "Poets and Warriors," *New York Times Book Review*, February 22, 1998.

10. Marcelo Brodsky, *Buena memoria* (Buenos Aires: La Marca, 1997).

11. I am indebted to Julio Menajovsky of the Archivo Nacional de la Memoria in Buenos Aires for sharing his presentation with me, given in 2006 at the second Bienal Argentina de Fotografía Documental, in Tucumán, Argentina, titled "Fotografía, identidad y memoria: La representación del terrorismo de stado, y fotografía: Entre el documento y la intervención" (Photography, identity and memory: The representation of state terrorism, and photography: Between document and intervention).

12. W. G. Sebald, *Austerlitz* (Munich: Carl Hanser, 2001; Eng. trans. New York: Random House, 2001).

13. Riley Sharbonno, in Monica Haller, *Riley and His Story* (Paris and Värnamo, Sweden: Onestar Press/ Fälth and Hässler, 2009/2011).

14. See the Committee to Protect Journalists, http://cpj.org/killed/2012/.

15. Gilles Peress, in conversation with MaryAnne Golon, Look3 photography festival, Charlottesville, Virginia, June 13, 2009, cited by Erica McDonald, http://www.ericamcdonaldphoto.com/#/ scribbling-in-the-dark---photographers-talks/scribbling-in-the-dark---look3-peress-2009.

16. See Phillip Toledano, http://www.dayswithmyfather.com/; and *Days with My Father* (Auckland, N.Z., and San Francisco: Blackwell/Chronicle, 2010). See also the film *A Shadow Remains* at MediaStorm, http://mediastorm.com/publication/a-shadow-remains.

17. James Balog, interview with the author. See "Of Art and Ice: James Balog," *Aperture* 198, Spring 2010.

18. See David Quammen, "Africa's New Parks," *National Geographic* Online Extra, September 2003. http://ngm.nationalgeographic.com/ngm/0309/feature3/fulltext.html.

19. Shahidul Alam, e-mail correspondence with author, March 28, 2009.

20. Julie Winokur, e-mail correspondence with author, May 26, 2009.

21. Antoinette de Jong, "Nuclear Devastation in Kazakhstan, Ukraine, Belarus, the Urals and Siberia," testimony at the European Parliament, February 29, 2012. http://www.unpo.org/downloads/425.pdf.

22. Ibid.

23. See Robert Knoth and Antoinette de Jong, *Certificate no. 000358: Nuclear Devastation in Kazakhstan, Ukraine, Belarus, the Urals and Siberia* (Amsterdam: Mets & Schilt, 2006). A Web excerpt was published in 2005 at http://www.pixelpress.org/chernobyl/index.html.

24. See Bruce Davidson, *East 100th Street* (Cambridge, Mass.: Harvard University Press, 1970).

25. "Geographic Society Replaces Its Editor in Unexpected Move," *New York Times*, April 17, 1990.

26. Gideon Mendel, "An Answer in Africa: In the latest in his Aids in Africa series, photographer Gideon Mendel now focuses on a remote rural project that is not only treating the sick—but may be a model for the continent," *Guardian*, November 25, 2005. Mendel's interactive project profiling specific people who were getting antiretroviral treatment against HIV/AIDS can be found at http://www.guardian.co.uk/aids/answerinafrica.

27. Ibid.

28. Annemarie Hou, e-mail message to author, September 12, 2012.

29. The resulting book was *Access to Life* (New York: Aperture/Magnum/Global Fund, 2009).

30. Jon Lidén, telephone interview with the author, June 4, 2009.

31. Philip Jones Griffiths, panel discussion at "Live from the NYPL: Magnum @ 60," New York Public Library, June 16, 2007.

32. David Rieff, *A Bed for the Night: Humanitarianism in Crisis* (New York: Simon & Schuster, 2003).

33. Celia W. Dugger, "Report Says World Bank's AIDS Efforts Are Failing," *New York Times,* April 30, 2009.

34. Naoto Kan, "Promise to the Next Generation," speech to the General Assembly of the United Nations, New York, September 22, 2010. http://www.kantei.go.jp/foreign/kan/statement/201009/22speech_e.html.

35. Jon Lidén, quoted in William New, "Global Fund Communications Director Steps Down," Intellectual Property Watch, February 13, 2012. http://www.ip-watch.org/2012/02/13/global-fund-communications-director-steps-down/. Internal audits by the Fund itself that had been publicized in the press in early 2011 showed that some of their allocations in four African countries were being misused, a small percentage of their total outlay, and not unusual in the world of aid. But several governments threatened to withhold their donations to the Global Fund, leading to an internal reorganization. Bill Gates, cofounder of the Bill and Melinda Gates Foundation, responded more calmly: "Given the places where the Global Fund works," he said, "it was not surprising that some of the money was diverted for corrupt purposes."

36. Judith Butler, *Frames of War* (New York: Verso, 2009).

CHAPTER 6
The Front Page and Beyond

It was midnight in a small hotel in La Plata, Argentina. After showing hundreds of slides and speaking for two hours about the recent history of photojournalism to the young photographers there for a one-week workshop, I'd had a call from my wife in New York. We chatted on the hotel phone for a quarter of an hour. To my surprise, when I came back to the informal classroom, though the lecture was long finished, most of the fifty-three students were still waiting, along with some of the other faculty (there were ten of us), to continue the discussion.

"How can I take a photograph to change my government?" The urgency of this question—posed late that night in 1989 by a Chilean photographer whose friends had suffered under his country's police state, and were still at risk—has never left me.

In La Plata, there had been an attempted insurrection on the first day of the workshop, not far from the hotel. For several hours we checked the small television sets in our rooms as undercover police in blue jeans fired their guns at people also wearing blue jeans. Shots were fired by one side or the other from behind parked cars; sometimes, barely looking, shooters would fire backward over their shoulders. It was nothing like a well-groomed, crisply lit Hollywood movie, with each side wearing different uniforms. It appeared chaotic, amateurish, and deadly—indeed, several people were killed.

Why did only four of the fifty-three young photographers in La Plata for the workshop—from Argentina, Brazil, Chile, and Uruguay—go and cover the mêlée, when nearly all of them were professional photojournalists? Some had been imprisoned or in exile during previous regimes. "We've had many attempted coups," I was told, "but this is our first workshop." Their rather disjointed portfolios suddenly began to make more sense to me: a few photographs of flowers, a picture or two of tanks, some portraits, then more flowers, followed by a few more tanks—this was their disturbing reality in the 1980s.

A parade by the police and military honoring their colleagues killed during the

unsuccessful coup passed directly in front of our hotel later that week. Many from the workshop went out to photograph at that point. Some, unexpectedly, were arrested, put into unmarked Ford Falcons and taken away. Groups of faculty and students went in search of those missing: disappearance in Argentina was hardly trivial. Now, thankfully, those missing were gradually located in the mazelike local police stations. The workshop leaders argued for their release (the fact that the workshop was sponsored by Kodak was helpful).

Why were only certain photographers arrested? There was speculation that it might have been because some of them had Nicaraguan visas. But it turned out also that those who held their cameras at the parade like tourists—that is, steadily in front of their faces with a fixed gaze—were generally left alone. Those arrested had a tendency to photograph more abruptly, putting the camera quickly to their eye and then dropping it. Later the police told us that some of them thought these latter photographers, appearing to work more furtively, had been making pictures of them as targets for future assassinations.

Wearing colorful *guayabera* shirts, two plainclothes policemen came to the workshop later in the week to apologize—or so they said. (Large pistols were barely hidden underneath their shirts.) They burst out laughing when they saw a photograph by one student of a couple kissing on a bench, part of a photo-essay on romantic encounters in the street. It had been made, it turned out, just as these policemen were arresting the photographer—somewhere in the background of the image there was a police station, which the policemen apparently thought was the subject of the photograph.

Not surprisingly, the week's events changed the character of the workshop. A couple of well-known documentary photographers who had come from around the world to teach wept as they projected their photographs of violence and strife before the entire group. For once, they felt understood—they did not have to convince anybody that the world could be like that.

The Chilean who had asked how to change his government cited the reaction to the famous 1968 photograph by Eddie Adams of a suspected member of the Vietcong being summarily executed. How could another photographer similarly roil his society so that it might rise up to oppose a government? (Don McCullin, while asserting his own failure to diminish conflict, has singled out the photogaphs by Adams and Nick Ut as the two images that did eventually help turn American public opinion against the Vietnam War.)[1] Given the dire circumstances in which many people live now, couldn't there be another photograph or a group of images that would ameliorate life significantly for those in intolerable conditions? More proactively, could one possibly anticipate what photograph would be helpful and go make *that* picture? Or could one cover a particular event and wait for something to happen that, once photographed, would be a spark to change one's government?

Certainly it is a great deal to ask of photographs. Even after the publication of

Adams's 1968 photograph, seven years passed before the Vietnam War finally ended, although newly elected president Richard Nixon's administration did order significant U.S. troop reductions in the following year, 1969 (and U.S. troops would leave Vietnam in 1973, the year after Ut's photograph was made). Adams himself was prouder of his 1979 reportage on Vietnamese refugees fleeing in boats, "Boat of No Smiles," which was thought to have helped loosen U.S. immigration laws for some two hundred thousand people being denied entry. He felt that his more famous photograph oversimplified and misrepresented what was actually going on, and he felt guilty that it ruined the life of the general who did the shooting.

But the thought that a photograph, or video, can focus a society on specific issues is nonetheless a seductive one. Sam Nzima's 1976 photograph of the wounded twelve-year-old Soweto schoolboy Hector Pieterson being carried by another student, Mbuyisa Makhubo, with Hector's sister Antoinette running beside them, similarly provoked public outrage. Pieterson and other schoolchildren had been shot in Soweto by South African government forces for protesting the imposition of Afrikaans as a language of instruction. The photograph became a symbol of apartheid-era brutality in South Africa: in 2002 an entire museum was founded linked to that single photograph, the Hector Pieterson Museum in Soweto.

The 1968 photographs of the My Lai massacre in Vietnam, released twenty months after the event by Army photographer Ron Haeberle, forced society to contemplate a different war than the one the U.S. government had been describing, and were also important as evidence in leading to a court case and the conviction of Lt. William Calley Jr. (initially sentenced to life imprisonment but freed after only three and a half years of house arrest). The 1991 videotape of policemen beating Rodney King in Los Angeles—an early and powerful example of citizen journalism—led to four police officers being put on trial (their acquittal sparked the 1992 Los Angeles riots in which more than fifty people were killed), and two eventually being convicted in a federal civil-rights suit. It also raised broader awareness of police brutality against minorities, again as evidence of activities that were officially denied.

It is worth reminding ourselves that, even in these days of too much imagery, the Abu Ghraib photographs did have an impact: a CNN/USA Today/Gallup poll, taken in 2003, just after the images were released, showed that nearly three-quarters of Americans said the mistreatment of the detainees was not justifiable under any circumstances. Bush's performance rating sank to what was then its lowest point: 46 percent. The poll also showed support for the war at its lowest since before it began.[2] As CNN later reported: "A year into the Iraq war, the American public had grown increasingly uneasy about the direction of the war, and the Abu Ghraib photographs gave anti-war protesters the ammunition they needed to rally around their cause and question Bush administration policies."[3]

Photographs that focus attention when there is already unease about certain policies undoubtedly have a greater chance of finding traction. But what can photographs do when there is already enormous anxiety about so *many* things, and news media thrive on continually exacerbating everyone's fears, including on issues that are transient and relatively minor? It becomes frustratingly difficult to still the barrage long enough to focus on any single issue, let alone to do something about it. And, given the complexity and scale of contemporary problems, there is considerable doubt among many that much can be done in any case to resolve them—so why bother?

A prominent photographer recently posed this question to me: "Has anyone seen a picture since Abu Ghraib that affected you like [Nick Ut's] of the girl being napalmed in Vietnam?" If such a picture were indeed made recently, it might not have registered in the swirl of issues and images. Or we might well have missed it altogether, given the rapid disappearance of something like a front page to tell us where to look. And its disappearance, like that of printed newspapers, seems to be accelerating: according to a 2011 speech by Francis Gurry, the United Nations agency head for the World Intellectual Property Organisation: "In a few years, there will no longer be printed newspapers as we know [them] today." He was rather sanguine in his analysis: "It's an evolution. There's no good or bad about it. There are studies showing that they will disappear by 2040. In the United States, it will end in 2017."[4]

The killing of visual journalist Tim Hetherington and photojournalist Chris Hondros in Libya, in March 2011, rocked the world of media, and many people personally. While talking about them to my class at New York University, shortly after their deaths, I realized that none of my students was familiar with their work. They were also unaware of Bryan Denton's photographs made during the anti-Qaddafi revolution in Libya, featured repeatedly in the *New York Times*, although only a few years before Denton had been an NYU student as well, sitting in the same room. In fact, in a small ceremony in Benghazi earlier that week, in an impromptu and eloquent eulogy for his older colleagues, Denton (quoting Plato) had compared Hetherington and Hondros, to "the torch-bearers of humanity—its poets, seers, and saints, who lead and lift the race out of darkness, toward the light. They are the law-givers, the light-bringers, way-showers, and truth-tellers, and without them humanity would lose its way in the dark."[5]

For a younger generation, print newspapers and magazines have already become increasingly archaic; in the ever-changing Internet environment serious imagery tends to get lost—particularly those images that require quieter, more prolonged contemplation. When I worked as a picture editor, we used to be concerned that a nearby

advertisement might diminish the import of a serious photograph; now the online image is often just one of many shuffled elements vying for attention, the ensemble easily and quickly displaced with a single click.

In this consumer-oriented, rapid-fire media, what issues come to the surface as societal priorities? Where is the communal glue that would focus large portions of society not only on that day's events, but on emerging concerns (and not only those that one is already obsessed about), when there still may be time to respond? Other than search-engine algorithms, which aggregate articles from elsewhere but hardly prioritize, where is the vision that cues us in as citizens so that we can try to determine what needs to be done? As Nancy Hicks Maynard, a former publisher of the *Oakland Tribune*, put it concisely in 1995: "Where is the front page in cyberspace?"

What happens to the sense of community that comes from proximity? Nearly twenty years ago, when I showed a pre-Web multimedia version of the *New York Times* that I had developed with Chris Vail to photographers in Paris, they were incensed. How would they know whom to sit next to in the café if they could not easily see which newspaper they were reading? Or, more broadly, how could one discuss the day's events on the train without knowing what article a neighbor is reading? In short: where were the common reference points to enable civil society to figure out its own future? (I am amazed, and dismayed, at the numerous e-mail messages that arrive almost daily from organizations that have decided what is best for me: preparing petitions and asking me to click "yes," as if I had no mind of my own, and neither did anybody else.)

Take the conflict in Syria. Or the state of the world as it warms. Or our schools and the education of our young people. Which of all the articles available for free online should we be reading? Which among the hundreds of thousands of images should we be looking at? Certainly none of us has time to look at them all. Perhaps it would make sense to ask those who know most about a given subject to help choose for us. When Hurricane Sandy hit New York and New Jersey in 2012, wouldn't it have made sense to ask a few people who experienced it (displaced homeowners, rescue workers, etc.) to select from the available imagery those photographs and videos that for them summed up the experience of the storm, and to tell us why? Certainly anyone would be free to make even more images, but maybe the greater problem is that there are already too many to comprehend.

Perhaps sometime in the near future we may begin to appreciate the suggestions of informed groups of people, a rotating cast of experts who have studied certain issues at length or lived through them, who can then guide us to the pieces online that we should be reading and looking at. We might value their input enough that we would be willing to pay a nominal sum for a new "front page"—one that will probably not look anything like the front pages of the past, given the rapid advances beyond paper into more

fluid environments. (My guess is that many would be seeing such a newly designed front page on their eyeglasses, as with Google Glass and other such inventions, with the GPS also encouraging the most micro-local news and advertisements—both an opportunity and another potentially acute set of distractions.)

This small sum, if collected from enough people, would also allow for new work to be commissioned: if a hundred thousand people paid five dollars per month, for example, that might enable an extraordinary painter to be sent to report on the transforming landscape of the Arctic, or a few innovative photographers to study the effects of gun culture in a range of countries, or a group with iPhones to report on the status of women in Egypt, or several inner-city students in a successful school to let others know why it is succeeding.

In making such assignments, innovative visual journalists could be urged to experiment with new media strategies that may be of value not only to readers of this front page, but to the entire documentary field. The effort might start with a small number of knowledgeable volunteers working as "curatorial advisors," using their social networks for advice, and then adding more to their ranks; a voting system could be implemented among the membership as advisors rotate on and off. A transparent code of ethics would need to be devised to let readers know how stories were created as well as to guide those being assigned, and short tutorials could be offered on new possibilities of reader-producer collaboration. There could even be a system of payment for material linked from other sites (such content would once again be esteemed to have financial value) that would be reciprocated for those linking to original material here. Perhaps the groups of advisors would be—like the editors and community leaders of yore—people we learn to trust. Perhaps, in forming these collectives of common interest we might learn to trust each other as well, and then find ways together to respond to those issues, both local and much larger, that we have identified as problems.

In 2011, at Aperture Gallery in New York, we tried creating a backward, inside-out exhibition that began to address some of these questions. It was called *What Matters Now?: Proposals for a New Front Page*. Rather than a conventional display of images already hung and ready to be looked at, we started with bare walls and people sitting around tables (and others Skyped in from around the world), discussing what each felt the rest of us should be aware of. There were five tables, each headed by a different moderator: Stephen Mayes of the VII agency; Iraqi artist Wafaa Bilal; *Aperture* magazine's editor-in-chief, Melissa Harris; curator and writer Deborah Willis; and myself. It was a ten-day collaborative effort—the public was invited both in person and via the Internet (there was a sixth table for anyone who walked in, or they could join any of the other five groups)—not only to fill the walls with the websites, photographs,

videos, multimedia pieces, drawings, and articles that guests and visitors recommended, but to explain why these selections were important.

It seems that we often find out only belatedly what we didn't know, but should have known. Or perhaps, given the search tools we now have, we tend to find out only what we *want* to know—or what, given our well-analyzed online interests, search engines decide to point out to us. On the very day that *What Matters Now?* opened to the public, September 7, 2011, CBS News reported: "According to the CIA's World Factbook, the United States now ranks 39th in the world when it comes to income inequality. What that means is that only 38 out of 136 countries have a less-equitable distribution of income than the United States; the list of countries with a more equitable income distribution includes Iran, Russia, Turkmenistan and Yemen."[6] Many had likely already suspected some kind of imbalance, but why had we not been told in such concrete terms? As of 2009 the combined fortunes of the United States' four hundred wealthiest people were equivalent to the combined wealth of the less affluent 50 *percent* of the U.S. population—a jolting disparity that no one seemed to know much about or was able to connect to the Reagan-era "trickle-down" theory of economics.

Our *What Matters Now?* discussions ended on September 17, the same day that Occupy Wall Street began—a nationwide movement peopled by protesters who were similarly shocked by the evolution of the country, and whose use of visual media was designed to a significant extent to help protect them from the police (protestors would record each other's arrests, on the lookout for instances of brutality). The conversations at Aperture preceding the protests reflected an uncertain status of both knowledge and citizenship among many attendees—what do we actually know (or expect to know), and what, if anything, can we do about it? Or, as one participant put it, the question is not *What matters now?* but *Does anything matter at all?*

If there was enough motivation for communities around the world to form similar "What Matters Now?" groups, they could recommend to other groups what to look at, serving as a communal filter. Some attendees commented that the building of a community of people talking to each other was the most important outcome of those ten days. Others found that what they appreciated most was the act of sharing their own personal front pages—stories from their native countries, their own backgrounds, or their areas of expertise.

Those at Stephen Mayes's table came to a conclusion that, in effect, the current environment makes explicit what was always problematic about media. He summarized their response: "Our current cultural anxiety stems from the loss of these fixed reference points and we're reaching out to replace them with new certainties, to find a new cultural consensus. But rather than looking for new conventions to replace the old, we should embrace the plurality and each take responsibility for our own management

of the information that flows around us."[7] Others at the exhibition felt differently—asserting that media strategies are necessary to prioritize events and issues, in order to create a community with at least certain similar preoccupations.

There have been attempts, making use of the Web, to systematize an approximation of the front pages of the future. Global Voices (globalvoicesonline.org), for example, foregrounds bloggers from countries that tend to be off the mainstream radar, or who may have insider perspectives on well-known issues. Socialdocumentary.net—with more than seven hundred exhibits (as of January 2013) submitted by its viewers—provides another contributory forum, for "photographers, NGOs, journalists, editors, and students to create and explore documentary exhibits investigating critical issues facing the world today";[8] it depends, of course, not on an overarching vision but on what particular photographers have been undertaking—from portraits of former members of the Vietcong by Don Unrau (who fought against them in the Vietnam War) to the daily life of people in Afghanistan by Paula Lerner.

Photojournalismlinks.com is an ambitious tracking system of much of what is being published, sorted by London-based photographer Mikko Takkunen, while Kickstarter and Emphas.is, systems for crowd-funding visual journalism, are ways to find out what subjects certain photographers in search of financial backing want to pursue, and to assist them should one desire to do so. (While many individual endeavors do find funding—perhaps because of the reputation of the photographer or the lure of the project itself—it may be considerably more difficult to find prominent homes for such projects.) Certainly Facebook can be useful for creating various communities of interest, as was seen during the Arab Spring and elsewhere, and Reddit (the self-described "front page of the Internet") is a system where highly idiosyncratic items—some serious and others along the lines of "My cat keeps trying to steal the feather duster"—rise and fall according to viewer voting. There is also software that allows one to take pieces from various journals to create a composite publication—although it may be difficult to find someone else compiling the same selection.

There are many technologies that have the potential to offer some help, and may transform the manifestation of what we think of as a front page—although with all these strategies the bridge between the individual and the larger world is uncertain, with the momentum, both economic and cultural, skewing toward personal preferences. Sixth Sense, in development at the MIT Media Lab over the past few years, is a cellphone-sized device that will allow one to project a newspaper onto the table while eating lunch, to make photographs by framing the air with one's fingers, and to superimpose new information to update older media, such as by projecting videos onto a printed magazine. (Pattie Maes, Sixth Sense's chief developer, somewhat ironically

suggested in 2009 that it might be adapted as a brain implant in a decade. But given the February 2013 approval by the U.S. Food and Drug Administration of an implanted artificial retina that functions in concert with a camera and processor for the visually impaired, the eventuality of such implants in various forms seems certain. And current experiments directly connecting the brains of rats so that they interface together — even thousands of miles apart — may offer the potential to do the same for humans one day.)[9] Google Glass and other such projects will similarly allow an augmented-reality overlay on what one sees, with GPS triggers that can be activated to show the history of a particular place as one walks through it; or perhaps to bring one to the Facebook page of the person sitting across the table via facial recognition, should it eventually be implemented; to simultaneously see what someone else is looking at; or to superimpose the news that one's far-flung friends have been reading that day. One can also use Foursquare and other such apps to get together with people who want to discuss health care, or the election, or the problems at a local school.

Some in the human-rights field are beginning to make use of new technologies to draw attention to world events, in order to do something about them. The United States Holocaust Memorial Museum's Google Earth site (the first initiative of their Genocide Prevention Mapping Initiative) and Amnesty International's satellite images have mapped out the massacres in Darfur. Another kind of "front page" — one of personal utility — includes interactive maps for disabled people in Barcelona, Geneva, and Montreal who would make GPS-tagged cellphone images for each other of places that may be difficult to traverse; other groups, including sex workers in Madrid and motorcycle couriers in São Paulo, have also shared imagery via "digital megaphones" at megafone.net.

One of the more experimental websites is This Is Kroo Bay, by Save the Children. It is an interactive site that attempts to immerse the viewer in the lives of residents living in a slum area of Freetown, Sierra Leone. Home to six thousand residents, Kroo Bay is built on a pile of rubbish, rife with malaria and cholera, without electricity or running water, and has a host of other problems. As the website puts it: "Kroo Bay is one of the worst places in Sierra Leone — a country that's officially recognized as the toughest place in the world to be born."[10] The site was created to allow a viewer to pan a camera 360 degrees around different locales, stop and hear stories from various residents as a way of getting to know them, watch "webisodes," with the hope that the viewer will emerge feeling that the experience, despite enormous distance, was a valuable, almost intimate one. Readers can send messages to each other or to the residents, and receive responses. People can contribute money while keeping an eye on developments in the neighborhood — Kroo Bay was able to open a clinic, for example, with the help of donations. While the experience is admittedly somewhat like watching reality

TV, it does make it possible to connect, if only virtually, with others in different circumstances (even though we are aware that the viewing is mostly one-way).

According to Rachel Palmer, Save the Children's London-based picture editor:

> We developed this project to push the boundaries of how an interactive experience can place our programme work in the homes of our supporters, to give them a "real life" immersive experience through cutting edge multimedia technology. . . . We wanted to give families a powerful sense of life there, and to show them how they could help. We believe this is a first in our sector, and raises the bar in communicating international development work. . . . This project has enabled people to connect with our work in a new and more meaningful way, helping us create deeper relationships with supporters. It has also generated very successful PR.[11]

Also looking for new audiences and engagements, the various social media, too, provide ways for photographers to attract their own followings, allowing them to increase the number of viewers looking at their photographs, while creating visual diaries and frequently sharing behind-the-scenes imagery. Such networks can be helpful in publicizing developing crises: John Stanmeyer recently photographed deteriorating health conditions among south Sudan's refugees for Doctors Without Borders, and collaborated with a number of organizations, including *National Geographic* and his own photo-agency, VII, to get his message out to more than half a million people: "We wanted to reach an additional quarter of a million Médecins Sans Frontières' [Doctors Without Borders] Twitter followers, tens of thousands on Facebook, and even more on Instagram." By giving Stanmeyer permission to use their Instagram account, *National Geographic* added another two hundred thousand viewers.[12]

The obverse side of the mirror is that all of us, not only those in extreme distress, have the potential to become someone *else*'s front page, with a concomitant loss of privacy and perhaps even autonomy. While we are concerned about voyeurism, about exoticizing the other, something much more banal but potentially terrifying is happening to those who have the illusion of watching from a place of comparative comfort. According to a 2012 report in the *New York Times*: "The average person today leaves an electronic trail unimaginable 20 years ago—visiting Web sites, sending e-mails and text messages, using credit cards, passing before a proliferating network of public and private video cameras and carrying a cellphone that reports a person's location every minute of the day." Furthermore, "to store the audio from telephone calls made by an average person in the course of a year would require about 3.3 gigabytes and cost just 17 cents . . . a price that is expected to fall to 2 cents by 2015."[13] Tracking a person's movements for a year—following a trail collected from their cellphone—would cost a trivial amount.

Storing video takes far more space, but the price is dropping so steadily that storing millions of hours of material will soon not be a problem. (Moreover, as John Villasenor, an electrical engineer at UCLA observes: "It's so cheap that you can afford to throw away 99.9 percent without looking at it.")[14] And, given the revolution in search technology, anything of potential interest is that much easier to locate. (I find it extraordinary that in the United States so many people are concerned about their right to defend themselves with automatic rifles, but so few seem concerned about self-defense against surveillance.)

In 1985, as the world appeared to have survived the dire prophecies of George Orwell's *1984*, cultural critic Neil Postman pointed out that perhaps the truer and more sinister vision of the future was actually an earlier one, expressed by Aldous Huxley in his 1932 novel *Brave New World*: "What Orwell feared were those who would ban books," says Postman. "What Huxley feared was that there would be no reason to ban a book, for there would be no one who wanted to read one. Orwell feared those who would deprive us of information. Huxley feared those who would give us so much that we would be reduced to passivity and egoism."[15]

Postman was prescient, but in fact both Orwell and Huxley seem to have been right. We live between a rock and a soft place. It would be helpful if our media would help us to better define and understand the territory; without knowing what it is, resistance is difficult.

As we consider where we want to go with our media, we need to think about what models will serve not only our needs but also our values, and then experiment to see how such models can be implemented. We will have to figure out ways to guide this revolution in media, rather than let it guide us—a proposition made more difficult by the fact that we are submerged in that which we are trying both to evaluate and to direct. To do so (and we have no choice but to try), we will probably want to consult the best ideas from contemporary and previous media the world over, including those who have been subjects, from NGOs, from a diversity of artists, from scientists and programmers, from politicians, ethicists, philosophers and the clergy, from social workers and psychiatrists, and from our neighbors. We will also probably want to stimulate more innovation among independents—including the countless nonprofessional witnesses—while figuring out ways to get all this information out to people so that they can help shape it and use it.

But all this can only be done in a spirit of dialogue with a universe greater than ourselves, one of metaphors as well as facts. Documentary photographers, at least many of them, have always seemed to approach the world with a touch of both the poet and the social worker, aware of both what is and what might be. They are, as the Chinese

artist and activist Ai Weiwei characterized his fellow artists, "work[ing] hard hoping to change it according to their own aspirations."[16]

A vignette: on a video screen in the lobby of the United Nations, all one could see was gray static with the sounds of children, heard as if from afar; if one placed one's hand firmly on a wooden hand that was attached near the screen on the wall, the static turned to sharp color video images of energetic, often smiling children. If one's hand was taken away, the gray static returned.

The project, by Istanbul-based artist Beliz Demircioglu, was featured in a 2005 exhibition as world leaders met in New York to discuss the Millennium Development Goals. The first premise was a simple one: only by staying engaged can we move forward. The second premise: image is not a given, it is a collaboration.

While some try to move the media revolution forward incrementally, there will be a few who will experiment with ideas that have the potential to more radically shift paradigms, like Borges's "Aleph," or Dziga Vertov's 1929 film *Man with a Movie Camera*, which was, as Vertov famously introduced it, "made with the intention of constructing a genuine international and absolutely visual language of cinema, on the basis of its total separation from the language of theater and literature."[17] In doing so, these innovators will undoubtedly discover that "multimedia" is not a process of simply adding more media, but of implicit relationships made resonant among the most divergent of media, and that what is most lacking among activist approaches are those that function proactively. These and other discoveries should serve as jumping-off points to transform the ways in which the world is mediated, while seeking both the revelatory and the useful.

A few ideas, to get started:

- Icelandic artist Björk describes the video of her song "Hollow," drawn from her pioneering app-based album *Biophilia*, released in 2011:

 > It's just the feeling when you start thinking about your ancestors and DNA that the grounds open below you and you can feel your mother and her mother, and her mother, and her mother, and her mother 30,000 years back. . . . So suddenly you're [in] this kinda tunnel, or trunk of DNA. . . . It's like being part of this everlasting necklace when you're just a bead on a chain and you sort of want to belong and be a part of it and it's just like a miracle.[18]

- David Rokeby's "Very Nervous System," first invented in the 1980s, uses cameras to photograph movement, and outputs the visual as music according to algorithms

that he has written.[19] Digital data can be output in any medium, not just the one in which they are initially created: a photograph can thus be turned into sound, or sound into image. Japanese artist Kenji Kojima has, for example, devised a system for "playing" a daily news photograph as if it were the score for a player piano.[20]

- Brian Eno, in a 1995 interview with Kevin Kelly for *Wired* magazine, foresaw the generation of his music through software, a cultural foray into artificial life: "I want to be able to sell systems for making my music as well as selling pieces of music. In the future, you won't buy artists' works; you'll buy software that makes original pieces of 'their' works, or that recreates their way of looking at things. You could buy a Shostakovich box, or you could buy a Brahms box. [These systems would create] music that I might have written but didn't!"[21]

- Canadian artist Luc Courchesne's 1990 interactive video installation *Portrait One* introduced the idea of "conversational" portraiture, in which a prerecorded, onscreen subject offers the live viewer questions to pose or to be answered; the ensuing "discussions" can be thought provoking, both for what is said and for what is left out. The image, in a sense, talks back, with much more to say than one might have thought possible.[22]

- Argentine novelist Julio Cortázar's 1963 novel *Rayuela/Hopscotch* is an inspired evocation of the nonlinear and the shuffled, protean narratives that result, while his pivotal 1959 short story "Las babas del diablo" (known in English as "Blow-Up") delves into the ambiguity of photography and its quantum collapse, given the presence of the subjective observer.[23]

- French filmmaker Chris Marker's 1965 *La Jetée* is an early but still vital experiment in hybrid still/moving-image storytelling, coupled with a folding and unfolding treatment of time and memory, in which still photographs function as nodes, brimming with unrealized possibilities—a hypertext in waiting.

- Uruguayan writer Eduardo Galeano employs a temporal collage in his extraordinary trilogy *Memoria del fuego/Memory of Fire* (1982–86), about the history of the Western Hemisphere, linking North and South. Among the juxtapositions in his project: up North, an overweight, reclusive Elvis Presley fires his pistols at his six television sets at Graceland while, in the South, Brazil's military dictatorship bans Picasso's erotic prints and the U.S. Declaration of Independence.[24]

- Wim Wenders explores the mental/emotional photography of dreams, and its obsessive qualities, in his 1991 film *Bis ans Ende der Welt/Until the End of the World*. In the film's vision of a postapocalyptic future, one makes a video and then, when it is broadcast, remembers the initial seeing so that the sensations can be translated directly into the brain of a blind person, who can then "see" the initial vision. This imagined system also allows sighted people to record, and then view, their own dreams.

- *El libro que no puede esperar* (The book that cannot wait), created in 2012 by a small publisher in Buenos Aires called Eterna Cadencia, gives a sense of urgency to reading, and is a reminder of the precariousness, and importance, of a physical object.[25] The volume comes sealed in a plastic wrapper; once it is opened, the book's ink begins to age and steadily disappear until, some two months later, one is left without words. Might one make a book of photographs the same way, to emphasize its urgency? Or perhaps create publications online that will fade?

- Raymond Queneau's *Cent mille milliards de poèmes/One Hundred Million Million Poems* is a simple but compelling 1961 experiment with resequencing narratives.[26] Queneau began with ten sonnets of fourteen lines, and then separated out each line so that they all can be rearranged; if one were to explore every possible arrangement, there would (according to Queneau) be enough to read for more than a million centuries—a nearly eternal collaboration between reader and writer.

- And of course there is John Cage, always hovering, for the aleatory arts. His *4'33"* is a silent performance in which the sounds of the environment are allowed to migrate to the foreground—like the image lying unattended outside the frame, invited in (thus the title of this book).

Like Cage's silent music, this passage from a 2012 *New York Times* Opinion piece by Bernie Krause may help bring our attention to what has been left out:

> On June 21, 1988, I recorded a rich dawn chorus in California's pristine Lincoln Meadow. It was a biome replete with the voices of Lincoln's sparrows, MacGillivray's warblers, Williamson's sapsuckers, pileated woodpeckers, golden-crowned kinglets, robins and grosbeaks, as well as squirrels, spring peepers and numerous insects. I captured them all.
>
> When I returned a year later, nothing appeared to have changed at first glance. No stumps or debris—just conifers and lush understory. But to the ear—and to the recorder—the difference was shocking. I've returned 15 times since then, and even years later, the density and diversity of voices are still lost. There is a muted hush, broken only by the sound of an occasional sparrow, raptor, raven or sapsucker. The numinous richness of the original biophony is gone.
>
> Lesson: While a picture may be worth a thousand words, a soundscape is worth a thousand pictures.[27]

Or might it be another lesson: there are connections to be made between picture and soundscape, between photographer and reader, between us and the world, between present and future—with new opportunities for actualizing them via a digital environment.

In conclusion, it may be helpful to keep in mind this passage from Martin Buber's *I and Thou*:

> I consider a tree.
>
> I can look on it as a picture: stiff column in a shock of
> light, or splash of green shot with the delicate blue and
> silver of the background.
>
> I can perceive it as movement: flowing veins on clinging, pressing
> pith, suck of the roots, breathing of the leaves, ceaseless commerce
> with earth and air—and the obscure growth itself.
>
> I can classify it as a species and study it as a type in its
> structure and mode of life. . . .
>
> In all this the tree remains my object, occupies space and
> time, and has its nature and constitution.
>
> It can, however, also come about, if I have both will and grace, that in
> considering the tree I become bound up in relation to it. The tree is
> now no longer *It*. I have been seized by the power of exclusiveness. . . .
>
> There is nothing from which I would have to turn my eyes
> away in order to see, and no knowledge that I would have to
> forget. Rather is everything, picture and movement, species
> and type, law and number, indivisibly united in this event.[28]

In trying to reshape the world, this may be a good place to start.

NOTES

1. Fred Ritchin, "Don McCullin: Dark Landscapes," *Aperture* 195, Summer 2009.

2. "Abu Ghraib Photos Were 'Big Shock,' Undermined U.S. Ideals," CNN.com, May 20, 2009. http://www.cnn.com/2009/WORLD/meast/05/18/detainee.abuse.lookback/index.html.

3. Ibid.

4. "Newspapers to Disappear by 2040: UN Agency Chief," AFP, October 3, 2011. http://www.google.com/hostednews/afp/article/ALeqM5gCptnAWIGeV2DHrDzfC_foveVEWw?docId=CNG.c7834de50dcbb3d3a3831e8bb861b7a7.441.

5. See C. J. Chivers, "Service Held for Combat Photographers and Doctor Killed in Misurata," "At War" blog, *New York Times*, April 22, 2011. http://atwar.blogs.nytimes.com/2011/04/22/service-held-in-benghazi-for-combat-photographers-and-physician-killed-in-misurata/.

6. Brian Montopoli, "Left Behind in America: Who's to Blame for the Wealth Divide?," *CBS News*, September 7, 2011. http://www.cbsnews.com/8301-503544_162-20102289-503544.html.

7. Stephen Mayes, e-mail message to the author, October 4, 2011. See "What Matters Now?" Aperture Foundation, New York, September 7–17, 2011. www.aperture.org/whatmattersnow.

8. Socialdocumentary.net mission statement: http://socialdocumentary.net/.

9. Jen Whyntie, "One Rat Brain 'Talks' to Another Using Electronic Link," BBC, February 28, 2013. http://www.bbc.co.uk/news/science-environment-21604005.

10. See This Is Kroo Bay, http://www.savethechildren.org.uk/kroobay/.

11. Rachel Palmer, e-mail message to author, May 28, 2009.

12. See Olivier Laurent, "The New Economics of Photojournalism: The Rise of Instagram," *British Journal of Photography*, September 3, 2012. http://www.bjp-online.com/british-journal-of-photography/report/2202300/the-new-economics-of-photojournalism-the-rise-of-instagram.

13. Scott Shane, "Data Storage Could Expand Reach of Surveillance," "The Caucus" blog, *New York Times*, August 14, 2012. http://thecaucus.blogs.nytimes.com/2012/08/14/advances-in-data-storage-have-implications-for-government-surveillance/.

14. John Villasenor, quoted in ibid. Data storage takes many forms: according to a January 24, 2013, report on National Public Radio: "If you took everything human beings have ever written—an estimated 50 billion megabytes of text—and stored it in DNA, that DNA would still weigh less than a granola bar." http://www.npr.org/2013/01/24/170082404/shall-i-encode-thee-in-dna-sonnets-stored-on-double-helix.

15. Neil Postman, *Amusing Ourselves to Death: Public Discourse in the Age of Show Business* (New York: Viking, 1985).

16. *Ai Weiwei's Blog: Writing, Interviews, and Digital Rants: 2006–2009* (Cambridge, Mass.: MIT Press, 2011).

17. Dziga Vertov, quoted in Vlada Petric, "Dziga Vertov as Theorist," *Cinema Journal* 18, no. 1 (Autumn 1978).

18. Björk, email correspondence cited in Dan Raby, "Björk Explores the World Within for 'Hollow,'" National Public Radio, "All Songs Considered," March 5, 2012.

19. More information on Rokeby's "Very Nervous System," including videos of his system in action, may be accessed at http://www.davidrokeby.com/vns.html.

20. Examples of Kojima's translations of news items (such as coverage of the 2011 Fukushima nuclear disaster) to music may be accessed at http://www.kenjikojima.com/newsmusic/index.irev?fukushimaVideo=true.

21. Brian Eno, quoted in Kevin Kelly, "Gossip Is Philosophy," Wired.com, n.d. http://www.wired.com/wired/archive/3.05/eno_pr.html. In the visual realm, in 2006, Eno created *Constellations (77 million paintings)*, a generative artwork in which approximately three hundred of his paintings are mutated to continually form imagery that neither Eno nor anyone else had ever seen previously.

22. A video showing Courchesne's *Portrait One* can been seen at http://vimeo.com/5827424.

23. Julio Cortázar, *Rayuela* (1963); *Hopscotch*, Eng. trans. by Gregory Rabassa (New York: Avon, 1966); and idem., "Las babas del diablo," in *Las armas secretas* (1959), Eng. trans. by Paul Blackburn (as "Blow-Up") in Cortázar, *End of Game and Other Stories* (New York: Pantheon, 1967).

24. Eduardo Galeano, *Memoria del fuego*, 3 vols. (1982–86); *Memory of Fire*, Eng. trans. by Cedrig Belfrage (London: Quartet, 1985–89).

25. *El libro que no puede esperar* (Buenos Aires: Eterna Cadencia, 2012). The book sold out of its entire first printing in a single day. See "A Book Written in Disappearing Ink," *Los Angeles Times*, June 28, 2012. http://latimesblogs.latimes.com/jacketcopy/2012/06/books-written-in-disappearing-ink.html.

26. Raymond Queneau, *Cent mille milliards de poèmes* (1961); *One Hundred Million Million Poems*, Eng. trans. by John Crombie (Paris: Kickshaws, 1983). See also work by other members of the Oulipo group—a loose gathering of experimental-minded writers and mathematicians founded by Queneau and François le Lionnais in 1960.

27. Bernie Krause, "The Sound of a Damaged Habitat," *New York Times*, July 28, 2012. http://www.nytimes.com/2012/07/29/opinion/sunday/listen-to-the-soundscape.html?_r=0.

28. Martin Buber, *I and Thou*, Eng. trans. by Ronald Gregor Smith (Edinburgh: T. & T. Clark, 1937).

Afterword

If the last century was the century of the Photograph, this century is that of Image—branding, surveillance and sousveillance, geo-positioning, sexting, image wars, citizen journalism, happy slapping, selfies, photo-opportunities, medical imaging, augmented realities, video games, snapchat, and, within it all, photography.

But photography, lest we forget in the nostalgia that now envelops it (consider Instagram, for example), has long been fiercely criticized for multiple reasons. It was thought of as highly aggressive—photographers *shoot* and pictures *freeze*, fragmenting time and space. "Through photographs, the world becomes a series of unrelated, free-standing particles; and history, past and present, a set of anecdotes and *faits divers*," Susan Sontag wrote in 1977. "The camera makes reality atomic, manageable, and opaque. It is a view of the world which denies interconnectedness, continuity, but which confers on each moment the character of a mystery."[1]

As such, photography can be seen as having been a gateway to the digital: the division into discrete segments of a reality once thought of as continuous. Rather than the analog with its continuous tones, Sontag was arguing for the photograph itself as particle, not wave, representing the world in rectangles that segmented space while fractionalizing time.

These discrete and "unrelated, free-standing particles" represented by photographs would each then be subdivided into millions of pixels, mediating reality not as "atomic, manageable, and opaque," but—at the level of the pixel—as *subatomic*, and, given the malleability of the digital, as considerably less solid. The photograph, no longer automatically thought of as a trace of a visible reality, increasingly manifested individuals' desires for certain types of reality. And rather than a system that "denies interconnectedness," the digital environment emphasizes the possibility of linkages throughout (the Web, for example)—from one image to another, from one pixel to another, from one person to another, instantaneously and over great distances.

Photography, to think of Sontag's critique in another way, sabotaged the Newtonian continuities with which we had grown accustomed to viewing the world and ourselves,

and instead argued (if only implicitly) for a quantum *interconnectedness*—and for the essential ambiguity of light as both wave and particle. In the shift to this newer conceptual framework, photographers and image-makers will find numerous innovative approaches, including ways to abandon some of their longstanding concentration on appearances for a potentially deeper commingling at the level of code, including that of our own DNA. Photography and other images will then be able to argue for a more encompassing connectedness among humans, among species, as well as between consciousness and the unconscious, and between past and future, that was not always evident before. And the photograph of a nude by Edward Weston, rather than being seen only as the archetype of the continuous-tone phenotype in all its magnificence, will also represent an entryway into the less visible levels of shared connectedness—the *everyone else* that the young woman sprawled on the undulating dunes, at the level of code and of her radiant humanity, also represents. (With his influential Zone System, in which tones are made discrete, Weston's friend Ansel Adams hinted at the digital revolution that was to come, allowing for more diverse modes of interplay within the strata of existence.)

We seem then to have created digital media to fulfill psychological, spiritual, and political needs—we want to find some ways in which to become more at one with our universe, and with ourselves. The fact that we have done this largely unconsciously points ever more strongly to the depth of our need and desire to both repair and reinvent our world. It is clear that we cannot survive if we behave solely atomically, for a single self, but only if we embrace the possibility of surrendering to a larger cosmos, one in which our thoughts and dreams are somewhere shared, in which we are not alone.

Bending the Frame is written as we enter a realm of possibilities that were up until now barely palpable; this book focuses upon some of the serious efforts that are being made to bridge various realities through media, particularly those by photojournalists, documentarians, and their newly assertive partners, the citizens. The intention, as must be evident, is to urge upon us further choices that may bring us to more resilient, sustainable, hopeful places.

NOTE

1. Susan Sontag, *On Photography* (New York: Farrar, Straus & Giroux, 1977).

INDEX

Italic page numbers indicate images. Notes are referred to by page and note number.

Y

Z

Acknowledgments

Many have helped me to better understand the issues in *Bending the Frame*. There have been the editors who have assigned me essays and articles to write over the years, and those who have published my two earlier books, *In Our Own Image: The Coming Revolution in Photography* (Aperture, 1990), and *After Photography* (Norton, 2008); several ideas expressed in them, especially from the latter book, are referenced and further developed here.

Numerous photographers from around the world have generously discussed their perspectives, both formally and informally, as have numerous editors at photographic agencies, NGOs, and humanitarian organizations. David Campbell was kind enough to share his research with me very early on. Many discussions with students, mostly at New York University, helped to shape my ideas, and several assisted at various points with research, including Erin Gordon, Rikki Gunton, Robert Sukrachand, Alison Wynn, and Sim Chi Yin.

Amy Yenkin, director of the Open Society Documentary Photography Project, and her colleagues have not only long carried a somewhat solitary torch in the field, but also provided funds to support the writing and production of *Bending the Frame*.

I would particularly like to acknowledge Chris Boot, Aperture's executive director, and its publisher Lesley Martin, who have stood behind this book. Amelia Lang and Alison Karasyk did much of the image research and Susan Ciccotti proofread the texts; I am grateful to them for their assistance at Aperture. My thanks also go to Sara Duell and Louis Lee, for their skillful design. Melissa Harris consistently and enthusiastically encouraged me to write for *Aperture* magazine on a number of occasions, essays that inform this book. Diana Stoll has kept *Bending the Frame*'s text as sharply articulated as possible, while being a steadfast ally in moving the entire project forward with consummate grace; I am eternally grateful to her.

My wife, Carole Naggar, shared the hills and valleys of this journey, as always providing timely feedback and a patient fortitude. And our children, Ariel and Ezra, constitute two extraordinary reasons for thinking seriously about the future, while they make the present such a pleasure.

Finally, the sudden loss of photographers of rare talent, Tim Hetherington and Chris Hondros, killed in Libya, not only leaves a gaping hole within the profession, but makes it even more imperative to understand what all this imagery might actually accomplish. It is to them, and to all the others doing the work, that this book is dedicated.

Reproduction Credits

Front cover

Michael Wolf, *Paris Street View #48*, 2010, copyright © Michael Wolf

Plates

Page 81: cover and opening pages of *Rolling Stone*, issue no. 224, "The Family," October 21, 1976, copyright © Rolling Stone LLC 1976. All Rights Reserved. Reprinted by Permission. "The Family" opened with *John DeButts, Chairman of the Board, AT&T, New York City*. Photograph by Richard Avedon, copyright © The Richard Avedon Foundation; page 82: cover and pages from *Telex Iran* by Gilles Peress, Aperture Foundation, 1983; page 83: James Balog, copyright © James Balog/Extreme Ice Survey; page 84: JR, copyright © JR-ART.net; page 85: cover and pages from *Picture Imperfect* by Kent Klich with Beth R., Journal, copyright © 2008; page 86: Jennifer Karady, courtesy Jennifer Karady; page 87: (top) James Reynolds, copyright © James Reynolds, (bottom) Celia A. Shapiro, copyright © Celia A. Shapiro; page 88: Susan Meiselas, copyright © Susan Meiselas/Magnum Photos; page 89: Chris Johnson, Bayeté Ross Smith, Kamal Sinclair, and Hank Willis Thomas, courtesy Chris Johnson, Bayeté Ross Smith, Kamal Sinclair, and Hank Willis Thomas, bottom installation photograph by Yoni Klein; page 90: Trevor Paglen, courtesy Trevor Paglen, Altman Siegel, San Francisco; Metro Pictures, New York; Galerie Thomas Zander, Cologne; page 91: pages from *Riley and His Story* by Monica Haller in collaboration with Riley Sharbonno, photographs by Sharbonno (2003–4), Onestar Press/Fälth & Hässler, copyright © 2009–10; page 93: (top left and right) Balazs Gardi, courtesy Balazs Gardi/Basetrack. org, Creative Commons (BY-NC-ND), (below left and right) Teru Kuwayama, courtesy Teru Kuwayama/Basetrack.org; page 95: (top) Hamed Hasan Salman, copyright © Hamed Hasan Salman/Daylight Community Arts Foundation, (bottom) Ahmed Dhiya, copyright © Ahmed Dhiya/Daylight Community Arts Foundation; page 96: Gustavo Germano, courtesy the artist.

Front cover: Michael Wolf, *Paris Street View #48*, 2010

Publisher: Lesley A. Martin
Editor: Diana C. Stoll
Managing Editor: Amelia Lang
Design Director: Emily Lessard
Designers: Sara Duell, Louis Lee
Production: Matthew Harvey
Senior Text Editor: Susan Ciccotti
Work Scholars: Alison Karasyk, Lauren Sloan, Luke Chase
Index: Enid L. Zafran, Indexing Partners, LLC.

Bending the Frame: Photojournalism, Documentary, and the Citizen is supported in part by a generous grant from the Open Society Foundations.

This volume is part of *Aperture Ideas: Writers and Artists on Photography*, a series devoted to the finest critical and creative minds exploring key concepts in photography.

First edition
Printed in the U.S.
10 9 8 7 6 5 4 3 2 1

Library of Congress Cataloging-in-Publication Data

Ritchin, Fred.
 Bending the frame : photojournalism, documentary, and the citizen / Fred Ritchin. -- First edition.
 pages cm. -- (Aperture ideas : writers and artists on photography)
 Includes bibliographical references and index.
 ISBN 978-1-59711-120-1 (pbk. : alk. paper)
 1. Photojournalism. 2. Photography--Social aspects. I. Title.

TR820.R558 2013
070.4'9--dc23

 2013006707

Aperture Foundation books are distributed in the U.S. and Canada by:
ARTBOOK/D.A.P.
155 Sixth Avenue, 2nd Floor, New York, N.Y. 10013
Phone: (212) 627-1999, Fax: (212) 627-9484, E-mail: orders@dapinc.com
www.artbook.com

Aperture Foundation books are distributed worldwide, excluding the U.S. and Canada, by:
Thames & Hudson Ltd., 181A High Holborn, London WC1V 7QX, United Kingdom
Phone: + 44 20 7845 5000, Fax: + 44 20 7845 5055, E-mail: sales@thameshudson.co.uk
www.thamesandhudson.com

aperture

Aperture Foundation
547 West 27th Street, 4th Floor
New York, N.Y. 10001
www.aperture.org

Aperture, a not-for-profit foundation, connects the photo community and its audiences with the most inspiring work, the sharpest ideas, and with each other—in print, in person, and online.